W9-AVX-078

high contrast

Curtin & London, Inc.
Somerville, Massachusetts

Van Nostrand Reinhold Company
New York / Cincinnati / Toronto / Melbourne

high contrast J. SEELEY

Printed in the United States of America

Published in 1980 by Curtin & London, Inc.
and Van Nostrand Reinhold Company
A division of Litton Educational Publishing, Inc.
135 West 50th Street, New York, NY 10020, U.S.A.

Van Nostrand Reinhold Limited
1410 Birchmount Road
Scarborough, Ontario M1P 2E7, Canada

Van Nostrand Reinhold Pty. Ltd.
17 Queen Street
Mitcham, Victoria 3132, Australia

10 9 8 7 6 5 4 3 2 1

Interior design and cover design: David Ford
Art and production manager: Nancy Benjamin
Composition: American Stratford Graphic Services, Inc.
Printing and binding: Halliday Lithograph
Jackets: Phoenix Color Corp.

All photographs and technical illustrations, unless otherwise credited, are by the author.

To Duby

Library of Congress Cataloging in Publication Data

Seeley, J
 High contrast.

 Includes index.
 1. Photography—Special effects. I. Title
TR148.S43 778.8 80-15413
ISBN 0-930764-21-8

Contents

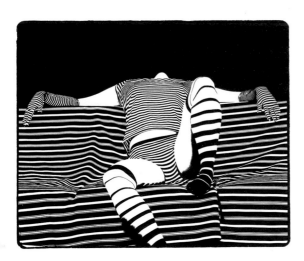
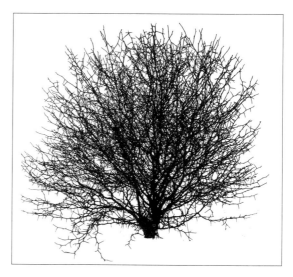

3 DARKROOM TECHNIQUES AND IMAGE MODIFICATIONS 51

4 SHOOTING FOR HIGH-CONTRAST CONVERSION 95

5 HIGH-CONTRAST PHOTOMONTAGE 173

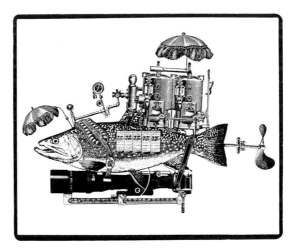

Preface

High Contrast is designed to be a complete technical guide for photographers and artists interested in using litho materials to make high-contrast photographs. Litho film is used to convert a continuous-tone image into a black and white image that is completely void of gray tones. The variety of effects that can be produced using litho materials range from the bold and graphic to the delicate and detailed. This book, when read from cover to cover, provides all the information needed to take the photographer from ground-floor basics to complex levels of high-contrast image production. It can also be used as a reference book by the experienced photographer who needs immediate access to step-by-step explanations of specific techniques.

The first two chapters cover setting up the darkroom and the basic high-contrast darkroom procedures. These chapters can be easily understood by anyone with a basic knowledge of photographic printing. Chapter 3 describes experimental extensions of these basic darkroom procedures. In Chapter 4, "Shooting for High-Contrast Conversion," a wide variety of studio and available light conditions are discussed and clearly diagrammed. Chapter 5, the last chapter, explains several classic, as well as original, photomontage techniques.

For their help, and support of this project, I wish to thank
 Arlene Dubanevich
 Vernon and Mil Seeley
 Dennis Curtin
 Nancy Benjamin
 Jim Stone

Grateful acknowledgement is also given to each of the photographers who have contributed work to this book:
 Oscar Bailey
 Irene H. Chu
 Pierre Cordier
 Betty Hahn
 Susan Fox Haywood
 Diane Hopkins Hughes
 Scott Hyde
 Kathleen Kenyon
 Ray K. Metzker
 Donna Morea
 Daniel Motz
 Bea Nettles
 Esther Parada
 Tom Porett
 Gina Rosenwald
 Naomi Savage
 Bill Seelig
 Carl Sesto
 H. Randolph Swearer
 Charles Swedlund
 George A. Tice
 Todd Walker

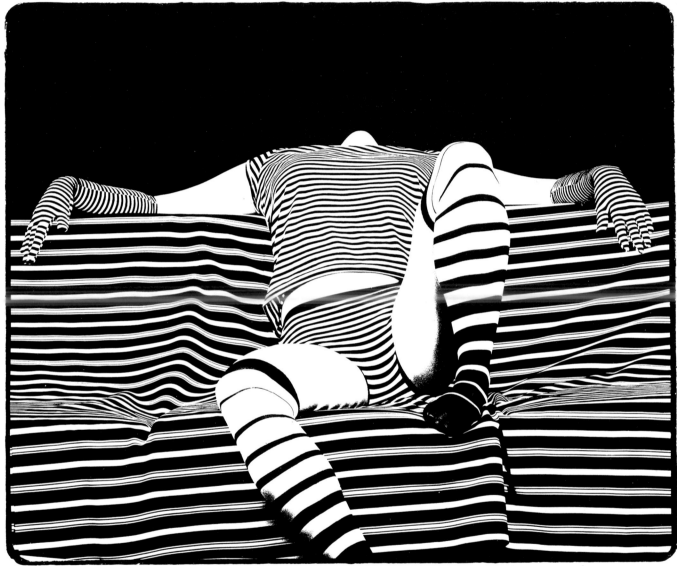

Number 167 From *The Stripe Portfolio*, 1977

1

Preparation and Materials

Preparing to make high-contrast prints is neither complicated nor expensive. A basic darkroom is adequate for most processes. As in conventional printing, the making of high-quality images requires good equipment and good basic technique. In addition to standard equipment and materials, you will need litho sheet film, litho developer, one or two special safelight filters, and some retouching materials.

The High-Contrast Conversion Process—Overview

The original image. The conversion process begins with a ▶
conventional continuous-tone negative. It would look like
this if printed on paper.

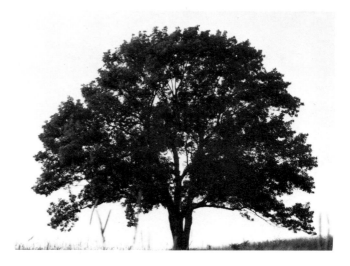

The high-contrast film positive. The same continuous-tone ▶
negative was printed on a piece of high-contrast (litho) film.
Areas that printed as black or dark gray on the continuous-
tone print are opaque on this film positive, and areas that
printed as white or light gray are clear.

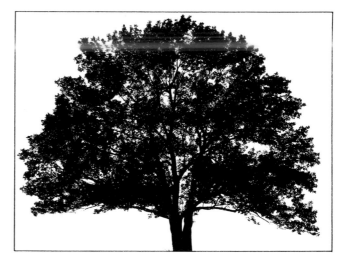

The final high-contrast contact negative. The film positive ▶
(above) was contact printed to a second piece of high-con-
trast (litho) film, creating this final litho negative.

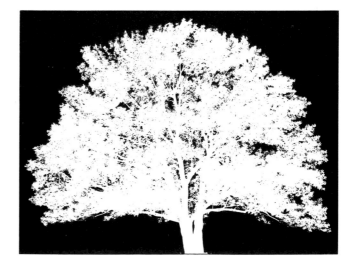

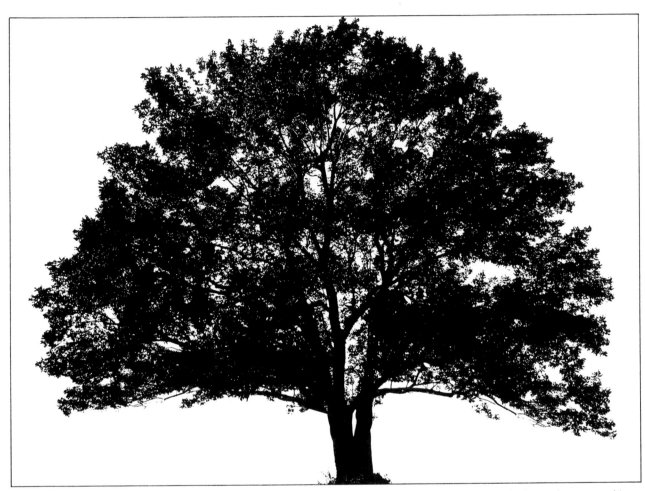

The final print on paper. The final negative was used to make this high-contrast image on paper.

Special Equipment and Materials for High-Contrast Work

Special Equipment and Materials

high-contrast (litho) sheet film, 4x5 or 8x10

high-contrast (litho) developer, powder or liquid

storage containers for chemicals

plastic bags for sheet-film storage

red safelight filters

contact printing frame

retouching equipment and materials (see page 34)

Basic Darkroom Chemicals and Mixing Equipment Checklist

standard film and paper developer

28% acetic acid for stop bath

standard fixer

hypo-neutralizing agent

wetting agent for film

chemical mixing pail and stirring paddles

funnel

thermometer

glass cleaner

two 1-liter (quart) beakers

Basic Darkroom Equipment Checklist

enlarger

easel

interval timer

grain magnifying scope

developing trays, at least six (flat-bottomed)

print tongs

safelight fixtures, adjustable type

drying line and clothespins

transparency viewer, light table, or light box

clock with sweeping second hand

red plastic safe filter for the enlarger

Litho film.

Litho developer.

LITHO FILM

Several manufacturers produce litho film. The best known and most readily available is Kodalith, manufactured by the Eastman Kodak Company. Litho film can be purchased from any photo supplier that carries graphic arts materials. Because each manufacturer produces many kinds of litho film, it is best to ask for a specific catalog number or for the most general-purpose type of film stock the supplier has on hand. Premium grade, general purpose polyester or acetate films are the most versatile. Litho film is available in standard and extra large sheet-film sizes, 35mm bulk rolls, and rolls up to 100 feet long and 48 inches wide. Litho film is expensive. If you are purchasing film to carry out a few preliminary experiments, a box of 4x5 or 8x10 sheets will suit your needs. Special types of litho film will be recommended for specific purposes later in the book (see chart on page 10).

LITHO DEVELOPER

There are several litho film developers available. They are quite similar and often interchangeable. It is advisable, however, to use the developer recommended by the manufacturer of the brand of the litho film being used.

Developer in powder form can be purchased premeasured in a set of foil bags. This set of bags makes both the A and B stock solutions in 1 gallon amounts. They must be prepared from the powder, one at a time, following the package directions. Following the directions accurately is very important. Use a funnel to empty the solutions into their separate storage containers. Make sure to wash the mixing container, stirring paddles, and funnel thoroughly between preparing the A and B solutions. Label and date the storage containers.

Developer can also be purchased as a set of concentrated liquids. The concentrated A and B

solutions come in 2½ or 5 gallon, plastic-lined, cardboard cube containers. The 2½ gallon containers hold enough concentrate to make a total of 20 gallons of working developer, and unless you are in a group darkroom situation, the powder, which makes 2 gallons of working developer, is more practical.

STORAGE CONTAINERS FOR DEVELOPER

Dark plastic gallon jugs are adequate for storing A and B stock developer solutions after they are prepared from powder, but plastic-lined cube containers are better. The plastic liner in the cube container deflates as the solution is removed. This keeps air away from the solution so it stays fresh longer.

Dark plastic jugs for storage of prepared A and B developer solutions.

Cube containers for storage of prepared A and B developer solutions. These are commercially available cardboard boxes with heavy plastic liners and plastic spigots.

PLASTIC STORAGE BAGS FOR SHEET FILM

Litho sheet film must be handled with care. Use plastic food bags or special large archival plastic sleeves for storage of litho negatives. If the negatives get scratched and dirty, they are useless and must be remade.

Inexpensive, non-archival, plastic storage bags are available in all sizes from The Pierce Company, 9801 Nicollet Ave. S., Minneapolis, Minn. 55420. Archival standard plastic and paper storage envelopes are available from Light Impressions Corp., Box 3012, Rochester, N.Y. 14614.

Safelight. This is a common type of safelight that can be conveniently fitted with a special red litho filter. The filter can be purchased separately.

SAFELIGHT FILTERS FOR HIGH-CONTRAST FILM

A box of litho sheet film can be opened, and the film can be handled, under red or certain types of orange safelights as if it were enlarging paper, but care must be taken to avoid prolonged exposure to the safelight. The total time the film is exposed to safelight should not exceed 5 minutes. This includes enlarging as well as developing time.

If the darkroom is equipped with standard, adjustable safelights, purchase two Ortho (red) filters and switch them with the filters that are normally used for black-and-white or color printing. Graphic arts suppliers also carry red-coated safelight bulbs that can be screwed into ordinary sockets. It is also possible to cut out pieces of inexpensive orange mask (see page 37) and attach them to existing safelight fixtures with black masking tape. It takes three layers of this masking material to effectively filter a 15-watt light.

CONTACT PRINTING FRAME

A contact printing frame is an essential piece of equipment for almost all the processes described in this book. If you already own a printing frame, make sure the glass is clean and free of scratches. Replace it with a new piece if it has defects. The contact pressure produced between the glass and the hinged back must be even from edge to edge. If it is necessary to purchase a printing frame, consider the fact that the size of the frame will limit the size of the final print produced by most high-contrast techniques. (See, in addition, the information given on the vacuum frame on page 45.)

The printing frame shown in the illustration on this page is the classic model. It has a wooden frame with a piece of glass and a pressure clamp back. These are made the same way today as they were in the 1850's.

The illustration shows the printing frame in loading position with the glass side down. When contact printing, a positive or negative film print is laid in the frame against the glass, emulsion side up. The unexposed film or paper is laid over the imaged film, emulsion side down. The hinged back is then laid into position. The spring clamps are pushed down and turned into precut notches that hold the back tightly in place. The printing frame is then turned over and exposure is made through the glass.

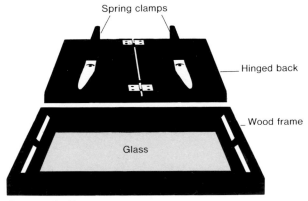

Contact print frame.

General Types of Litho Film for Creative Use

Type	Approximate Thickness	Properties
General-purpose polyester, premium grade	.004''	General use. Recommended for use when dimensional stability is required. It is important that film hold its size when certain masking or overlay techniques are used.
General-purpose acetate, premium grade	.005''	General use. Recommended for use when scraping, scribing, or stippling is required. Emulsion can be removed from the acetate base with less difficulty than from the polyester-based film. Not as stable as polyester. Good for in-camera use; thickness prevents sagging.
Thin-base polyester	.002''–.003''	Minimum loss of detail when thin-base film is printed upside-down to reverse the image. Recommended for montage application when two or more layers of film are overlapped for contact printing.
Matte-base polyester	.004''	Good surface for pencil or ink additions, produces a good contact without Newton's rings (see page 44).
Line films	.004''–.005''	25%–50% lower in cost than premium litho films. Some brands show inconsistent characteristics. Adequate for triple contact method and other uses where image simplicity is desired. Not recommended for fine-grain images.

General Types of Litho Tray Developers

Type	Properties
General-purpose, tray processing, A and B powder form	Recommended for general use with all films listed on chart.
* Fine Line, A and B powder form	Sharp, high-contrast rendition of fine detail with maximum contrast between clear and opaque areas. Recommended for use with still-development technique (see page 86).
Liquid general-purpose litho developer concentrate	Convenient, consistent. Must be purchased in very large amounts. Diluted with water to working strength; strength can be adjusted.

* An Eastman Kodak product

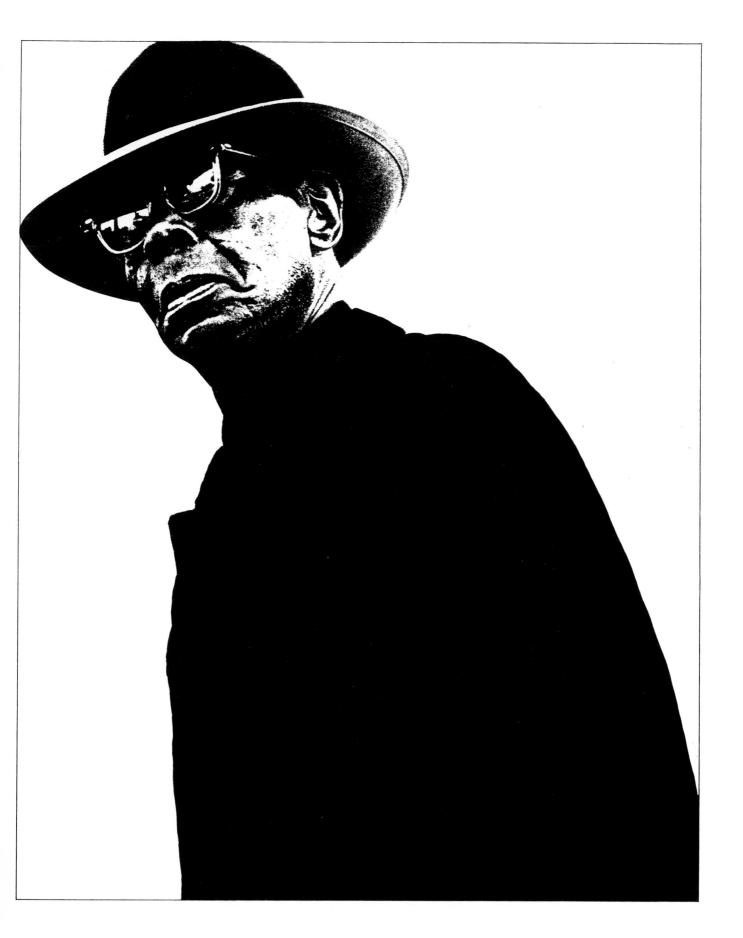

Setting Up the Darkroom

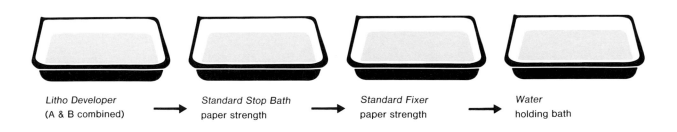

Litho Developer
(A & B combined) → *Standard Stop Bath*
paper strength → *Standard Fixer*
paper strength → *Water*
holding bath

Begin setting up the darkroom for work with litho film by changing the safelight filters. A safelight about 1.2 meters (4 feet) above the developer and another the same distance from the enlarger base should be equipped with 15-watt bulbs and red 1-A or orange mask filters. All other standard yellow safelights should be kept at twice this distance from the film.

The chemical setup is simple. With the exception of the special litho developer and a simplified wash technique, processing is the same as for conventional black-and-white paper. Use flat-bottomed trays that are slightly larger than the film you intend to use.

If the litho stock developer solutions have just been mixed from powder, allow them to cool before using. All chemicals should be between 19°C (66°F) and 21°C (70°F). Prepare a working solution of developer by mixing together, in the quantity needed, an equal amount of A and B stock solution. Consult the chart to determine the amount of developer to use in the tray. Follow the manufacturer's directions if you are making a working solution of developer using the liquid concentrates. The mixed litho developer exhausts more rapidly than paper developer at a rate determined in part by the extent of use and amount in the tray. Standard litho developer should be able to process the equivalent of fifteen 8x10 sheets per liter (quart), if used during the first 20 minutes after being mixed.

A standard stop bath and paper-strength fixer follow the developer. A deep tray of water is sufficient for washing. The final tray should contain a film-strength solution of a film wetting agent such as Kodak Photo-Flo.

To minimize contamination of chemicals during mixing, you should use separate mixing vessels for each chemical, if possible. If several chemicals must be mixed consecutively in the same vessel, prepare them in the order in which they are to be used in processing and rinse the vessel thoroughly between each chemical. Although traces of developer in a fixing bath will have little effect on the film, small quantities of fix in the developer can cause chemical fogging.

When you set up the chemicals, put out a small beaker of water to hold a pair of print tongs, and another beaker or container with warm water for rinsing your hands. Use the print tongs to transfer film from one tray to the next. This can be difficult because the film sometimes sinks to the bottom of the tray, but with practice you will be able to use the tongs efficiently without scratching the film. To avoid contamination of the developer, the tongs should rest in the beaker of water after use in the stop bath or the fixer. Occasionally you will get developer or fixer on your fingertips. Avoid the impulse to wipe them on a towel or your clothing. Rinse your hands in the container of warm water and then dry them. This prevents chemical transfer to your clothing or other items in the darkroom and subsequent contamination.

Many of the processes in this book require the movement of dripping wet film from one area of the darkroom to another. Keep the dry areas of your darkroom totally dry.

Health and Safety in the Darkroom

High-contrast photography is probably no more hazardous than regular black-and-white photography, but common sense should prevail in the darkroom. Recent studies of other types of chemicals show that it is prudent to presume that any industrial chemical is potentially dangerous unless proven otherwise. Take these basic precautions when working in the darkroom.

1. Store all chemicals safely. Keep them out of the reach of children.

2. Keep your darkroom well ventilated. Ideally, it should have at least ten total air changes per hour.

3. Wear a mask when mixing dry chemicals. Inhalation of developer dust is particularly hazardous.

4. Avoid all skin and eye contact with chemicals. Do not store stock solutions at or above eye level.

5. Be careful with electrical cords and appliances. Nothing electrical should be within arms' length of the sink.

6. Keep safelight levels as bright as your materials will permit.

7. Read labels and follow directions carefully. The prepackaged photographic chemicals recommended in this book bear precautionary labels that should be studied carefully.

8. When cleaning up, dump one chemical tray at a time, flushing each down the drain with plenty of water. There is additional information on this subject in pamphlet J-28, published by The Eastman Kodak Company, Rochester, N.Y. 14650.

Tray Size/Amount of Developer

Tray Size	Total Amount of Solution
4x5–5x7	(300mL) 10 oz.
8x10–10x12	(600mL) 20 oz.
11x14–13x16	(800mL) 28 oz.
16x20–18x22	(1800mL) 64 oz.

Developer should be mixed in small amounts because it exhausts rapidly.

Selecting a Negative

Two simple methods for transposing an image from a continuous-tone negative to litho film are described in the next chapter. When selecting a negative to use with either of these procedures, try to visualize the effect conversion to high-contrast will have on the image.

In the conversion process, all dark and light tones in the original camera negative will be translated into total black and total white. Mid-gray tones can turn completely black, completely white, or be reproduced as a sharp granular pattern. This pattern originates from the grain of the camera negative. The conversion to high-contrast greatly exaggerates the grain's size and sharpness. The response of litho film to different negatives varies with the character of each.

Begin experimenting with the high-contrast conversion procedures in the next chapter by selecting a negative that already represents a contrasty scene or subject, one with clearly defined lights and darks. Make several high-contrast conversions using this negative to gain a basic familiarity with the processes and materials.

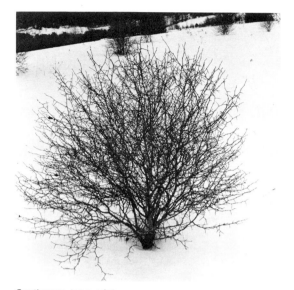

Continuous-tone print.

Continuous-tone print.

DONNA MOREA: Untitled, 1976
High-contrast print made from the same continuous-tone negative used to make the print at left.

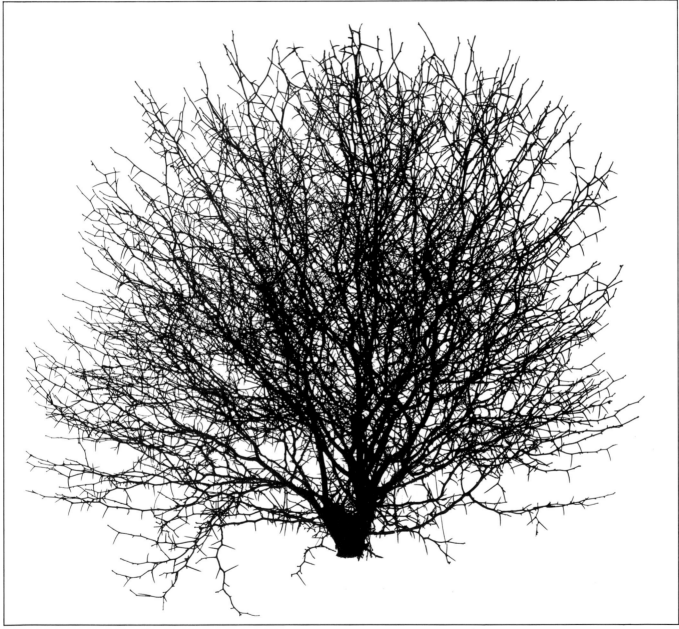

High-contrast print made from the same continuous-tone
negative as the print on facing page. Details in both the
highlight and shadow areas have characteristically
''dropped out.'' Some background detail was intentionally
removed to simplify the image.

Can Negatives Be Positive? Most people associate the word *film* with the negative image that comes from the camera. Similarly, the word *print* is usually associated with a positive image on paper. Actually, either a negative or a positive image can be recorded on either paper or film. Most photographic materials, including litho film, are negative-acting and will reverse the dark and light tones of the images they receive. When working with litho film materials, you can use the same film stock to carry both positive and negative states of the image. Both positive and negative litho transparencies are referred to as ''film prints.''

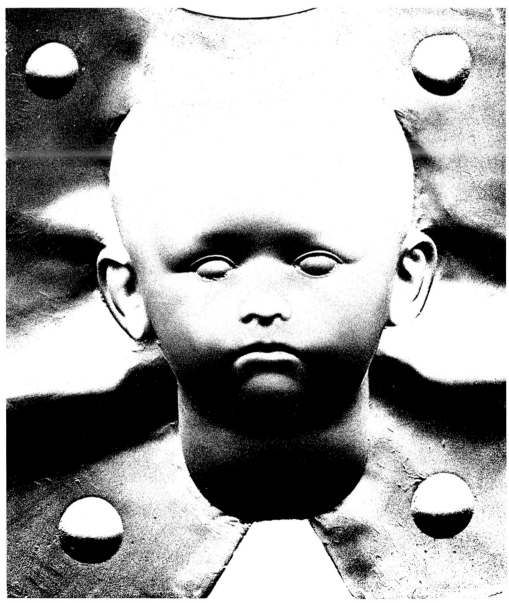

ANTIQUE DOLL HEAD, PLASTER MOLD.
Positive print on litho film.

Negative film print made by contacting the film positive
shown on the opposite page to a piece of litho film.

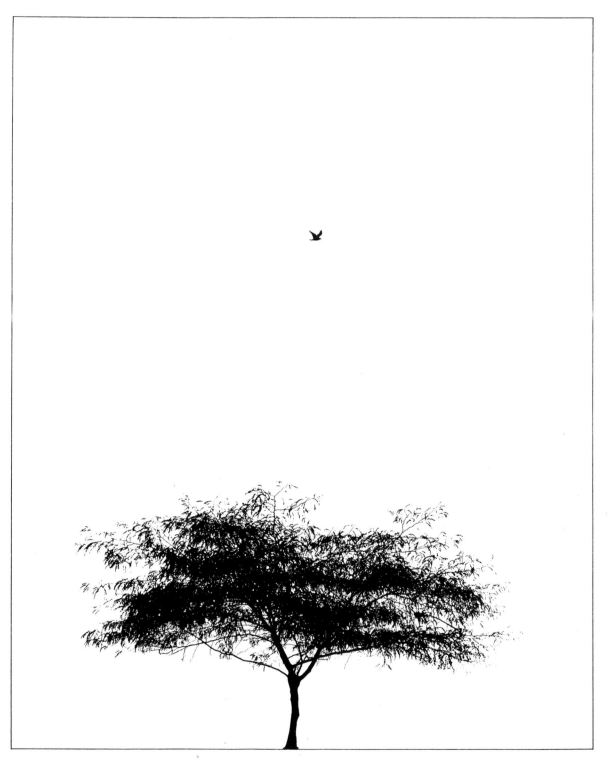

TREE, BIRD, 1971

2

Basic Darkroom Conversion Processes

Producing a high-contrast paper print from a continuous-tone negative requires two basic intermediate steps. First, a positive high-contrast image is made by printing the original continuous-tone negative on litho film. This can be done by enlarging or contact printing. Second, that positive film image is contact printed to another piece of litho film to produce a high-contrast negative. This negative can then be used in the final step to make a print on conventional photographic paper.

The triple contact method is the more simple of the two techniques for making a high-contrast print. The original negative is contact printed on a small piece of litho film. The result is a positive high-contrast film print. After being processed and dried, this positive is contact printed to a second piece of litho film. The resulting film negative is processed, dried, and enlarged on conventional continuous-tone paper to produce the final high-contrast print.

The other technique, the enlargement method, offers a wider latitude for individual interpretation. Here the original negative is enlarged to its final size directly on litho film. This enlarged film positive is then contact printed to another piece of litho film. The final print is made by contact printing the resulting film negative to conventional photo paper.

How to Make a High-Contrast Print from an Existing Negative:
Triple Contact Method

Step 1—Making a Film Positive

Step 2—Making a Film Negative and a Final High-Contrast Print

Making a Film Positive

1. **Set up the enlarger** as you would to make proof sheets. This procedure should be carried out under red safelight.
2. **Dust** the contact printing frame and negative carefully with a negative brush.
3. **Place the unexposed litho film** with the selected negative, emulsion to emulsion, in the contact printing frame (see contact printing frame, page 9). The light-colored side of the litho film is the emulsion side. Several negative frames can be exposed simultaneously, but it is best to expose them one at a time to determine the best exposure for a particular negative.
4. **Expose** after placing the print frame under the enlarger and setting the timer. The exposure time will be approximately the same as that needed to make proof sheets on a rapid photo paper.
5. **Develop the film.** Slip the exposed film into the developer, emulsion side up. Rock the tray *very gently* to provide agitation; rocking can be done by alternately lifting corners and sides of the tray (for more information on agitation, see page 43). Full development, which results in total opacity in the dark areas, should take between 2¼ and 2¾ minutes at 20° C (68° F). Slight overdevelopment can be tolerated in some images, but underdevelopment results in streaks. When the development begins, there is no visible image for the first 10 to 15 seconds. Gradually, a faint image begins to appear. The image darkens at a uniform rate for the remainder of the development period. If the image develops too rapidly, reduce the exposure time and try again. Insufficient density after 2¾ minutes of development indicates a need for increased exposure. (See page 28.)
6. **Lift the film out** by one corner after development is complete. Let it drip for 2 or 3 seconds.
7. **Transfer the film to the stop bath.** Gently agitate it for about 10 seconds.
8. **Fix the film.** Agitate the film in the fixer gently and constantly. After about a minute the light areas of the image begin to clear. Make a mental note of the amount of time it has taken these areas to clear completely. The total fixing time should be about twice this amount of time.
9. **Rinse briefly, then inspect** the film by holding it up to a transparency viewer or by turning on the room lights and viewing it in front of a white surface. Accurate judgment of the developing time requires experience. Our eyes are relatively insensitive to red light. Density appears much greater in the developer under the safelight than it does against the reflected white light. It is always necessary to check the image in this white light after fixing.
10. **Wash the film** in a deep tray for 3 minutes. For films that must have a long life, such as a final litho negative, the wash time should be increased to 10 minutes. If several film prints are to be washed, wash them one at a time to avoid scratching.
11. **Treat in a wetting agent.** After washing the film, immerse it in the wetting agent solution for 15 seconds.
12. **Dry.** Hang the film on a line by one corner in a dust-free area and let it drip dry. Put the positive into a clean plastic bag as soon as it is completely dry.

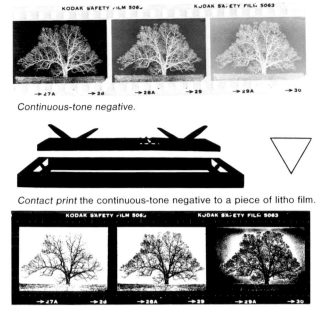

Continuous-tone negative.

Contact print the continuous-tone negative to a piece of litho film.

Litho film positive resulting from the contact above.

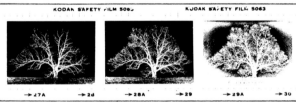

Contact print the litho film positive to a piece of litho film.

Final litho film negative, the result of the contact above.

Making a Film Negative and a Final High-Contrast Print

1. **Contact print** the processed and dried film positive, with an unexposed piece of litho film, emulsion to emulsion (see contact printing frame, page 9). The emulsion side of a processed film print will reflect the slight height of the emulsion when studied under safelight.

2. **Process the film** using the same procedure described for processing the film positive on the facing page.

3. **Trim the litho negative** and fit it into the enlarger negative carrier. Emulsion should be face down.

4. **Enlarge the litho negative.** The high-contrast negative can be printed in the same way as a continuous-tone negative on almost any enlarging paper. Use your own standard paper and chemical setup. Richer blacks can be obtained by mixing a stronger developing solution. If you normally use a developer 1 part stock to 2 parts water, try using a 1 to 1 ratio.

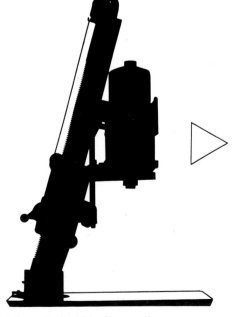

Enlarge the final litho film negative on a piece of conventional enlarging paper.

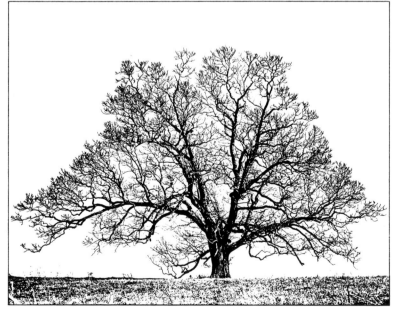

Final print. The resulting high-contrast print on paper.

How to Make a High-Contrast Print from an Existing Negative:

Enlargement Method

Step 1—Making a Film Positive

Step 2—Retouching Litho Film

Step 3—Applying a Border

Step 4—Contact Printing the Film Positive to Make a Final Contact Negative

Step 5—Making the Final Print on Paper

The remainder of this chapter gives instructions for converting a continuous-tone image to a high-contrast image using the enlargement method. Additional information, given after each step, will enable you to understand and control the variables associated with quality control in the litho process. The skill with which each step of the process is executed affects the final image. The first step, making a film positive, however, is the most critical. The quality of the final image depends heavily on the quality of the original continuous-tone negative and the degree of skill used to enlarge it.

Making a Film Positive

1. **Clean** the enlarger lens and the continuous-tone negative carefully with a negative brush.

2. **Position the negative** in the enlarger, emulsion side down.

3. **Adjust the print size and focus** as if making a conventional print. The magnifier used for focusing should have a piece of scrap litho film under its base to provide accurate height for the mirror.

4. **Make a test strip** on litho film to determine the best exposure time. The speed of most litho films is approximately the same as that of fast enlarging papers.

5. **Develop the film.** Slip the exposed film into the developer, emulsion side up. To provide adequate agitation, rock the tray by gently raising the sides 6 to 12mm (¼ to ½ inch). (See page 43.) Full development, which results in total opacity in the dark areas, should take between 2¼ and 2¾ minutes in 20°C (68°F) developer. Slight overdevelopment can be tolerated in some images, but underdevelopment will result in streaks. When the development begins, there is no visible image for the first 20 to 30 seconds. Gradually, a faint image begins to appear. The image darkens for an additional 1 to 1½ minutes. If the image develops too rapidly it has been overexposed. Reduce the exposure and try again. Insufficient density after 2¾ minutes of development indicates a need for increased exposure.

6. **Lift the film out** by one corner after development is complete. Let it drip for 2 or 3 seconds.

7. **Transfer the film to the stop bath.** Gently agitate it for about 10 seconds.

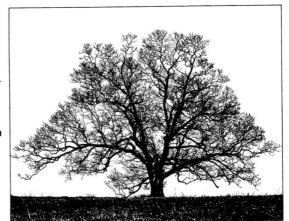

Continuous-tone negative.

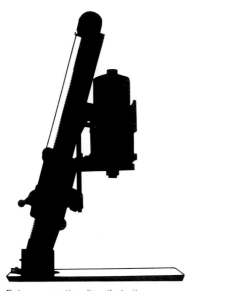

Enlarge negative directly to its final size on litho film.

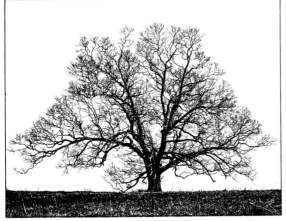

Litho film positive. This resulting image is in its final size.

Contact print the litho film positive to a piece of litho film.

8. **Fix the film.** Agitate the film in the fixer gently and constantly. After about a minute the light areas of the image will begin to clear. Make a mental note of the amount of time it has taken these areas to clear completely. The total fixing time should be about twice this amount of time.

9. **Rinse briefly, then inspect the film** by holding it up to a transparency viewer or by turning on the room lights and viewing it in front of a white surface. Accurate judgment of the developing time requires some experience. Since the human eye is relatively insensitive to red light, the density will appear much greater in the developer than it will against the white light.

10. **Select the test section** that shows the desired amount of detail. Reset the timer to the exposure indicated, and recheck the enlarger focus.

11. **Make the exposure** on a fresh piece of litho film. Repeat steps 5–8.

12. **Wash the film** in a deep tray for 3 minutes. If several film prints are to be washed, wash them one at a time to avoid scratching.

13. **Treat the film in wetting agent.** Immerse it in the solution for about 15 seconds.

14. **Hang the film to drip dry,** by one corner, on a line. To prevent accumulation of dust, put the positive into a clean plastic bag as soon as it is dry.

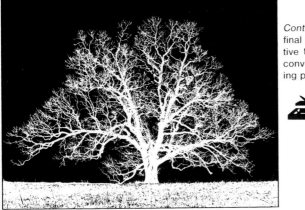

Final litho film negative, the resulting image.

Contact print the final litho film negative to a piece of conventional enlarging paper.

Final print, the resulting high-contrast print on paper.

DETAIL: HIGH-CONTRAST SHEET FILM SIZES

The amount of detail in the high-contrast image is controlled to a great extent by the relative size of the litho film prints used in each step of the conversion process.

The triple contact method uses a small litho film print to convert the original continuous-tone image to high-contrast. The smaller the litho film print, the less capacity it has to record detail, and the more abstract the rendition of the final image made from it will be.

The maximum amount of detail can be retained by enlarging the continuous-tone negative directly to its final size on litho film in the first step of the conversion process. Since the size of the final image is established at this point, the remainder of the process is carried out by contact printing, without further enlargement.

Intermediate levels of detail can be carried through the conversion process by using medium-sized litho film prints. For example, you may prefer, for aesthetic or economic reasons, to enlarge a 35mm negative on a 4×5 piece of litho film, contact the resulting film positive to make a litho negative, and then enlarge this negative on paper to make the final print.

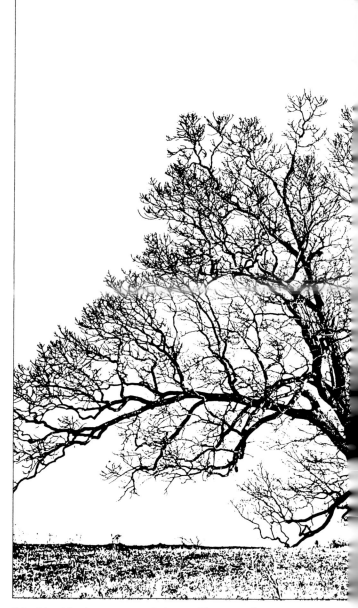

This side of the image was made from a 35mm negative using the triple contact method. This method uses the least amount of litho film and produces the greatest degree of image simplification.

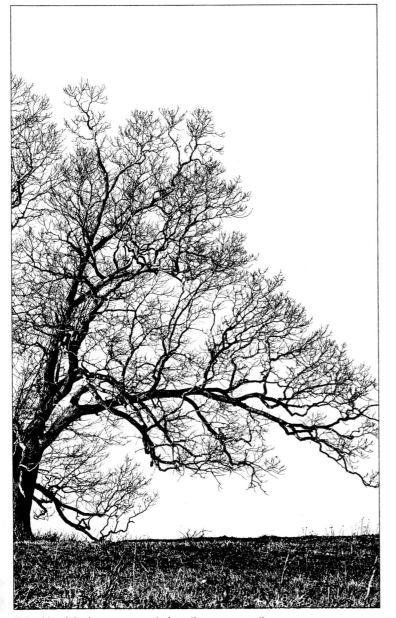

This side of the image was made from the same negative, but enlarged directly to its final size on 8x10 litho film. The enlargement method uses more film, and produces a more detailed image.

SHARPNESS OF THE POSITIVE: ENLARGER FOCUS

The enlarger must be carefully focused to make a sharp film positive from a continuous-tone negative. The sharpness of the litho film print is determined by the sharpness of the visible grainlike pattern that represents the mid-tone areas. This pattern originates from the grain of the continuous-tone negative, but the dots, rather than being soft and gray as they appear on the continuous-tone negative, are hard-edged and black. If the image is not evenly sharp across the entire film positive, the cause of the problem is likely to be one of the following: a lack of precise enlarger focus; a problem with enlarger alignment; or movement of the film or enlarger during exposure. Litho film is very sensitive to the sharpness of the detail it receives. The slightest blur will have a drastic effect on both the detail and the contrast of the final image.

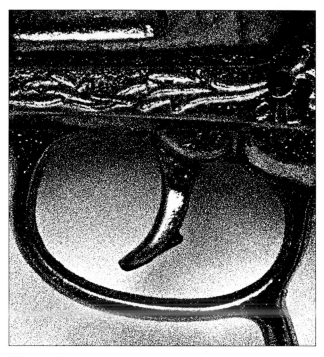

This magnification of a detailed area from the image of the toy gun shows the appearance of the film grain pattern in a carefully focused print.

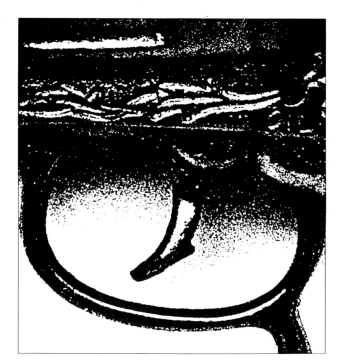

A slight shift in enlarger focus causes the grain to become enlarged and blurred. This image also shows a great increase in contrast which is a side effect of imprecise enlarger focus.

PECK STREET PARKING LOT, 1972

OVERALL DENSITY: ENLARGING TIME

"Density" is the lightness or darkness of the film print. A wide range of density renditions is usable. A darker or lighter image may be more desirable, depending on your aesthetic intentions.

Enlargement exposure time is one of the factors affecting density. Each of the three prints on the top, opposite, was made from the same negative. The only variable was the enlargement exposure time.

An underexposed (but normally developed) film positive. Maximum detail is retained in the shadow areas but the highlight areas have a washed-out appearance.

OVERALL DENSITY: STANDARD DEVELOPING TIME

Development is another factor affecting density. The ideal developing time is 2½ minutes. It's possible, however, to vary the developing time 15 or 20 seconds in either direction and still have a usable film print. A correctly developed negative must always reach total opacity in the dark areas. There should be no haze or blurring around the edges of these areas. Increasing time in the developer enlarges the grain and/or thickens lines and fine detail. Decreasing the ideal developing time by more than 20 seconds will rarely produce a usable film print. As in normal printing, the objective is to give the print sufficient exposure so that it will reach the desired degree of density within the optimum developing time.

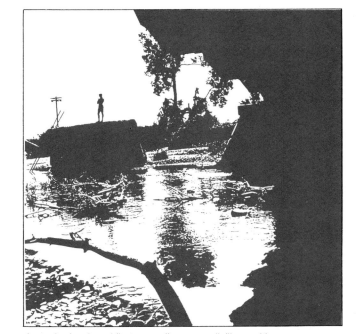

An underdeveloped (but normally exposed) film positive. The film positive was not given enough time in the developer to build to a sufficient level of density. When held up against reflected white light, the dark areas of the film print transmit light. This positive would not produce a satisfactory contact print.

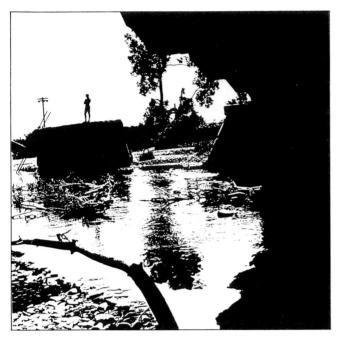

A normally exposed (and normally developed) film positive. A balance of detail is preserved in both highlight and shadow areas.

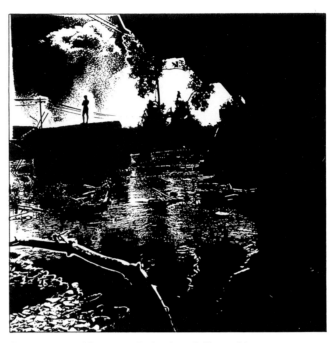

An overexposed (but normally developed) film positive. There is maximum detail in the highlight areas but the shadow areas have turned completely black. It is not unusual for an overexposed high-contrast image to have a more interesting appearance than one that is normally exposed.

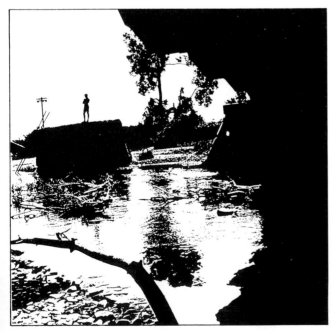

A normally developed (and normally exposed) film positive. Density has been allowed to reach a level of total opacity.

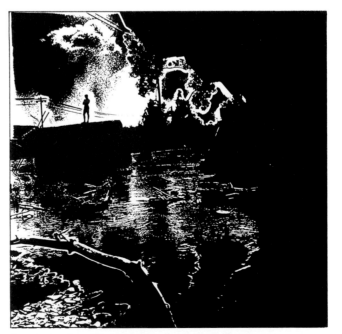

An overdeveloped (but normally exposed) film positive. This print has been allowed to remain in the developer too long. The darkroom safelight has begun to fog the highlight areas. Study the sky section in the top middle area. Overdevelopment typically produces this mild ''solarized'' effect or a smoky, blurred appearance.

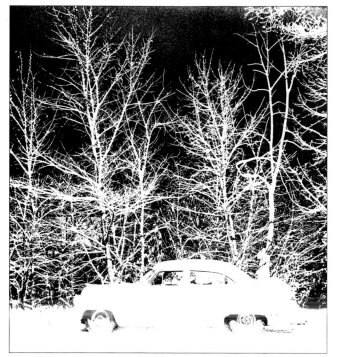

When the overall exposure time was adjusted to retain detail in the shadow areas, it was insufficient to describe the detail in the highlight areas of the car.

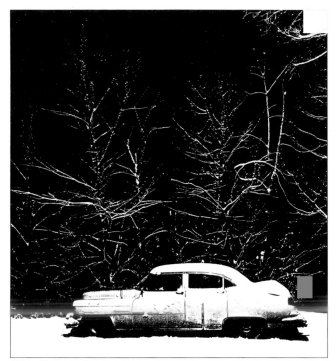

When the overall exposure was adjusted to bring out detail in the highlight areas of the car, most of the detail in the shadow areas was lost.

LOCAL DENSITY CONTROL: DODGING AND BURNING-IN

If the overall density is acceptable, but some small areas require a little less or a little more exposure time, litho film can be dodged or burned-in during the enlargement exposure.

If a specific area is too dark, it can be lightened by dodging, or blocking light during the initial exposure. After the entire print receives an overall exposure, additional time can be given to selected areas that are too light by burning-in, the opposite procedure.

Green florist wires make excellent stems for "dodgers." They are thin and dark enough to avoid printing on the image. Smaller litho enlargements require smaller "dodgers." For 8 x 10 printing, the larger end of the dodger should be the size of a nickel and the smaller end half that size. The stem should be long enough to reach any point on the print.

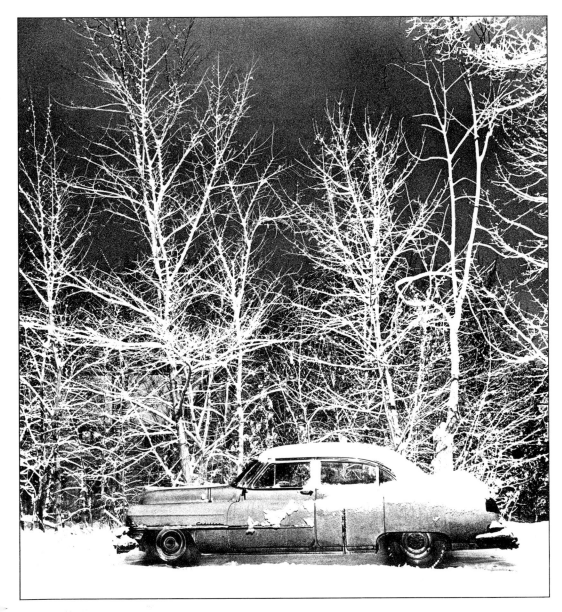

Burning-in and dodging. Through the use of conventional burning-in and dodging techniques, a balance of highlight and shadow detail can be preserved.

A Good Film Positive

A good litho film positive will not permit light to pass through the opaque areas. Clear areas should be completely clear. Any grain dots should be totally opaque and sharp around the edges. The positive may show a very slight brownish tone, but extensive brownness indicates underdevelopment or exhausted developer. There should be no evidence of streaks or wave patterns.

A few pinholes (clear specks) will be present in the opaque areas of the film. These are caused by dust particles that settle on the negative or litho film during the enlarging process. There is some dust in the cleanest of darkrooms. If these pinholes are extensive, clean the negative and the condenser and try making the film print again. If this fails to eliminate the problem completely, the film positive can be retouched.

How to Make a Print from a Color Slide

A color slide, because of its color and emulsion structure, will produce an enlargement on litho film that is slightly different in character from one made from a continuous-tone, black-and-white negative. A color transparency tends to produce a more contrasty litho film print because of the litho film's orthochromatic response to colored light from the projected slide. There is a lack of response to red and oversensitivity to blue.

Because the slide is a positive, the resulting litho enlargement will be a negative. This eliminates the need for a second exposure to litho film.

In the example shown on this page, the conversion of the color image resulted in such a high level of contrast on the litho film that the image became extremely simplified.

A high-contrast litho print made from a color slide. Because color emulsions tend to increase image contrast on litho film, this extreme level of image simplification was produced in a simple two-step process. The slide was removed from its cardboard mount and contact printed to a piece of litho film. The resulting high-contrast image, a litho negative, was then enlarged directly to conventional printing paper.

LANCE FREELENZ: Untitled, 1969

Enlargement Method, cont.

Retouching Litho Film

Litho film is a rugged material. Details can be removed from, or added to, an image on litho film by scraping, cutting, stippling, or masking. At its simplest, retouching consists of painting out pinholes on the final negative. With more complex retouching, in both the positive and negative film states, the content and character of the original image can be completely transformed. The way in which these techniques are used depends on your skill, patience, and visual intentions.

Retouching Materials and Equipment Checklist

Most of these materials are available from larger art supply stores.

Necessary:

small bottle of red liquid opaque

#3 and #00000 sable detail brushes

medium weight X-acto knife with #22 blade

transparent tape (high quality)

red lithography tape (black masking tape can be substituted)

orange plastic mask (black construction paper can be substituted)

lighted surface to work on, transparency viewer, light-box, or light-table

small metal ruler

scissors

scalpel or razor knife

graph paper

pad of wet media acetate (specially treated to accept ink, opaque, etc.)

dropper bottle

Useful:

scribing or etching tools

opaque lacquer pen

Opaque supplies.
A. Water kept in a dropper bottle.
B. Bottle of red, opaque masking paint.
C. Plastic jar lid.

Transparent tape for general use.

A

B

C

D

Brushes and pens for application of opaque solution.
A. Felt-tipped, opaque lacquer pens.
B. Technical pen filled with dense black ink.
C. #3 red sable brush.
D. #00000 red sable detail brush.

Red lithography tape for masking large areas.

SCRAPING AND CUTTING

Some photographers work with chemical reducers to remove unwanted areas from film. Because of the heavy density of litho film emulsion, and the inconvenience of using reducers and bleaches, it is usually easier to remove unwanted detail areas from the litho film by scraping the emulsion off the positive film print. The best instrument for scraping is a medium-weight X-acto knife with a #22 blade. The very tip of the blade, held at the correct angle, will remove the smallest details.

Large unwanted areas can be removed by cutting them out with scissors. When an area of the positive is cut away telltale marks and trim lines will show when the contact negative is made. These are opaqued out on the negative before the final print is made (see page 38). All the scraping and cutting work must be done while the image is in the positive state.

Scribing, stippling, and scraping tools for removing emulsion from the base of the film.
A. Lithographer's scribing needle.
B. Etching needle.
C. Medium weight X-acto knife with a #22 blade.

Cutting and trimming tools.
D. Detail scissors.
E. Large shears.
F. Designer's scalpel or razor knife.
G. Metal ruler.

A B C D E F G

STIPPLING

You can simulate small areas of grain on litho film by using the point of the X-acto blade or a lithographer's scribing needle to make little nicks through the emulsion. This stippling technique is useful for camouflaging imperfections in the granular areas. It can also be used as a drawing technique to add details to the image. It takes skill and practice to develop proficiency in stippling. Try various instruments until you find the right tool. Most film prints seem to have some areas that can benefit from a limited amount of discreet stippling. If done well, it will not be noticed. Do as much of the stippling work as possible on the positive print and then touch up your work, as required, by restippling the final contact negative. Working in both states will give you clear and opaque dots that closely resemble film grain.

Tools that scribe, scrape, and stipple. Their effects are shown here as they remove emulsion from an opaque area of litho film. A and C show an etching needle and a lithographer's needle scribing lines through the emulsion to the clear base of the film.

B and D demonstrate the effects of an X-acto knife. The most versatile of the three tools, it can be used to scrape away large areas of emulsion, to scribe a line or stipple the emulsion to simulate film grain.

A B C D

MASKING: ORANGE PLASTIC MASK

Another retouching technique called "masking" can be used to eliminate unwanted details from an image in either the positive or negative film state. The area to be eliminated is covered, or masked, with a material that completely blocks the transmission of light through the film. If an area is masked out on the film positive, that area will be black on the final paper print. Masking has the opposite effect when applied to the film negative.

Orange plastic mask is a heavy plastic sheet that is used for masking. It is sold under a variety of brand names and is available in sheets or rolls from most printer supply outfits. * This material offers many advantages over black paper which can be substituted. Because it is translucent, it can be laid over the film to be masked, and the needed shape can be traced and cut to fit exactly. It is also thinner than black paper and lint free. Masking should always be applied to the base side of the litho film so it does not interfere with the contact. Transparent or lithography tape can be used to hold it in place.

* "Orange Strip" is one of the brands of this material. It is manufactured by Plastigraph Industries, Inc., New York, N.Y. 10010, and sold through graphic arts dealers.

A B C D E

Pens and brushes for applying various masking solutions.
The marks these tools produce are shown here. A and B,
opaque lacquer pens, contain a red lacquer. Once applied
to the film, this solution can be removed only with rubbing
alcohol. C, a *technical pen* used for drawing straight or
free-hand lines on the film. This pen uses a dense black
drawing ink. D and E, *brushes,* used for application of the
conventional water-base opaque masking paint.

MASKING: OPAQUE

Opaque is a red, claylike, masking paint available
from most graphic arts dealers and some art
supply stores. It can be used directly from the jar,
but if you intend to do a lot of retouching work,
prepare it as professional lithographers do. Stir
the opaque completely and pour it into a shallow
plastic container. Small plastic lids, 3 or 4 inches
in diameter, work well for this purpose. This
pooled opaque will dry into a solid cake in about
two days. To use the opaque, put a few drops of
water into the middle of the dried cake, and
gently swish it around with the detail brush until
the opaque reaches the consistency of cream.
Turn the tip of the brush to form a point. Apply
the opaque to the litho film in single, even

*A professional method for preparing opaque masking paint
for use.*

Shake the bottle thoroughly, stir completely, and shake
again. Fill a small plastic lid with the liquid opaque. Tap the
lid after it has been filled so that the thick solution will set-
tle evenly. Allow the solution to dry into a solid cake by
placing it in an open area for about two days.

strokes. The mixture should be applied thick enough to cover evenly in one stroke. If it is too thick, it will crack off or interfere with the contact printing process. If it is too thin, it will not adhere to the film. Where it is applied correctly, light will be blocked from passing through the film.

When extensive masking with opaque is required, work on a glass surface lit from below, such as a light-table, transparency viewer, or light-box. Use a small desk lamp over the film so the opaque can be seen on the surface as it is applied.

Opaque dries quickly unless the air is extremely humid. Drying speed can be increased, if desired, by adding 3 or 4 drops of rubbing alcohol to the mixture.

It is best to do work with opaque on the base side of the film. The solution is water soluble and can be removed if a mistake is made.

Opaque is most efficiently used to touch up small detail or edge areas. Larger areas should be masked with black or red lithography tape or orange mask cut to fit the shape of the particular area.

Special felt-tip pens containing a fast drying red lacquer intended to serve the same purpose as opaque are available. Their convenience is questionable because it often takes two coats of lacquer to block light transmission adequately. However, they are effective for eliminating small pinholes. The pens are not an adequate substitute in most cases for the traditional water-base opaque paint.

Put one or two drops of water into the dry cake.

Use a brush to blend the water and the opaque together until it reaches the consistency of cream. Turn the tip of the brush to make a point. Apply the opaque to the litho film in single, even strokes.

Applying a Border

While making an enlarged film positive that is going to have a black or dark background, you can use the blades of the print easel to define the final outside edges of the image. Some easels do not produce a clean crisp edge. If this is the case, the edge can be improved on the final litho negative. Lay the negative over a piece of graph paper and, using the paper as a guide, apply lithography tape to the base side of the film to redefine the edges of the image.

When the enlargement has a white (clear) background, it is usually necessary to create some type of line to separate the white areas within the image from the white paper that will surround it in the final print. If you normally use an oversized negative carrier to create a black border around your prints, you may want to continue to use this technique when making enlarged film positives in high-contrast work. If a more precise border line suits the image, it can be drawn, laid down with thin plastic tape, or scribed into a separate piece of litho film.

A border line can be applied directly to the positive film print. It is advisable, however, to make the border on a separate piece of film using one of the following methods, and then sandwich it with the film positive of the image when you make the final contact negative. A border that is made on a separate piece of film has the advantage of being reusable. If you work in two or three standard enlargement sizes you can make master borders once and reuse them continually.

HAND-DRAWN METHOD

A technical pen and ruler can be used to draw a border directly onto treated acetate. This is a more precise technique than the tape method shown on the facing page, but it does require a certain degree of proficiency with a technical pen. In addition to the pen, a drawing board and T-square should be used to draw an accurate border. Use dense black ink. Certain dark red inks work well for this purpose also. Draw the border lines so that they overlap by about 3mm (⅛ inch). The drawn lines must be consistent in both weight and density. Use an ink compass if you need to draw a curved border. After the border has been drawn on the acetate, contact print it to a sheet of litho film. After this border negative is processed and dried, mask out the overlapping lines on the corners with opaque or red lithography tape. This negative is contact printed to make the positive-border film print.

CHART TAPE METHOD

This method is the easiest for making a border. Unfortunately, because of the elasticity of the tape, it isn't as precise as the other methods. Chart tape, or border tape, can be purchased in art supply stores and is available in a number of widths. There are decorative border patterns as well as straight-line varieties. Black matte tapes 1/64 inch or 1/32 inch (.397mm and .794mm) wide are the most useful.

First attach a piece of finely ruled graph paper to a smooth, flat surface. Indicate in pencil the four corners of the border line on the graph paper. Tape a piece of treated acetate (spotlessly clean) over the graph paper and apply the chart tape by slowly unrolling, and adhering it to the acetate. Use the graph paper as a guide and do not allow the tape to stretch as it is applied. If the tape does not go down straight the first time, peel it off and try again with a new piece. Allow the tape to overlap at least 6mm (¼ inch) at the corners. Contact print the tape border to a piece of litho film. This should be done immediately after the border is completed because the tape tends to shrink and curve after being stored. Process and dry the negative-border film print. Mask out the overlapping lines on the corners with opaque. Contact print the negative to another piece of litho film, preferably thin base (see page 10). Process and dry.

SCRIBING METHOD

With this technique a border is made on a separate sheet of fully exposed and processed litho film. The border line is scribed through the emulsion of the exposed film to its clear base.

To expose the sheet of film give it a healthy dose of room light. Process it normally and dry. Use a fixer without a hardener if possible. Draw the point of an etching needle or a lithographer's scribing tool along the edge of a metal ruler to scribe the border line through the emulsion. Overlap the lines at the corners. Paint the overlapping lines out with opaque on the base side of the film. This piece of film becomes the master border negative. A border positive can be produced by contact printing another sheet of litho film to this negative.

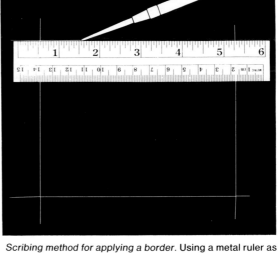

Scribing method for applying a border. Using a metal ruler as a guide, scribe through the emulsion of an exposed sheet of acetate litho film with an etching needle or lithographer's needle. The corner lines are purposely overlapped as they are scribed. Overlapping lines are masked out on the base side of the film.

Chart tape method for making a border. This thin plastic tape can be applied to a sheet of clear acetate or directly to a film print. A piece of graph paper can be placed beneath to function as a guide for adhering the tape. The corner lines should overlap. The overlapping lines can be masked out with opaque to form square corners when the film is in a negative state.

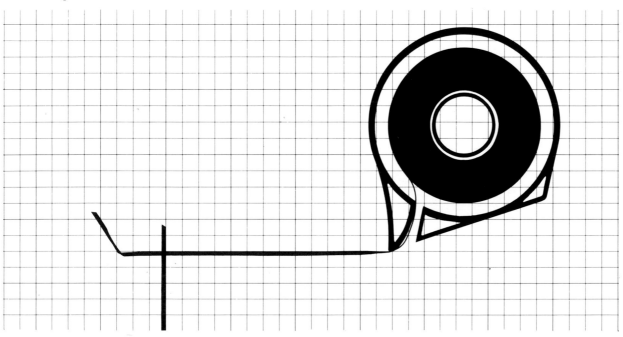

Contact Printing the Film Positive to Make a Final Contact Negative

When the film positive is made, in the first stage of the enlargement process, the aesthetic character of the image is established. When the positive is contact printed to make the final litho negative, the only aim is to fully retain the detail recorded on the film positive.

1. **Set the enlarger** as you would to make proof sheets. Raise the enlarger head high enough so that it projects a cone of light large enough to cover the area of the contact printing frame.

2. **Thoroughly clean the glass** of the printing frame. Dust the film positive.

3. **Place the film positive in the printing frame,** base side against the glass. Then place an unexposed piece of litho film, emulsion to emulsion, with the film positive, and clamp the back on the printing frame.

4. **Make the exposure.** Place the printing frame, glass side up, under the enlarger, and activate the timer. Typical problem areas are those of high density in the negative where only minute detail is present. These areas sometimes drop out even when the overall exposure is correct. Exposure in these areas can be increased locally by flashing light through the litho negative using a penlight flashlight.

5. **Process the film.** Repeat the procedure described for processing the positive film print. The same criteria apply.

6. **Dry** the completed negative in a dust-free environment.

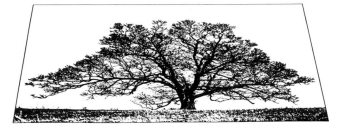

Litho film positive (enlargement). Contact printed to . . .

Unexposed litho film, results in . . .

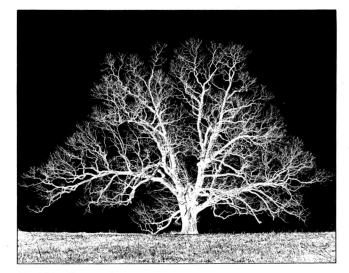

Final litho film negative.

A Word About Agitation

If litho film is placed in the developer and allowed to develop without any movement, the developing action begins rapidly but soon slows down as the developer, in contact with the surface of the emulsion, becomes exhausted. If the film is agitated, however, fresh developer is continually brought to the emulsion surface and the rate of chemical activity remains more constant. This is the reason that agitation has such an important effect on the degree of development obtained. Agitation also prevents uneven development. If agitation is insufficient, the exhausted solution, loaded with halide from the dense areas of emulsion, may flow slowly across the film and form streaks called "drag lines."

Since the degree of agitation affects the rate of development, timing the development and making test strips will mean little if a consistent agitation technique is not used. Agitate continuously as follows: raise the left side of the tray ¼ to ½ inch, lower it gently and smoothly, and then immediately repeat this action on the other three sides going around the tray. This operation constitutes an agitation cycle which requires a total of about 5 seconds. Standardize the method of agitation to obtain uniform results. Agitation should be started immediately and continued until the recommended development time for that particular film has elapsed.

DENSITY OF THE CONTACT NEGATIVE

The amount of detail retained on the final contact negative from the film positive is determined by the density of the negative. The density is affected by exposure and development in the following ways:

Too Little Exposure

The dark parts of the negative do not reach opacity during a full 2¾ minutes in the developer.

Too Much Exposure

The negative turns too dark in the developer before 2¼ minutes have elapsed. Lines thicken and details block up before shadow areas fully develop.

Too Much Development

If the developing time is increased beyond 2¾ minutes to try to save an underexposed negative, there will be a faint solarization effect that begins to appear in the light areas (see page 77).

Too Little Development

If the negative is pulled from the developer before 2¼ minutes have elapsed, the opaque areas will not be dense enough to block light from passing through when the final print is made.

QUALITY OF CONTACT

Poor contact is a common problem. The contact pressure created by the printing frame must be even across the entire image area or light will seep around the edges of image details while making an exposure, causing them to thicken or blur on the contact print. If the negative and the undeveloped film are not placed together emulsion to emulsion the thickness of the film base can also cause light seepage.

Various types of contact printing frames are available. Some produce tight contact while others do not. This seems to depend more on the particular printing frame rather than on its general design.

When the humidity is at a certain level, small rings that look like an oil residue form in the printing frame between the glass and the film. These are called Newton's rings and they indicate that a tight contact has been made. Occasionally, however, the rings themselves become a problem because they print. There isn't much you can do except wait for the humidity to change or use matte-surface litho film (see page 10).

An unsharp image results from uneven contact. The contact was not tight along the right side, causing blurring and loss of detail. Here, the problem occured during the *contact printing* of the film positive. The defect was carried on the final negative, and shows here on this detail from the final print.

When a poor contact is made in the *final print stage*, a smoky blur will occur around the density areas. There is also loss of some detail.

The result of *good print frame pressure* throughout the process.

The Ultimate Instrument for Contact Printing: The Point Source Light Setup

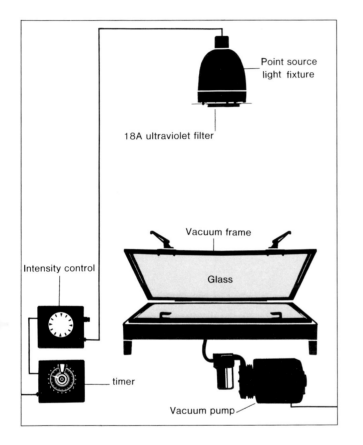

A point source light setup is the best instrument for making sharp contact prints. It is used primarily by professional offset printers who do contact printing every day. There are two parts to the setup: the light itself, which is a special high-intensity lamp, and a vacuum frame which is typically a short metal table with a rubber cushion, a hinged window, and a pump. The materials to be contact printed are placed on the rubber mat and the glass window is lowered and locked down. A motorized pump draws out the air from the inside of the frame, creating a tight contact between the glass, the film print, and the unexposed material.

The point source light and the vacuum frame together produce the highest quality contact print possible on either film or paper. The light and frame can usually be purchased separately. For photographers who do a lot of contact printing, the vacuum frame is a worthwhile investment. A small vacuum frame can be placed under the enlarger for exposing a contact print. The point source light itself improves only finely detailed images.

A special ultraviolet filter, the Kodak Wratten 18A for example, can be used with a point source light to help retain extreme highlight and shadow detail. This filter is expensive and makes a difference only in the most detailed contacts.

Preparation of the Final Negative—Summary

A. The film positive. The clear area around the tree was cut away to eliminate the dust specks. The remaining part of the film was then taped to the border film print, which served as a base. Some retouching (masking and scraping) was done at this stage.

Transparent tape is used to attach tree film positive to the border film positive beneath it.

Tree film positive is trimmed so that it crosses the border film positive in as few places as possible.

Border film (below, emulsion side up)

Tree film positive (above, emulsion side up)

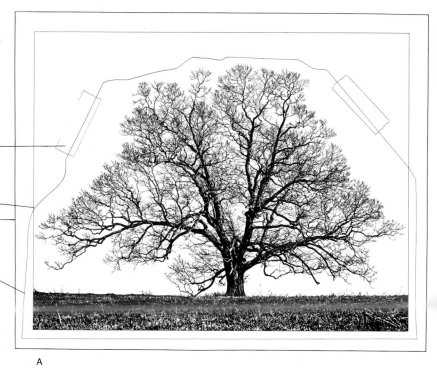

A

B. The final film negative (made by contact printing the film positive shown above). Notice that there are faint traces of the cut lines and pinholes left from accumulated dust on the film and the glass of the contact printing frame. The three negatives (B, C, D) represent three progressive steps in preparing the same final negative.

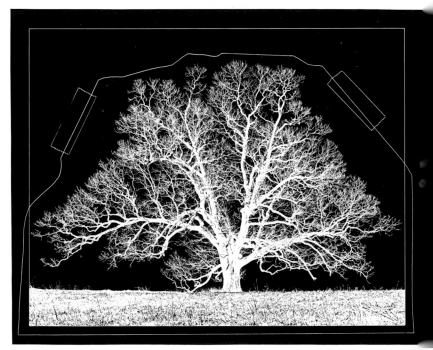

B

C. The final film negative. Orange mask was cut to size and taped on the negative to cover cut lines and pinholes located on the inside of the frame around the top of the tree. The mask was held in position by red lithography tape. An orange mask was also applied outside the border of the image. This produced a clean white zone around the final print. If you work in a standard size, the same mask can be reused to make other prints.

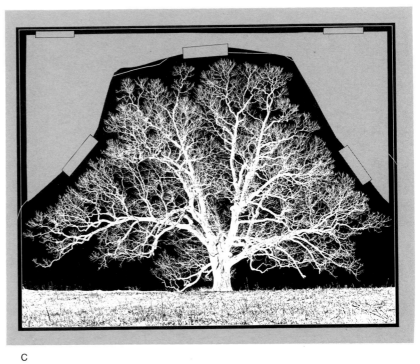

C

D. The final film negative. The last step was to mask any remaining pinholes by painting over them with opaque. The negative was then ready for final contact to photo paper.

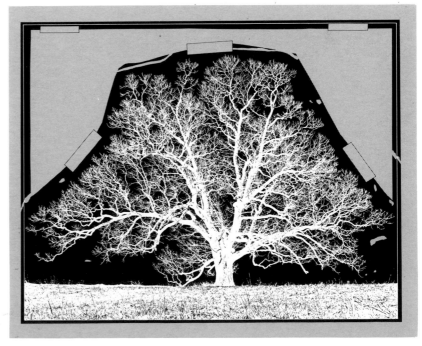

D

Making the Final Print on Paper

Contact printing a high-contrast film image on paper is a straightforward process. Simply place the final film negative, emulsion to emulsion, with a piece of conventional enlarging paper in the contact printing frame and expose under the enlarger. A standard paper-developing chemical setup is all that is needed to process the print. The contrast level of the litho film negative is so high that virtually all standard photo papers and developers will produce acceptable images.

Processing is normal except standard paper developers are sometimes used in a more concentrated form to deepen the blacks. The developer tends to exhaust faster when a large proportion of prints being processed are predominantly black. When they are predominately white, the fixer tends to exhaust more rapidly.

If you intend to make a series of prints, select a standard photographic paper and developer. Test several paper and developer combinations. Some papers that make poor continuous-tone enlargements may turn out to work quite well for high-contrast imagery. Extremely high contrast papers work well for images that contain little grain or detail, but fine-grain, high-contrast images require a medium-contrast paper for the best definition. There are ortho papers specifically designed for contact printing with litho films. Most of these use litho developer rather than paper developer. This can be convenient particularly when using paper for proofing purposes. Ortho papers produce an excellent image, but the stock itself has a very plastic appearance.

After you select a standard paper and developer combination, it is helpful to make a reference print by exposing a full sheet of the stock you have selected to a heavy dose of room light. Fully develop, fix, and wash the print. After it is dry, cut it into a dozen smaller swatches. Submerge one of these in the developer and keep it there during the printing session as a reference for maximum black.

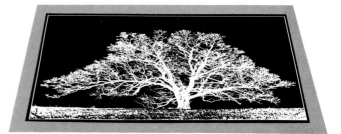

The final film negative is contact printed, emulsion to emulsion, to photographic paper.

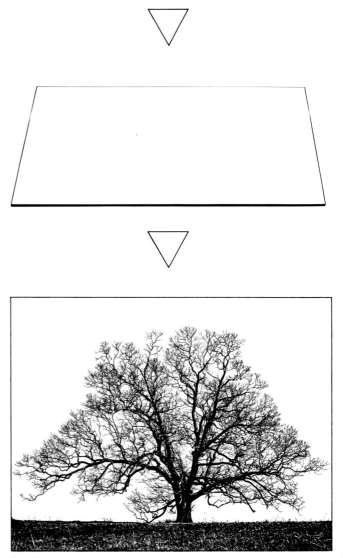

The final print on enlarging paper.

High-Contrast Contact Prints—Troubleshooting

Symptom	Problem	Remedy
White specks in black areas	Dust on glass, print, or paper	Clean glass and dust prints before each printing
Blacks too light	Insufficient exposure or development	Adjust appropriately
	Exhausted developer	Dump completely, mix fresh solution
Uneven blacks	Uneven exposure light	Readjust light for evenness
	Insufficient agitation	Attend to prints while they are developing, agitating consistently
	Exhausted developer	Dump completely, mix fresh solution
Grayed-out white areas	Light fog*	Check safelights for leaks, decrease amount of safelight, check unexposed paper stock for evidence of accidental fogging
	Chemical fog* from: overdevelopment, exhausted developer, contaminated developer	Shorten standard developing time, mix fresh developer
Blurring around density areas	Poor contact	Check print frame
	Upside-down negative	Reprint emulsion to emulsion

NOTE: These are the most common problems; there are many others.

High-contrast prints can also be afflicted by most of the other problems encountered in conventional printing.

* Fog is an overall density in the photographic image caused by unintentional exposure to light or unwanted chemical activity.

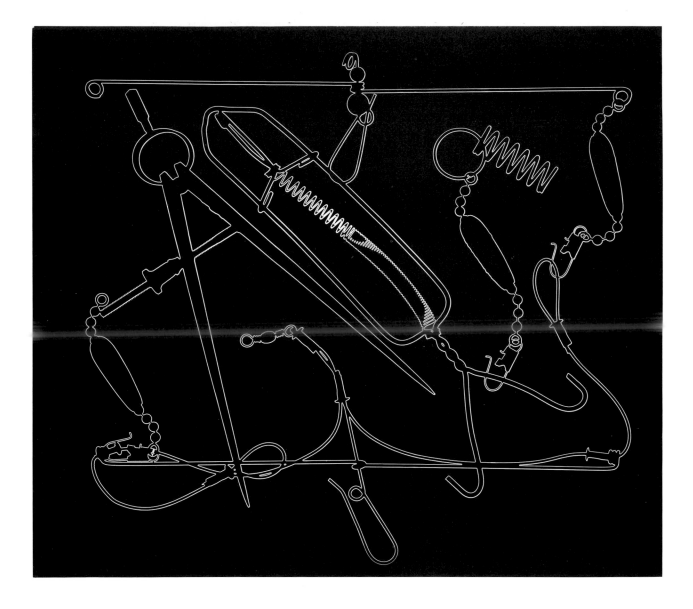

3

Darkroom Techniques and Image Modifications

Litho film and enlarging paper can be used in many of the same ways in the darkroom. In fact, many special techniques that are used to modify the appearance of an image when printing on paper will work more effectively on litho film. Litho film, because it is film, has distinct advantages over paper. Any effect that is recorded on film can be easily duplicated at any time on paper by contact printing. Because film can be contact printed, the state of an image can easily be reversed to produce either a positive or a negative final image.

The more familiar techniques described in this chapter, some of which date back to the early 1800s, have been modified to accommodate the special qualities of litho film. Other techniques are new. Their effects are described and procedures explained for the first time.

Lithograms

Shadow pictures, or "photograms," were made long before lenses were used to produce photographic images. Among the early experimenters was Thomas Wedgwood. In 1802 he published the results of his experiments. He had placed pieces of lace on photo-sensitized paper; the lace was removed after prolonged exposure to sunlight, leaving a shadow record of its shape on the paper. The process became popular with several artists in the 1920's. Christian Schad, a Dada pioneer, called his images "Schadographs." Schad's contemporary, Man Ray, called his images "Rayographs," and introduced many new variations on the process. The final name, "photogram," was coined by another well-known practitioner, Laszlo Moholy-Nagy, in 1922. The term has been in general use ever since to describe similar cameraless images.

Photograms are commonly used as an introductory device for basic photography instruction because of their directness and simplicity. While suiting this purpose quite well, the standard assortment of objects that students have on hand—car keys, combs, pull-tabs, coins, and the like—produces rather ordinary and unexciting images. The technique has a far greater potential, particularly when litho film is used as an exposure base instead of enlarging paper. A photogram made on litho film will be referred to here as a "lithogram."

The act of finding subjects for lithograms is itself part of the creative process. Virtually anything that produces a shadow or transmits light can be laid on a piece of film and printed. You should look for subjects that produce interesting silhouettes or subjects that have interesting transparent or translucent qualities.

To make a lithogram, raise the head of the enlarger to project a pool of light large enough to cover the size of sheet film that you are using. Turn off the enlarger light and close the lens down to f/8. Position the film, emulsion side up, under the enlarger. Litho film can be handled under a red safelight and it is possible to watch as you arrange the objects on top of the film. Place a red safe filter into the filter holder of the enlarger and switch on the enlarger light if more light is necessary.

Determine the correct exposure by making test prints. Then, make the final exposure. The lithogram can be processed in litho developer and standard stop and fixing solutions as if it were a regular high-contrast film print. When the processing is complete, the objects will be shown as clear silhouettes against an opaque background. When dried, this litho negative is contact printed to photo paper to create a finished positive lithogram. The process can be taken a step further by contact printing the litho negative to a second piece of film. The resulting positive film print will produce a negative image when printed on paper.

Another method for setting up the lithogram is to arrange the objects on a clean sheet of glass placed over a light box. Using the light from the box to arrange the objects gives you an opportunity to preview the shapes the objects will produce. Because you can see, you are able to adjust and refine the arrangement with reasonable precision. A piece of graph paper can be placed between the light box and the glass for reference. When the light from the box is switched off, the unexposed film is positioned under the enlarger and the glass is moved from the light box to its final position directly over the film.

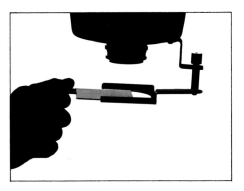

A red plastic safe filter can be used below the lens to check the coverage of the projected light. It can also provide illumination to work by while you are arranging the objects on the film. The filter will prevent the enlarger lamp from exposing the film. When you are ready to make the print, turn the enlarger light off, remove the filter, and make the exposure.

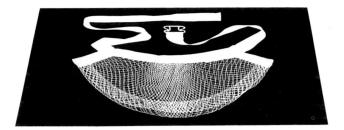

The litho film negative can be contact printed to photographic paper to produce a final positive image (dark silhouettes against white background).

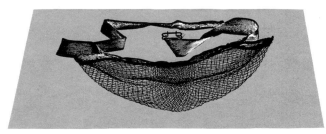

An object placed directly on a sheet of litho film will produce a shadow image when exposed to light.

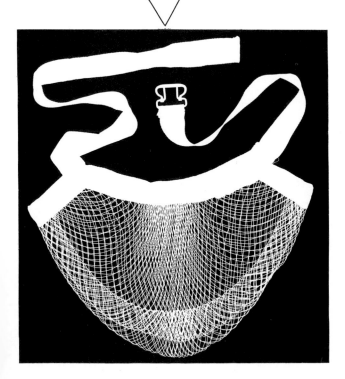

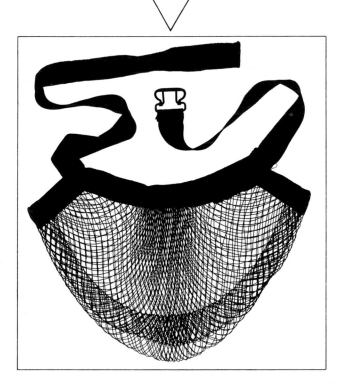

Tonality

A lithogram that looks more like a conventional photogram is made by developing the litho film in a half-strength solution of paper developer. This increases the likelihood of a safelight fog, so raise the safelights a little higher or double filter them. The diluted developer brings out subtle gray-brown tones in the negative. A low- to medium-contrast enlarging paper will retain most of this tonality when contact printed with the negative. The two most prevalent problems with the technique are dust and inadequate agitation. Dust and lint that drift onto the film during exposure produce pinholes that cannot be retouched effectively. Care must be taken to keep movement to a minimum in the darkroom once the unexposed film is out of the box. The film must be constantly but gently agitated in the tray during the entire developing period.

The lithograms of the ferns on these two pages illustrate other methods of producing limited tonality using a sheet of frosted glass and a penlight flashlight.

A *penlight flashlight* and a sheet of frosted glass were used to make this lithogram. The ferns were laid on a piece of frosted glass and the glass was laid over the litho film. A normal lithogram was made first. Then an exposure was made on a second piece of film by tracing around the ferns with a penlight flashlight. Both prints were processed and dried. A contact film print was made of the first fern print and was then overlaid with the film print of the original flashlight tracing. A final negative and, finally, a paper print were made from the combination of film images.

The ferns were arranged on a sheet of frosted glass, textured side down. The glass was then laid over a sheet of litho film. Any variation of light intensity was reproduced as soft-edged granular tone areas.

This print was made in a similar way to the print on the facing page, except that the flashlight tracing was made through a film print rather than the actual ferns. The glass was again used to produce the soft tonal effect.

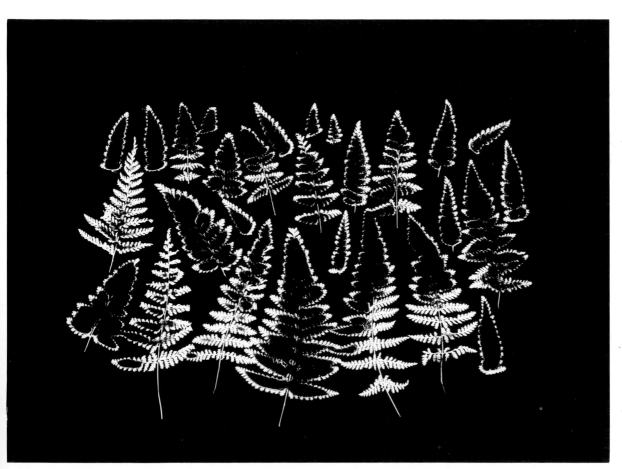

Blowups

Lithograms of small objects, or fragments of larger lithograms, can be sandwiched between two thin pieces of glass, slipped into the enlarger, and greatly enlarged. This is a particularly interesting treatment for objects with elegant shapes or fine detail. For example, a precise lithogram of a butterfly wing, when enlarged, will show the attachment of featherlike scales to the wing. The pattern looks similar, but not identical, to film grain.

An extreme enlargement of a small detail is made by enlarging in steps. Starting with a negative lithogram, blow up and print on litho film the general section that interests you. After processing the resulting positive, a section of the section is enlarged, and so on, until you have isolated the most fascinating detail.

Small, flat objects with interesting transparent or silhouette qualities can sometimes be sandwiched between glass sheets, like an over-sized microscope slide, and enlarged directly onto the film.

Alternative Light Sources—Suggestions

Light sources other than the enlarger can be used to expose lithograms. The appearance of the lithogram can be altered completely by changing the quality and/or direction of the light.

Try a number of variations: adjust distance or focus, change the angle, even modify the shape or concentration of the light itself. Consider the effects of moving the light source during the exposure. Use the light to produce multiple shadows. Allow the light to seep under the edges of certain objects, or to form reflections that can be captured on the film. A penlight flashlight, for example, can be used to direct or intensify light on specific areas, and even function as a drawing instrument.

There is further opportunity for experimentation with light sources after the first negative is made. Instead of using an overall light to contact print the lithogram on paper or on another piece of litho film, you can use a small light source to trace through the negative as if it were a stencil. The contact can be tight or the litho negative can be casually laid over the unexposed litho film (or paper). You can create an interesting blurred or diffused effect in this way. The following is a list of alternative light sources.

shaped enlarger light (cut paper stencil in carrier)

point source light, see page 45

flame from candle

spark from flint (stove or torch lighter)

chemical glow sticks

flashlights

penlight

miniature Christmas tree lights

fluorescent tubes

desk lamps

flash units

light box

slide projector

illuminated children's toys or game boards

A simple lithogram made from a mangled section of bed springs and three skeletonized leaves.

Silhouette Subjects for Lithograms—Suggestions

medical instruments, other professional tools

hardware

small machine parts

small-scale grill or wire work

crumpled aluminum foil

stencils

transfer lettering

kitchenware

feathers, leaves

small toys

dollhouse, model railroad equipment

doilies, lace, netting

fabrics with an open weave

configurations made with dark string

dominoes, miniature building blocks

Rorschach-type ink blotches on treated acetate

cereals

alphabet soup

pasta

other foods

Transparent and Translucent Subjects for Lithograms —Suggestions

prisms

marbles

artificial ice cubes, ice

science lab glassware

patterned glass, shattered glass

clear or translucent rubber tubing

antique glassware, bottles, glass cigar tubes

rubber gloves

plastic boxes, storage containers

quartz, other clear rocks or materials

insect wings

plastic eating utensils, plastic dishes

negatives in loose or tight contact

x-rays

tracing paper; folded, crushed, cut, and over-lapped

crumpled cellophane

whole plant forms

seashells

gelatin

molasses

airplane glue*

fruit and vegetables, ultra-thin slices

store candy

Christmas decorations

light bulbs

printed matter**

soft rubber toys: snakes, lizards, bugs, etc.**

templates for drafting

* Applied to clear acetate. The acetate is placed over film before exposure is made.
** Some objects are dense and require prolonged exposure.

A simple lithogram. These objects were arranged directly on a large piece of litho film. After exposure to white light from the enlarger, the film was processed, dried, and retouched. This is the resulting contact print on paper.

Tone Line

The tone line technique is a contact printing procedure that transforms a high-contrast image into a line impression. Actually, the term is a misnomer: the line generated describes the exterior and interior contours of the subject, and completely *eliminates* all of the tones.

A tone line is made by aligning corresponding positive and negative litho film prints of the same image and contact printing the joined film prints with an unexposed piece of litho film. Even though the film prints appear to cancel each other out completely when viewed from straight above, the thickness of the film base will allow light coming in at an angle to pass between the opaque areas of the two films. This forms a line image on the unexposed film below. A piece of white plastic is used over the contact printer during exposure to redirect light through these spaces.

1. **Select a negative.** Images that are silhouetted or very graphic in appearance work well for this process. Remember that interior as well as exterior contours will create lines.
2. **Make a positive litho film print.** It is usually best to work with 4x5 or 8x10 sized litho film.
3. **Make a corresponding litho negative** by contact printing the positive to another piece of film. It is important that the two prints have *equal densities.*
4. **Align the two prints** base to base; use a light table if possible. If the films are of matching density and are correctly positioned, there will be a complete cancellation of light transmission when the sandwich is viewed straight down through a lupe or magnifier. Tape the two prints together securely with transparent tape.
5. **Set the enlarger lens** at its widest aperture and the timer for a 30- to 60-second exposure, depending on the intensity of the enlarger bulb. Raise the head of the enlarger so that it projects a pool of light large enough to cover the print.

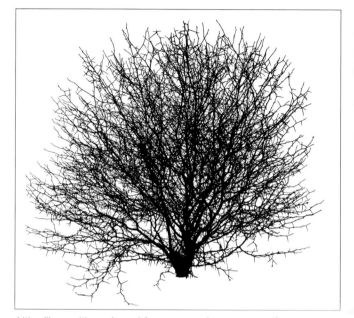

Litho film positive enlarged from a normal camera negative (step 2).

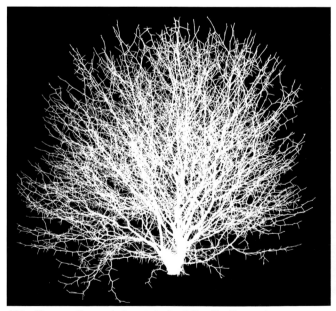

Litho film negative made by contact printing the film positive (step 3).

6. **Place the joined film sheets and unexposed litho film in the contact frame** so that the layer with the greatest dark area is in contact with the emulsion side of the unexposed film. It is possible to substitute enlarging paper, but printing the image first as a litho negative allows for retouching and reversal of the image.

7. **Place the print frame in position** under the enlarger and cover it with a sheet of thin, translucent white plastic. The design of most frames allows for sufficient space between the plastic and the glass, 13mm to 19mm (½ inch to ¾ inch).

8. **Expose the print.**

If you don't have a piece of white plastic handy, an identical result can be obtained by manually directing the light into the clear channels of the litho sandwich. You can do this by systematically making a series of exposures while holding the print frame under the enlarger at a 45-degree angle to the lens. The aperture should be set at f/16 and the timer between 15 and 30 seconds. The timer should be activated eight times to complete the exposure cycle: one full exposure is given to each side and corner. The frame needn't be held perfectly still for each exposure, but the 45-degree angle must be maintained.

The quality of the line formed depends on several factors: the original film format; the quality and character of the subject matter; the size of the litho film used; the quality of the contact pressure in the print frame; and the length of exposure and development. Since there are so many variables, you will have to experiment to perfect the technique.

The detail that registers in the tone-line image depends on light conditions in the original scene, the size of the camera negative, the thickness of the litho film used in the process, and the size of the litho positive and negative. There are a variety of possible effects. If you want thin, delicate lines to describe the image in great detail, work

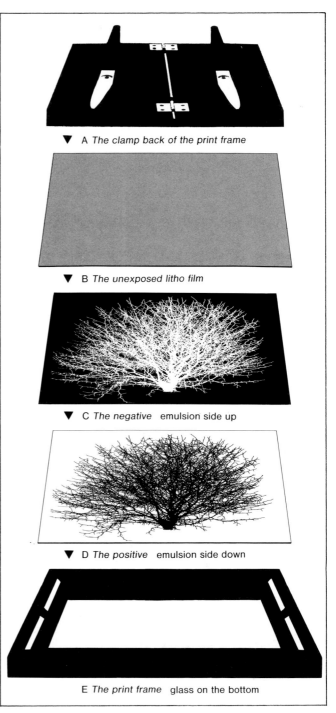

▼ A *The clamp back of the print frame*

▼ B *The unexposed litho film*

▼ C *The negative* emulsion side up

▼ D *The positive* emulsion side down

E *The print frame* glass on the bottom

The illustration above designates the order in which the prints should be arranged in the print frame to produce a tone-line image. In actuality, the positive and negative must be taped together prior to final positioning in the frame (step 4). The frame is shown in its loading position, glass down.

with a large-format camera negative and use large positive and negative litho prints to make the tone line. If, on the other hand, you want a thicker line to describe a simpler image, work with a small-format camera negative, and use small positive and negative litho prints to make the tone line. The tone line can be enlarged or contact printed to make the paper print.

It is also possible to use a positive and negative without matching densities to produce a tone line that varies in thickness and detail. A litho positive can also be combined with a continuous-tone negative.

The first tone-line print on litho film will be a black line on a clear field. This film print can be printed directly on photographic paper or it can be contact printed to another piece of film to reverse it before the final paper print is made. Undesirable areas can be retouched before the final print is made.

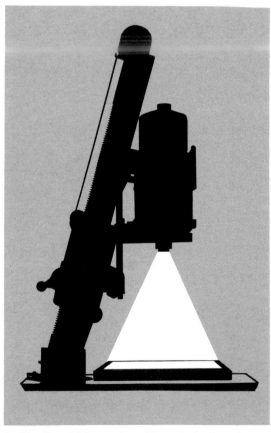

Position the print frame, glass side up, under the enlarger to receive an exposure of white light. A sheet of white translucent plastic is laid over the print frame to redirect the light into the clear channels between the positive and negative.

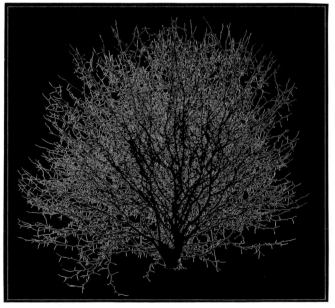

Negative tone-line print. If a print is made on paper directly from the first tone-line transparency, it prints as a black image with white lines.

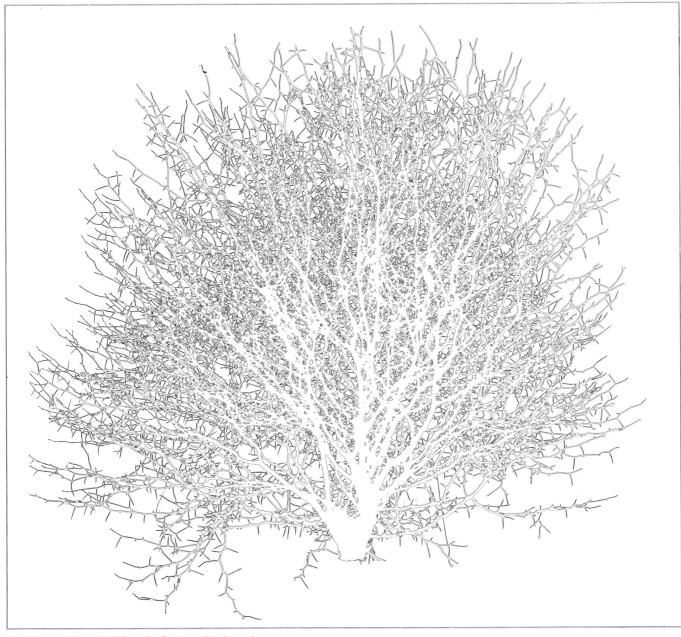

Positive tone line print. When the first tone line is made on litho film, it is a positive image (black lines on a clear field). If you want this positive image on paper, make a contact print of this first tone-line film print on another piece of litho film and contact print the resulting negative film print on paper.

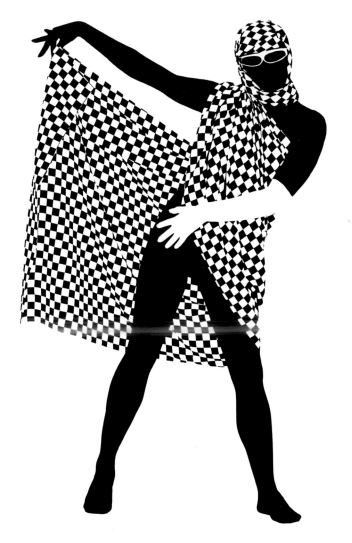

Original image.

Tone-line treatment. The black-and-white clothing here demonstrates the characteristic contour description of the tone-line process. Note that the *edge* was converted to a line in each place where black met white.

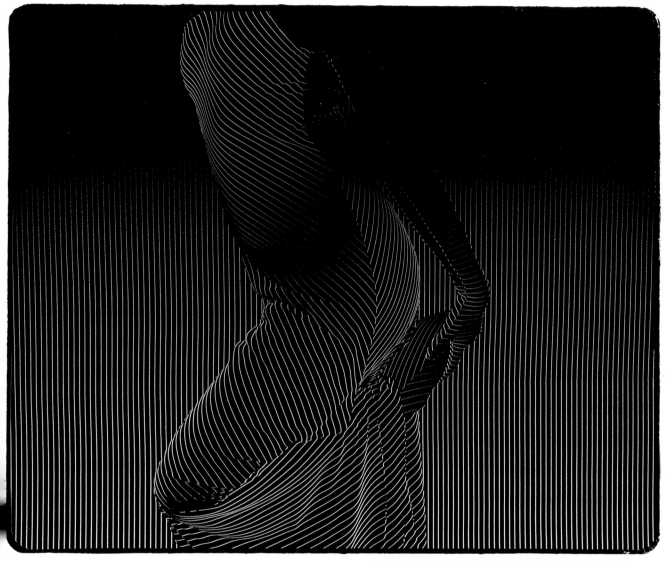

Intentional misalignment, a negative tone line. The model was originally dressed in a striped gown. She was photographed against a background made of the same material.

ADJUSTING POSITIVE AND NEGATIVE REGISTRATION

In a precision tone-line image all contour lines will be of equal thickness. If you want the lines to be thinner, or even nonexistent around half of the image, the positive and negative can be intentionally misaligned (step 4). This causes the light to be blocked on one side of the image, while increasing the amount of light admitted on the opposite side. This technique is occasionally interesting in itself, but is usually more effective when combined with drawing, lithograms, or other processes.

Screens: Weaving a Pattern into the Image

A new visual element can be introduced into the litho film process with the use of any of a wide variety of screens. During contact printing or enlarging, a screen can be placed between the image and the litho film. The screen filters the image in such a way that it integrates the pattern of the screen with the detail of the image.

Screens must be employed judiciously or the results can be disappointing. When used as an overall filtering device, screens often tend to overwhelm the photographic subject without adding any visual interest. Experiment with some of the suggested screens to get a sense of the visual results you can expect.

COMMERCIAL SCREENS

There are many commercially prepared texture screens designed specifically for direct contact use in photography. There are also less expensive, adhesive-backed screens manufactured for graphic artists and illustrators that can be used in the same way. These artist's screens are available in hundreds of patterns ranging from simple lines or dots to flying palm trees. They can be easily contact printed to litho film to make a litho screen without even removing the translucent backing sheet. Once contact printed, they can be used as screens in either their positive or negative state. When contact printed with a litho film image, the screen will introduce a pattern into the clear parts of the image. Two or more can be overlapped to produce interesting moiré patterns.

These artist's screens can also be used by removing the adhesive backing and adhering the entire sheet to the emulsion side of the film print. After the screen is attached to the film print, sections of the pattern can be removed. This is done by lightly cutting around them with a knife, and gently peeling off the unwanted area. It is even possible to introduce two screens into the image. One can be adhered to the emulsion side of the litho film; the other can be attached to the base side. The balance of tone or pattern can be adjusted by removing sections of pattern from both sides. Tone-line positives (see page 60) often make excellent base images for this treatment.

Homemade Screens—Suggestions

Objects, such as those listed below, can be placed directly on the litho film. Exposure will create a pattern of sharply focused shadows on the litho film that can be used as a screen in either a positive or negative state.

Subjects that have graphically interesting surface textures or patterns can be conventionally photographed on continuous-tone film, then simply enlarged on litho film. The high-contrast film print can then be used as a contact screen.

textured or decorative glass	interior, exterior walls
fresh or skeletonized leaves	sandpaper, roofing material
fabrics, lace	sand, gravel, rock
splatter painting, airbrush*	tree bark, wood
string	sky
translucent papers	torn billboards, maps, charts
dried foods (rice, macaroni, etc.)	wrapping paper, marbleized end paper

* Thinned, liquid water-base opaque is applied to treated acetate, then contact printed to litho film.

The individual figures in this print were contact printed through a patterned screen and then rearranged, in composite, to form the final image. The screen was made by overlapping two artist's pattern screens.

''Autoscreen''

''Autoscreen,'' manufactured by Eastman Kodak, is a special litho film that has a preexposed 133-line screen (dot pattern) built into the emulsion. Although intended for use in offset lithography, it also has some interesting creative uses. When you enlarge on it, it transposes the image into a photo-mechanical dot pattern. The configuration and size of the dots are determined by the density of the various parts of the image. In the darkest areas there will be only small, white dots against a predominantly black field. The lightest areas of the image (that receive minimum exposure) have small, black dots against a white field.

Most films are equally sensitive to light throughout the emulsion surface. Autoscreen works in a different way. The emulsion is composed of thousands of light-sensitive dots, each acutely sensitive at the center, but gradually decreasing in sensitivity around the edge. A weak exposure affects only the more sensitive center portions of the dots. Stronger exposure causes an increase in the size of the dots.

The smallest *overall* dot pattern is produced when the image is enlarged directly to its final size on Autoscreen. This produces the greatest degree of simulated tonality. The scale of the overall dot pattern will be smaller than that used in newspaper reproduction but larger than that in the halftone reproductions in this book. If Autoscreen is being used to simulate continuous tone, the flashing technique (see page 88) will help extend the apparent tonal range.

As an experiment, try contact printing a 35mm negative to Autoscreen and then contacting the Autoscreen to a piece of regular litho film. When the resulting negative is enlarged, the dots will also become enlarged. From close range the image will be quite abstract, but at a distance it will appear more realistic. When this technique is used to enlarge Autoscreen, the dots become large enough to be used in photosilkscreen and other printmaking processes.

Autoscreen can also be used in the camera to obtain a screened negative directly (see page 98). You can substitute Autoscreen for conventional litho film when experimenting with almost any of the darkroom processes described in this chapter.

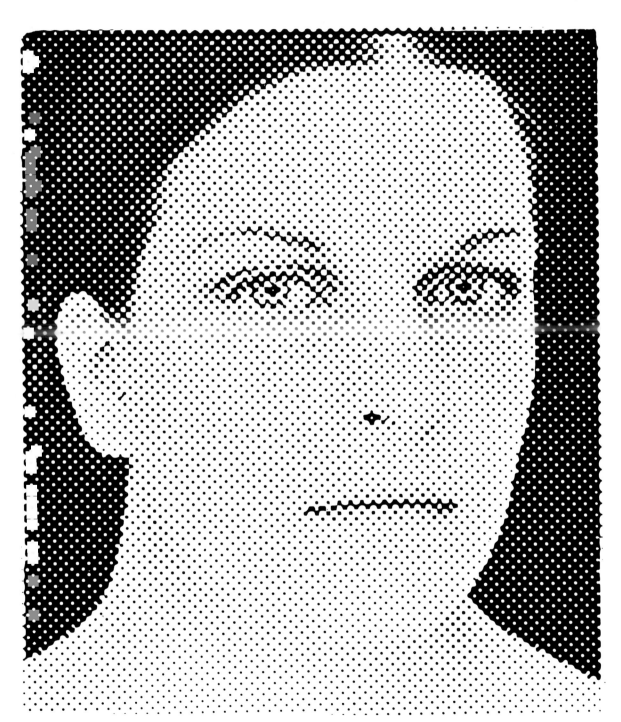

Autoscreen litho film will automatically introduce a halftone screen into any image that is printed on it. It can be handled in the darkroom as if it were conventional litho film. This image was made by contact printing a 35mm negative to a small piece of Autoscreen. After being processed and dried the Autoscreen positive was contact printed to a piece of standard litho film to produce a final negative. This negative was then enlarged to make this final print. Because the dot pattern is built into the film, the smaller the working size, the larger the dots will be in proportion to the image when the film is enlarged.

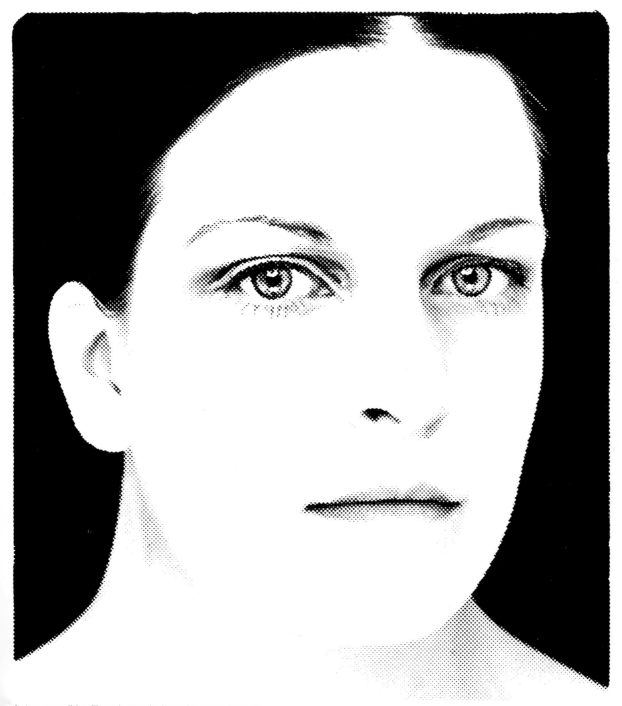

Autoscreen litho film print made from the same camera negative as the one on the facing page. For this print the 35mm continuous-tone negative was enlarged to a slightly larger working size (6x7cm) on Autoscreen. The image was dodged to keep the skin white. After being processed and dried the Autoscreen positive was contact printed to a piece of standard litho film to produce a final negative. This negative was then enlarged again to make this print.

Sabattier Effect

The Sabattier effect, commonly referred to as "solarization," is named after the French scientist Armand Sabattier who first described it in 1862. Most photographers, at one time or another, have experimented with the effects of this process on continuous-tone enlarging paper. Whether you are using paper or litho film, the ex- posure and developing processes work the same way. Solarization makes use of a primary expo- sure and secondary (flash) exposure midway through development. This second exposure causes areas that would normally remain light to turn dark and produces an image that has both positive and negative elements. As the light areas

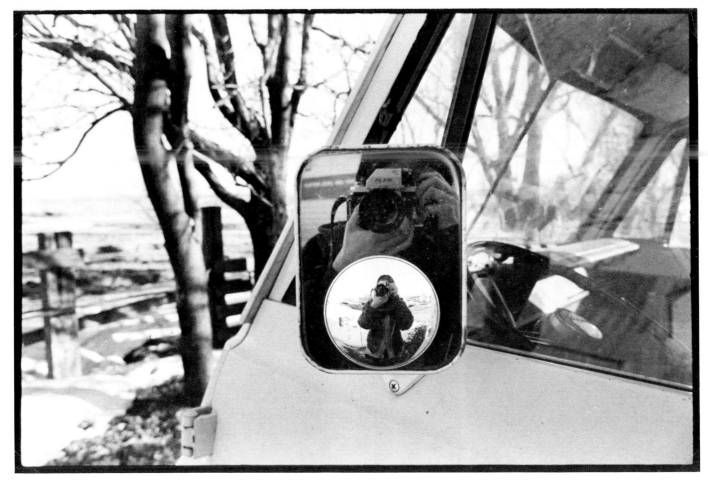

ESTHER PARADA: *Oklahoma Self-Portrait,* 1974
This is a continuous-tone print made from a 35mm nega-
tive. This image was selected for the Sabattier process be-
cause of its strong formal elements and intricate detail.

turn dark, they can be studied under the safelight. When the image reaches an appealing level, the print is removed from the developer and normal processing is completed. If left in the developer long enough, the print will eventually turn completely black. When the conditions are right, just before the point at which the negative and positive reach equal density and join, there will be a distinct white line outlining the contours of the image. This happens because deposits of bromide collect around the contours of the image, shielding this area from full development. These contour lines will vary in thickness and look slightly different from those produced by the tone-line process.

ESTHER PARADA: *Oklahoma Self-Portrait,* 1974
To produce this Sabattier effect, Esther Parada used a technique similar to the one described in the text. Two things were done differently; she worked directly from the original 35mm negative and she used paper developer. The original negative was enlarged on a sheet of 4x5 litho film, and the solarization took place during the development of this enlargement.

A Setup for Experimentation

To follow the procedure for creating the Sabattier effect, as it is described here, begin with a litho negative. This negative will be contact printed to another piece of litho film and the Sabattier effect will be produced on the resulting litho positive as it is being developed. Any litho image—positive or negative—can be solarized.

Decide if the size of the solarized film print is going to be the size of the final image or if the image is going to be solarized as a small film print and enlarged later. Either method will work, but bear in mind the possibility that many pieces of film might be used before a satisfactory image is achieved. If you are experimenting for the first time, try using a 4x5 litho negative. The completed solarization can then be contact printed the same size or enlarged in a 4x5 enlarger.

Litho film. Any type, including line film, will produce good results.

Chemicals. Use a standard setup.

Light source. Use the enlarger. A developing tray with the exposed film will be placed directly under the enlarger to receive the flash exposure. Place it inside a larger tray to prevent the chemicals from splashing onto the baseboard.

Start with this contact printing procedure and then modify it based on results of your own tests.

1. **Clean all glass and film surfaces.**
2. **Make a test print** to determine basic exposure. The exposure should be sufficient to develop the image fully in 45 seconds. The enlarger light should project a pool of light covering about twice the area of the contact printer. The aperture should be fully open.
3. **Make the primary exposure** and move the contact frame to one side.
4. **Move the developing tray.** Leave the print locked inside the contact printer while you move the tray to a position directly under the enlarging lens. Using a red safe filter over the lens switch on the enlarger lamp to check position. Or you can mark the tray position beforehand with masking tape on the baseboard.
5. **Reset the enlarger timer** for the flash exposure. It should be three-quarters of the primary exposure. Reset *only* the timer; all other enlarger adjustments remain the same.
6. **Begin development.** Remove the exposed litho film from the printing frame and slip it into the developer. Agitate for the first 15 seconds only. The tray should remain still for the remainder of the developing sequence.
7. **Make the flash exposure** after the print has been in the tray for a total of 1 minute.
8. **Study the Sabattier effect.** It should begin immediately after the flash exposure. Do not agitate.
9. **Pull the print** from the developer when it reaches the desired degree of solarization. This should fall in the range of about 20 to 40 seconds after the completion of the flash exposure.
10. **Complete processing.** Be particularly careful about agitation. Agitate the film gently during the entire time it is in the stop bath and fixer trays.
11. **Make a film-contact print** from the solarized film. It is not always possible to reach an ideal density level in the solarized film print. The density level can be improved when the solarized film is contact printed onto another piece of litho film to make the final negative. Compensate for inadequate density on the solarized film print by underexposing and overdeveloping the contact negative. Too much density can sometimes be corrected by increasing the exposure time.
12. **Retouch the final negative** and make the final print.

The Sabattier effect is produced on the litho film image as it is being developed. The effect is quite similar to the negative tone line, which is a less difficult technique. On close examination, however, you will notice that the lines on this print are not of uniform thickness, as they would be in a normal tone line.

EXAMPLE DATA

Primary exposure 4 seconds.

Development 1 minute, agitating for the first 15 seconds.

Flash exposure 3 seconds initiated after a total developing time of 1 minute.

Development terminated 30 seconds after the end of the flash exposure.

Total time in developer tray: 1 minute, 33 seconds. The process was carried out in the film size shown here.

FACTORS AND VARIABLES

The Sabattier process described here is not guaranteed to work perfectly. It is intended only as a starting point. The key factors to control are:

The primary exposure

The flash exposure

The point at which the flash exposure occurs.

Since the Sabattier process involves a long chain of variables that can be particularly frustrating, it is important to adopt a relaxed and experimental attitude. Take notes as you work, and try to control as many variables as possible. Be sure to set aside plenty of time and film.

Under ideal conditions this process can produce unique results, but the most typical effects are more efficiently produced by using the tone-line process.

The Sabattier effect. The base image for this print was a composite: the right side was a negative image; and the left side was a positive. The litho print was removed from the developer after the flash exposure, before it reached a state of maximum solarization. This print was made directly from the solarized film print.

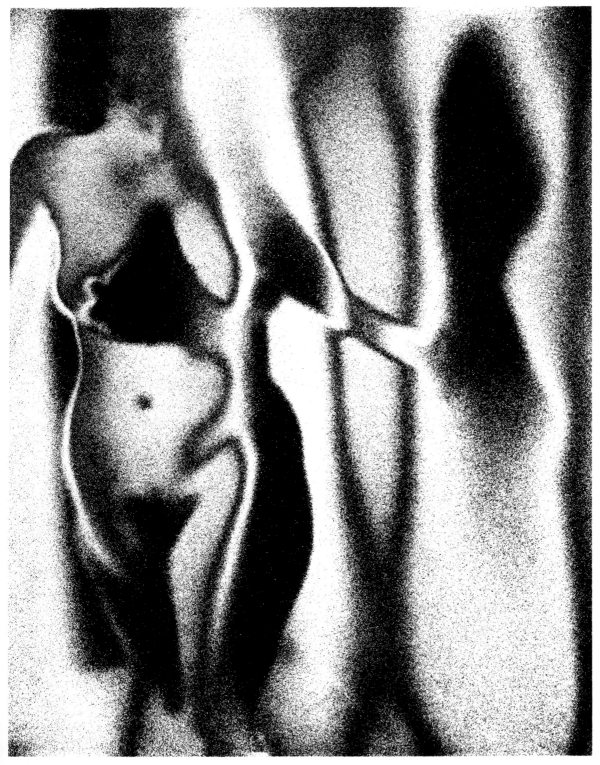

TODD WALKER: Untitled, 1974

Tone Separation

Tone separation, often called "posterization," is a method using a *series* of litho film enlargements that represent different density levels of the same original camera negative. Three or more separate enlargements are made from the camera negative on litho film. Each enlargement is given progressively longer exposure time. In this way, each represents—in high contrast—a different region of the continuous-tone scale.

These "separations" and their corresponding contact negatives, shown on the facing page, can be recombined in several ways. The most common approach is to contact print the negatives, one at a time, in register to the same piece of medium-contrast enlarging paper. The paper is developed only after the three separate exposures have been made. To tonally separate the three densities represented on the litho film negatives, the paper is given a different amount of exposure through each negative. Light (short), medium, and dark (long) exposures should correspond to the appropriate litho negative. Extensive exposure and registration testing is required. The technique rarely produces interesting results in black-and-white, but the negatives can also be printed through filters on color photo paper and used in multicolor proofing or printmaking processes.

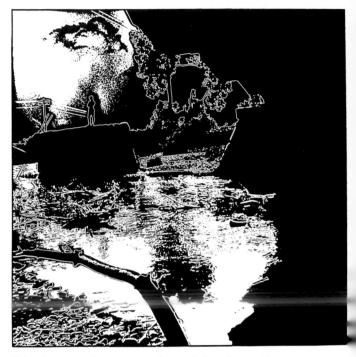

This print was made from a negative made from the combination of the medium film positive and the negative of the dark film positive. It combines positive and negative features and closely resembles the Sabattier effect. It is one of many possible combinations of the set of light, medium, and dark exposures on the facing page.

POSITIVE-NEGATIVE FILM COMBINATIONS

A positive and negative from the set of six film prints shown on the opposite page can be taped together and contact printed to create a new positive-negative variation of the basic image. An effect similar to the Sabattier can be created in this way. If you want to go further with the combining process, make contact prints of combinations of the original six negatives, and then combine the resulting film prints with the original film prints.

In this series of examples, increased exposure, not development, was used to make the images progressively darker. Each increase in density introduced new bits of visual information in the highlight areas as it obscured information in the dark areas. A complementary set of three negatives was then made by contact. The six film prints can be used in many combinations. ▶

Light film positive.

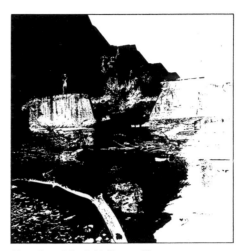

Negative of the light film positive.

Medium film positive.

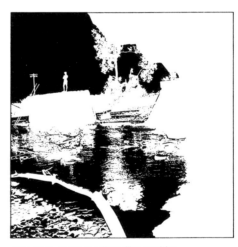

Negative of the medium film positive.

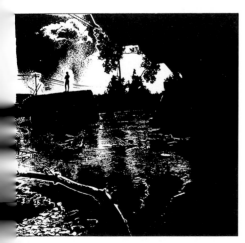

Dark film positive.

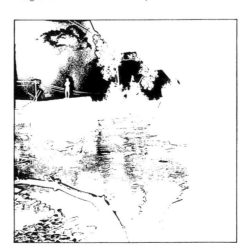

Negative of the dark film positive.

The Chain Reduction Technique

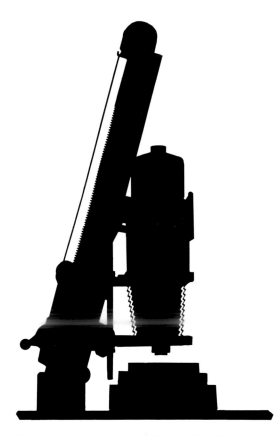

The enlarger setup for chain reduction. First the head is moved to its lowest position. Then the bellows is fully extended by turning the focus knob. After the negative has been inserted, books or boxes are stacked beneath the lens to bring the projected image up into the focus range. The enlarger remains in this position for the first two stages of reduction.

By positioning litho film very close to the enlarger lens, you can project an image on the unexposed film that is actually *smaller* than the negative in the carrier. As you know, the smaller the image is on the litho film, the simpler its description in high-contrast. When a continuous-tone negative is reduced, dark areas fuse with black areas, light areas fuse with white areas, and mid-grays become either solid black or solid white. The product of this first reduction, a small positive, can be processed and dried and then put back into the enlarger and reduced again. With each step, the image becomes more simplified and abstracted. After the reduction process is complete, the image is so small it usually must be enlarged in steps to produce the final size image.

The house shown in the example on pages 80 and 81 has been reduced two steps from a 35mm continuous-tone negative. It is possible to go a number of steps beyond this. An experienced printer using Fine Line Developer (see page 86) for the final reduction steps can reduce the image to the size of the head of a pin and still retain a recognizable image! The best way to work with this process is to make a series of reductions from a selected negative, then with a magnifying lens study the entire set on a light table to determine which reduction produced the desired degree of simplification.

This process has the advantage of using a minimum of film. In the example shown, the film required for the entire process could have been cut from a single 4x5 sheet. This is a good way to make use of pieces of film left over from other processes. Knowledge of this technique gives

you an added degree of versatility when working with continuous-tone negatives. Depending on the darkroom process employed, the same negative can be used to produce a variety of high-contrast renditions, ranging from finely detailed to totally abstract.

The actual operation of different enlargers and enlarging lenses will vary somewhat, but the procedure described here works with most equipment with only minimal adjustment. The process looks complex and time-consuming, but you will find it surprisingly simple.

1. **Lower the enlarger head** as far as possible.
2. **Extend the bellows** as far as possible by turning the focusing knob.
3. **Insert the negative** into the enlarger. A glass carrier is more convenient than a metal one.*
4. **Build up a platform** beneath the lens by piling up books, photo boxes, or other level objects. Switch on the enlarger light and keep adjusting the level until the image projected onto the surface of the top object of the platform appears relatively sharp.
5. **Refine the focus.** Do not use an easel, but place a scrap piece of film directly on the top level. Focus carefully using the focusing knob.** Because the lens is so close to the film, it is not possible to use a magnifier.
6. **Close down the lens** to its smallest aperture and turn off the enlarger light.
7. **Place the unexposed litho film under the lens.** Use an oversized piece of film at least 50mmx80mm (2x3 inches) so that it can be efficiently handled.
8. **Expose, process, and dry** the first reduced positive.
9. **Project the reduced positive.** Do not change the enlarger setting. Use a glass carrier or cut the film to fit into your 35mm carrier. To keep the focus level consistent, use the same type of carrier throughout the process. Take care not to disturb the enlarger while changing films. Align the image so that it is in the center of the projected pool of light.
10. **Expose and develop,** using a new piece of litho film to make the reduced negative. Again, the film should be larger than the exposed image for easy handling. Be careful not to overdevelop the tiny image.
11. **Complete the processing and dry** the film.
12. **Reset the enlarger** by retracting the bellows and raising the head. Remove the platform. Next the image will be enlarged rather than reduced.
13. **Insert the final reduction into the enlarger** and adjust the size and focus of the enlarged image until it is the size of the largest format your enlarger can accept: 35mm, 2¼, or 4x5 (see step 16).
14. **Expose, process, and dry** to make the enlarged litho reduction.
15. **Retouch and contact print** the positive to produce the final negative.
16. **Enlarge the final negative** on paper.

* A glass carrier can be made by hinging together two pieces of 4x5 glass with masking tape. Clean all four sides before each use.
** Additional abstraction can be created by intentionally leaving the image slightly out of focus.

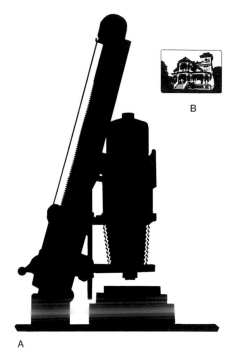

B

D

A

C

E

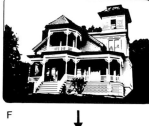
F

G

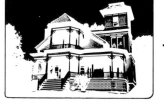
H

I

A. *Enlarger* set to make first reduction from continuous-tone negative.

B. *First reduction* (positive); actual size shown.

C. *Enlarger* set at same position to make second reduction from first reduction.

D. *Second reduction* (negative); actual size shown.

E. *Enlarger* reset to enlarge second reduction.

F. *First enlargement of second reduction;* actual size shown.

G. *Contact.* The first enlargement is contact printed to litho film to produce the final negative.

H. *The final negative;* actual size shown.

I. *Enlarger* set to make a print on paper from the final negative.

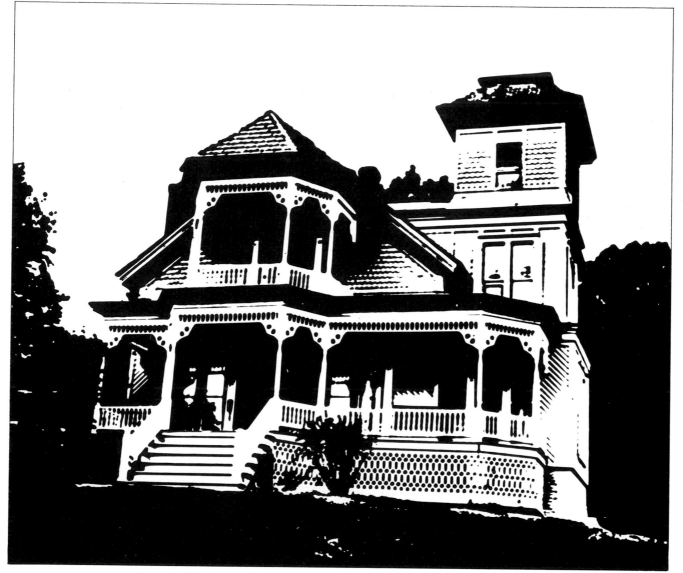

The final print. This image simplification is the result of a two-step chain reduction process (shown on the facing page). Further simplification could have been accomplished by reducing 3 or 4 steps rather than 2.

High-Contrast Blowup

Enlarging small segments of existing litho negatives or positives can be a fascinating source of new material. Blowups of litho film transparencies are quite different from blowups of continuous-tone negatives. Litho film will always produce a sharp edge where an opaque area stops and a clear area begins. Even if you enlarge as little as 1% of the total litho film print, producing a very abstract image, these edges will remain sharp.

It is likely that your enlarger will not extend high enough to reach the desired degree of enlargement. You can enlarge the image in steps if this is the case. Begin by raising your enlarger head to its highest elevation. Place the easel with unexposed litho film below and make a print that records only the general area of the negative in the enlarger that interests you. After you have exposed, processed, and dried the print, put it in the enlarger and enlarge the enlargement. If you

This photograph was taken from a sail plane on 120 film. It was printed through frosted glass to sharpen the granular structure (see page 90).

want more, then enlarge the enlargement of the enlargement! You can go as far as you like with this. If the last enlargement turns out to be positive rather than negative, simply contact print it to make a litho negative before printing it on paper.

This is an enlargement from the contact negative of the image on the facing page. It is a small detail that has been greatly enlarged.

The Detailed Image

The photo on the opposite page (along with several others throughout the book) is not representative of what most people think of as a high-contrast image—even though it is totally black and white and devoid of all gray tones. This kind of image is more delicate and realistic than others made with litho film.

Litho film, because it is designed to carry the extremely small dot pattern required for offset lithography, has a remarkable capacity to record the very smallest details. While able to accommodate these minute details, it cannot reproduce the grays of the continuous-tone image. To simulate the original negative, litho film must convert all midtones into a grain pattern. The lightness or heaviness of this pattern functions (in a limited way) to represent the tonality of the original negative. The effectiveness of this representation depends on the resolution of the pattern. The print must be critically focused, exposed, and developed. When examined closely under magnification, the pattern must be sharp and opaque (see enlarger focus, page 26).

You will find that as a contact print on photo paper the fine-grain, high-contrast image is quite different in appearance from a continuous-tone print. Certain images respond particularly well to this treatment.

Detailed high-contrast film images are well suited for use with certain printing processes, particularly screenless photo offset. In this process, ink is printed on paper to look much the same as the darkened silver on the litho film. It is a "yes or no" proposition. Ink is completely opaque in offset lithography or it does not print at all. There is no *real* tonality as there is in continuous-tone photography.

The following recommendations will help you to make a technically good detailed image. The suggestions can be used either together or separately to control specific aspects of the high-contrast process. Keep in mind that the ultimate success of any of these techniques is closely keyed to the quality of the original camera negative.

FILM FORMAT FOR FINE DETAIL

The larger the format of the original camera negative, the finer the grain pattern on the litho enlargement will be. The greater the degree of original camera negative enlargement, the larger the grain pattern on the litho enlargement will be. To preserve fine grain pattern, the amount of the litho enlargement should be kept to a minimum.

CARL SESTO: *Rockport, Maine,* 1969
This photograph was originally shot on conventional 4x5
film. It was enlarged to this final size on continuous-tone
sheet film. The sheet film negative was still-developed in
Fine Line Developer. It was then contact printed to litho
film. That final negative was used to produce this print.

The Detailed Image, cont.

"Fine Line Developer" and Still Development

A fine-grain detailed effect can be assisted by both developer and agitation techniques. Eastman Kodak makes a product called "Fine Line Developer" that is specifically designed to allow tiny areas of high-contrast detail to be retained on litho film. Using Fine Line Developer subtly increases fine detail in shadow and highlight areas. It is purchased in powder form and is mixed and stored as A and B stock solutions. The total development time should be 2 to 2½ minutes. The

Fine Line Developer and still development. The original 2¼x2¼ inch negative was enlarged onto a 4x5 piece of film. It was given the development treatment described in the text above, then contact printed to a second piece of 4x5 litho film which was developed normally. This final negative was enlarged directly to paper to the size shown. Because the Fine Line Developer was used prior to the second enlargement, the grain pattern in the print is larger than that usually associated with this development technique; but its structure is typical of a print that has been still-developed in Fine Line Developer.

developer can be used in exactly the same way as regular litho developer or with a special technique called "still development." With this technique the film is agitated in the developer continuously for the first 20 to 40 seconds and then is allowed to remain still at the bottom of the tray for the balance of the developing period.

BEA NETTLES: *Coral Reef*, 1977

The Detailed Image, cont.

Flashing the Film Enlargement

The simulated tonal range of an enlargement on litho film can be increased slightly by exposing the film to a low-level light *after* the primary exposure but *before* development. This is called a "flash" exposure. You can use this technique to lower the contrast of the enlargement and extend the range of shadow and highlight detail. Use a Kodak adjustable safelight equipped with a 15-watt bulb and an OA (greenish-yellow) filter. Lay the piece of exposed film, emulsion side up, on a piece of black paper and expose it to the safe-light, set at a distance of 120cm (4 feet) from the film. A recommended range for trial flash exposure is 60 to 90 seconds. This technique seems to work most effectively in combination with still development in Fine Line Developer. Maximum effect has been obtained when a very pale pink tone is perceptible after 2 minutes of development. Some photographers also flash litho film prior to making a contact print from the litho positive. The effect of this, however, is only evident in the most subtle, fine-grain images.

A portion of a 2¼x2¾-inch negative was enlarged to this final size. To retain maximum detail, the litho film was flashed 25 seconds with a safelight equipped with a Kodak OA filter prior to still development in Fine Line Developer.

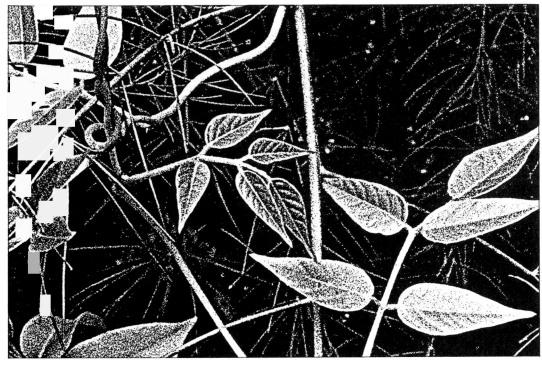

Detail from the image on the facing page.

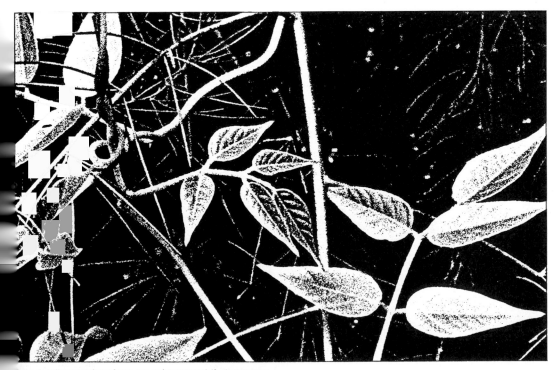

This detail was taken from an enlargement that was pro-
cessed in exactly the same way, but was not flashed.
There is less detail in both the shadow and highlight areas.

Frosted Glass Contact Screen

An enlargement can be made through a piece of frosted glass placed over the litho film on the base of the enlarger. This process helps produce a detailed high-contrast image. It is probably the best method of transposing detail from normally exposed continuous-tone negatives to litho film.

The glass actually screens the projected image through the random grainlike pattern etched on its surface. The pattern introduced by the glass is so similar to the grain of continuous-tone film that most people can't detect that a screen was used at all. The pattern of the frosted glass and grain of the camera negative work together to produce a very fine sharp grainlike pattern. At the same time, the contrast of the image lessens slightly, smoothing out the midtones and the transitions from dark to light. This technique is particularly useful for reproducing large mid-tone areas (sky, water, skin tones, etc.).

Frosted glass is available from most glass companies. Even though it all looks the same, one piece may be more suitable than another for use as a contact screen because of its texture. The thickness of the glass is unimportant. If the supplier has more than one kind, it is worthwhile to buy a small piece of each and run comparative tests. Nonglare glass works in much the same way, except that the resulting texture seems to be less random in appearance. You will need glass that is large enough to completely cover the largest film size you intend to use.

Frosted glass automatically flashes the film as the enlargement is being made; additional flashing will lower the contrast level too much for most images.

1. **Set the negative** in the enlarger and project it as you normally would. Adjust the print size and rough focus the print directly onto the baseboard of the enlarger. Do not use an easel.

2. **Refine the focus** by placing the grain magnifier on a piece of scrap film. Align the mirror of the scope with the center of the projected image.

3. **Position the unexposed litho film** on the baseboard of the enlarger. Using a red safe filter under the lens, switch on the enlarger lamp and move the film until it aligns with the projected image. Switch the enlarger lamp off.

4. **Close the lens down** and remove the filter.

5. **Position the frosted glass,** rough side down, over the film. Be extremely careful not to move or scratch the film. The glass should completely cover all four edges of the film.

6. **Improve the contact** by holding the glass down with one hand and wiping a dry rag across it—*in one direction only.* Apply a medium amount of pressure. If the humidity is low enough, this will cause a static charge, making the film cling tightly to the glass.

7. **Make the exposure,** burning and dodging as necessary. The exposure time must be increased by about 20% because of the density of the glass. After the exposure, gently lift the glass about 25mm (1 inch) and let the film detach and drop down by itself. Trying to separate the film and the glass manually will scratch the film.

8. **Process the film,** using still development (see page 86) in regular or Fine Line Developer.

Note: Frosted glass, Fine Line Developer, and still development all have a tendency to lower the contrast of the film print. This may not be an advantage with all images.

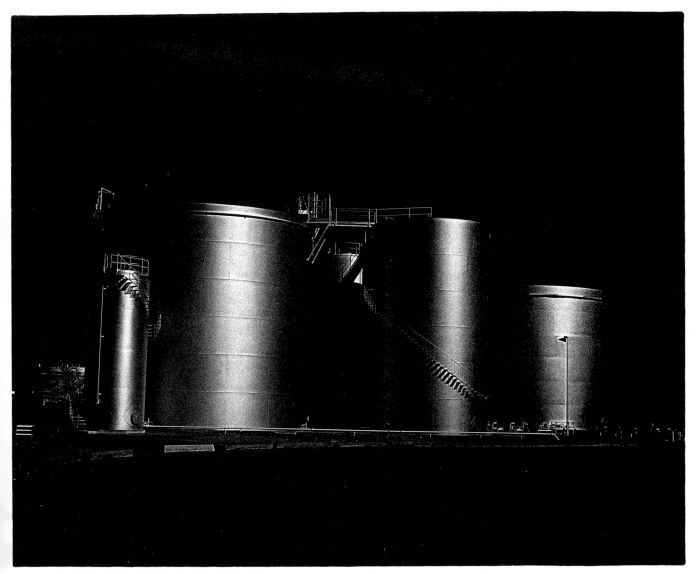

The negative of this photograph was enlarged through a
sheet of frosted glass. The texture of the glass and the
grain of the original negative work together to sharpen the
grain pattern. A polarizing filter was used to darken the sky
when the camera exposure was made.

The Detailed Image: Frosted Glass Contact Screen, cont.

Detail from the print below.

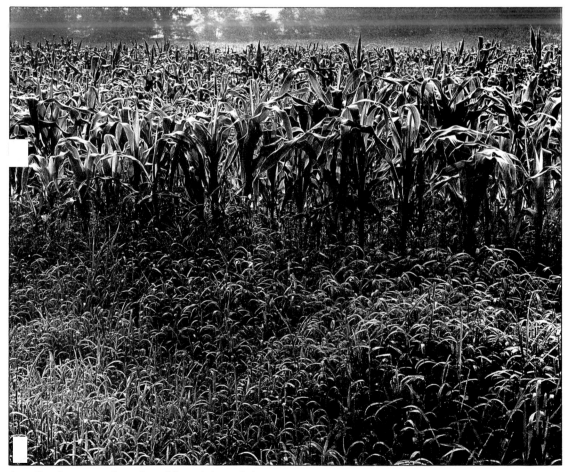

A medium-format negative enlarged through frosted glass.
Note the smoothness and clarity of the grain structure and
the decrease in overall contrast.

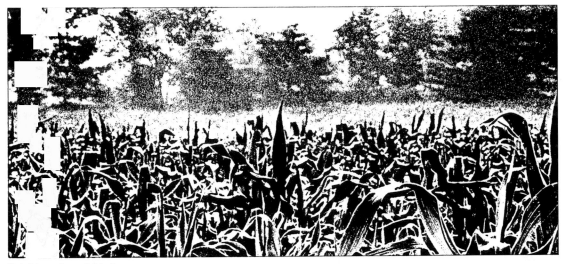

Detail from the print below.

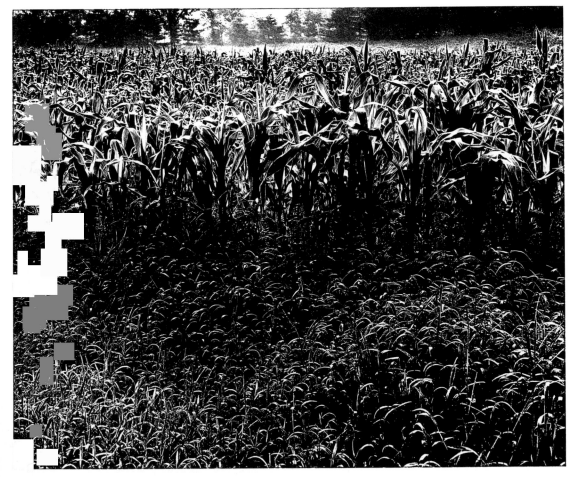

This is the same negative enlarged directly on litho film without the use of frosted glass. The grain structure is not quite as sharp and the contrast is increased, obscuring some detail in both shadow and highlight areas.

UNTITLED, 1979

4

Shooting for High-Contrast Conversion

The information presented in this chapter is directed toward helping you shoot continuous-tone negatives specifically for darkroom conversion to high-contrast film.

To this point, discussion of technique has concentrated on darkroom procedures designed to alter images made from existing negatives. It is likely, however, that the best high-contrast images will be produced by shooting specifically for the particular process involved. In this way, the basic image and process can be finely tuned to complement each other. Explanation of darkroom procedures has preceded the explanation of shooting to expedite the learning process. It takes darkroom experience with litho film to be able to visualize the end result of the conversion processes.

Selection of Film for the Camera

It would seem logical to load high-contrast film directly into the camera. Litho film *is* made for 35mm and 4x5 cameras and it is occasionally useful to shoot it directly. But most often this "shortcut" would turn out to be the long way around. The slowness of the litho film is a major problem; with an exposure index between 4 and 12 it necessitates the use of a tripod, even in bright conditions. Making a continuous-tone negative with a planned conversion in mind is usually a better approach. This allows you to use the negative to make a range of creative interpretations, in high contrast as well as continuous-tone. With very few exceptions (see pages 98 and 234), there is really nothing you can do by shooting litho film directly in the camera that you cannot more effectively accomplish by using one of the conversion processes. A black-and-white film with an ASA rating of 400 is well suited for general use when making negatives intended for conversion.

Smaller-format negatives characteristically produce litho film prints that are bold and graphic. This shot was taken with a 35mm camera, then converted in the darkroom via the triple contact method (see page 20) to produce this simplified interpretation of the building.

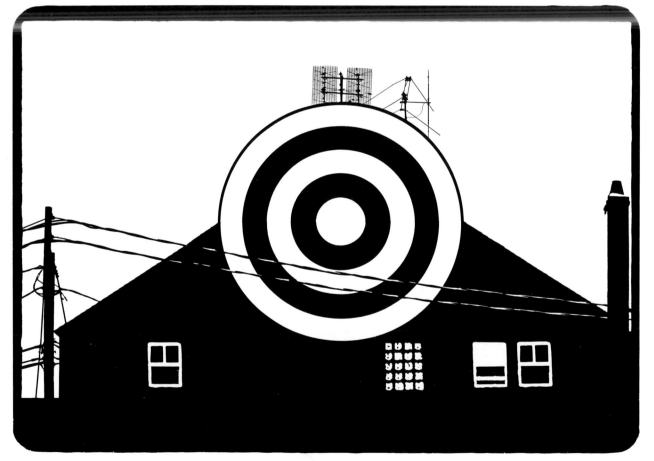

CAMERA NEGATIVE FORMAT

When you are shooting continuous-tone film intended for conversion, the size of the original negative will make a difference. The smaller the negative, the less detail is recorded. Formats of 35mm and smaller produce a final image that is characteristically bold and graphic. There is a corresponding increase in image detail as negative size is increased.

This is the same subject photographed in the same light with a medium-format camera. The enlargement method (see page 22) was used to convert the negative to litho film. The combined effects of larger-format camera and conversion technique work together to preserve the fine detail of the subject.

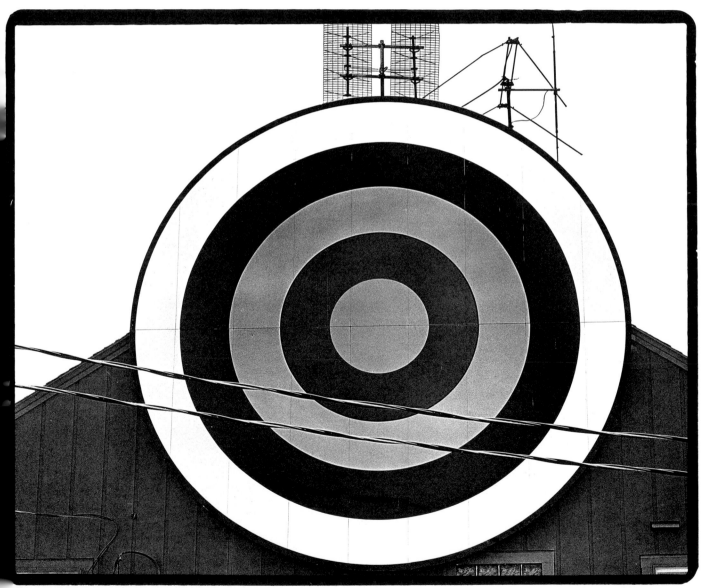

Shooting Litho Film in the Camera

There might be a special reason that you want to load your camera with litho film. For example, you might want to study its unique response to color, bypassed in the conversion process (see page 236).

Exposure in daylight requires an E.I. (exposure index) setting of 10 to 12, in tungsten light 4 to 8. For this reason, it is advisable to make 5 exposures bracketing them ½-stop apart. You can avoid reciprocity failure problems in daylight by using a shutter speed of ¼ second or faster and adjusting the aperture accordingly. Exposure is critical and must be *perfect* to produce a usable negative. The film has an important advantage over panchromatic film: it can be loaded and developed under red safelight instead of complete darkness.

If you want to shoot with medium-format litho film or just make a quick study in 35mm, a small piece of film, large enough for a single exposure, can be cut and laid into the back of the camera. This procedure isn't particularly handy as a working technique since it requires running in and out of the darkroom each time an exposure is made, but in certain situations it can be of some use. The piece of film should be trimmed to the exact width of the regular film that your camera takes, but slightly longer than a single frame. This will provide an edge for handling during development. Open the camera in the darkroom under red safelight and lay the piece of film across the filmplane, emulsion toward the lens. Close the back before leaving the darkroom and go to make the exposure. With some cameras you may have difficulty overriding lock systems tied in with the film-advance mechanism. Try to find a way to cock the shutter without advancing the film. If there is no other way, the lens can be locked open and exposure initiated and terminated by removing and replacing the lens cap.

The negative should be tray-developed in regular or Fine Line Developer. If you are shooting subject matter that is immediately accessible to the darkroom (and is also stationary), exposure can be perfected by immediately developing each negative as it is made and reshooting until the litho negative produced is satisfactory.

PINHOLE CAMERAS

Litho film is a particularly convenient material for use in pinhole cameras. It can be cut to fit any size camera, and then loaded, and developed under red safelight. The daylight film speed rating (10–12) requires exposure time similar to fast enlarging paper.

Exposed pinhole film should be tray-developed in regular litho film developer for a high-contrast effect. A continuous-tone image is obtained by using a weak solution of paper developer. The resulting negative can be contact printed or enlarged. If the image is enlarged take care when focusing, as the grain of the litho film is extremely fine.

OSCAR BAILEY: *Self-Portrait,* 1975

Oscar Bailey used litho film to make this self-portrait with a pinhole camera. The film was cut to size and loaded in the homemade camera. The resulting negative was developed in a 1 to 5 dilution of a standard print developer to achieve this continuous-tone effect. The negative was enlarged to produce the final print. Bailey's left hand is replacing a piece of black tape used as a shutter. The advantage of using litho film in a pinhole camera is that it can be loaded and processed under a red safelight.

Adjusting the ASA Setting

PUSHING THE FILM

"Pushing" is a technique often used by photo-journalists when shooting under low-level light conditions. The idea is to increase effective film speed by systematically underexposing and then overdeveloping the entire roll of film.

Underexposure will cause a significant loss of detail in the shadow (clear) areas of the negative. Overdevelopment will cause an increase in density in the highlight (opaque) areas. This results in an increase in contrast that is considered to be a deficiency in continuous-tone photography, but it is the *reason* for pushing film when doing high-contrast work. If the objective is to emphasize the contrast, it can be done by push processing the film.

As a general formula, shooting a roll of film at twice the normal ASA setting will require an increase in developing time of about 50%. Quadrupling the speed should be followed by a 75% to 80% increase in developing time. The temperature of the developer can be raised or a special high-energy developer can be used to shorten this developing time.

In a studio situation, the best approach is to shoot a test roll under the planned lighting conditions and make a quick developing test. In this way, minor adjustments can be made to suit the quality of the subject. Because this is a *combined* exposure and development technique, you cannot push a single shot on a roll of film. The entire film must be subjected to the complete treatment.

PULLING THE FILM

"Pulling" film is the reverse of pushing film. The camera negative is pulled by intentionally overexposing and underdeveloping it to retain as much shadow and highlight detail as possible. It is often necessary to pull film intended for high-contrast conversion, if that film is to be exposed under high-contrast lighting conditions and the intention is to make a fine-grain, detailed conversion. The camera negative must be within a contrast range that is low enough to be translated by the litho film.

When an entire roll of film is exposed in contrasty light, the exposure should be increased 1 stop. This is followed by a 25% to 35% decrease in developing time.

When shooting camera negatives specifically for fine-grain, high-contrast conversion, some photographers use pulling in normal, as well as contrasty, light situations. This is usually done in conjunction with the enlargement method (page 22) and still development in Fine Line Developer (page 86) to produce very fine-grain litho enlargements with maximum shadow and highlight detail. Remember, however, that many camera negatives that are adjusted to make highly detailed conversions will be so flat that they will be unsuitable for conventional printing.

To make normal negatives that are suitable for conventional printing as well as high-contrast conversion, apply pull processing only to film shot under contrasty lighting conditions.

Daylight: General Considerations

The photographer shooting with high-contrast conversion in mind can utilize a wide variety of daylight conditions. Bright sun on a clear day creates dark, hard-edged shadows. The length and orientation of these shadows depend on the position of the sun in the sky. This strong, specular light brings out the graphic qualities of objects.

Diffused light cast by a bright but overcast or hazy sky can be equally useful for high-contrast image description. Under these conditions, detail that will hold up during the conversion is recorded in both shadow and highlight areas.

Backlight—light originating from behind a subject—often occurs at sunrise or sunset. This light condition can be used to create a silhouetted image.

While the extremes of the three conditions of daylight described in this chapter—specular, diffused, and backlight—have the greatest potential for high-contrast work, there are numerous combinations of these conditions that work successfully with certain types of subject matter.

Light that is not interesting in the original scene is not likely to be interesting in the final high-contrast image. Study the shadows and try to predict just how the particular subject or scene will look on paper as a high-contrast image.

Light and shadow are the key elements in the description of the image on litho film. A bright sun on a clear day will cast dense, hard-edged shadows. The length and orientation of these shadows depend on the actual position of the sun in the sky.

TOM PORETT: 1968

This photograph, and the one on the facing page, were
both originally shot on Tri-X 120 film. The camera was
equipped with a wide-angle lens. The film, which was ex-
posed and processed normally, was enlarged on 4x5 litho
film. A litho negative was made by contact and enlarged to
the final size.

TOM PORETT: 1968

Specular Light for Texture or Graphic Effect

Direct sunlight is specular light. Functioning as if it were a small, intense, focused source, the sun creates dark shadows with sharply focused edges. When shooting under these conditions, try to visualize the abstracting process that will take place during the conversion to litho film. Darks will become jet black, the lighter areas of the subject will become paper white. When specular rays of light strike light-tone areas in a scene, these areas tend to block up on the continuous-tone negative, causing them to appear as white after the conversion. Most dark areas of a scene, whether they are dark in color or dark because they are in shadow, are likely to become black spaces. Areas of tonal transition will be abruptly separated.

As the sun changes position in the sky, the length and orientation of the shadows change dramatically. When the sun hits an object from a 90-degree angle, textural qualities of the surface become greatly exaggerated. In the early morning or early evening, when the sun is low in the sky, it creates the longest shadows.

Architectural subjects work particularly well for high contrast when illuminated by low-angle, specular sunlight. If you shoot a building in clear, direct sunlight, the contrast imparted by this light glancing across the features of its form will sharpen and exaggerate lines and produce a bold graphic image on the film.

When very strong contrast is created by light falling on specific parts of a subject, you may decide to exaggerate this effect by underexposing slightly and purposely let the details in shadow areas drop out of the image entirely. This treatment can sometimes dramatically alter the appearance of otherwise ordinary subjects.

BILL SEELIG: *High Jumper*, 1974

Diffused Light for Softness and Detail

Sunlight is diffused as it passes through a cloud cover or atmospheric haze. In a bright but overcast situation the whole sky functions as a very large single light source. Sunlight is also diffused when reflected from a large, broad surface, such as a mountain, a building, or a snow or sand mass. A condition of light referred to as "open shade" exists in an area that is shaded from direct sunlight but is indirectly illuminated by light diffused as it is reflected from the ground and nearby objects. When light is diffused it strikes the subject from many different directions. The result is a wraparound effect, producing a lower-contrast light condition typified by very pale, soft-edged shadows.

The direction of the light is a critical factor. When diffused light falls on the subject from camera position, it will illuminate the subject in virtually shadowless light. The light will evenly wrap around the subject, striking it from all directions visible to the camera (180 degrees). A key point to remember when using this diffused light in high-contrast work is that you will have only minimal shadows to help describe shape and volume. The subject must have sufficient built-in contrast—from coloration or structure—to benefit from this light condition. Since nothing is obscured by shadow, the negative carries a maximum of subject detail.

When diffused daylight strikes the subject from the side, top, or bottom only, the effect is quite different. The side nearest the light source is illuminated, but the opposite side is in shadow. The darkness of the shadow side depends on the amount of light being reflected onto it from nearby objects.

This directional, diffused light produces interesting areas of transition where the bright side joins the dark side. With specular light, this would be a sharp line cutting across the subject where highlight stops and deep shadow begins. With directional, diffused light, however, this area becomes a soft, gradual fade.

Shooting in diffused daylight requires skill in both exposing the original negative and printing it on litho film. Exposure should be accurately calculated for the average mid-gray tone.

Most creative work in high contrast has traditionally involved specular light. The special qualities of diffused light have yet to be discovered by most photographers.

7:56 A.M.

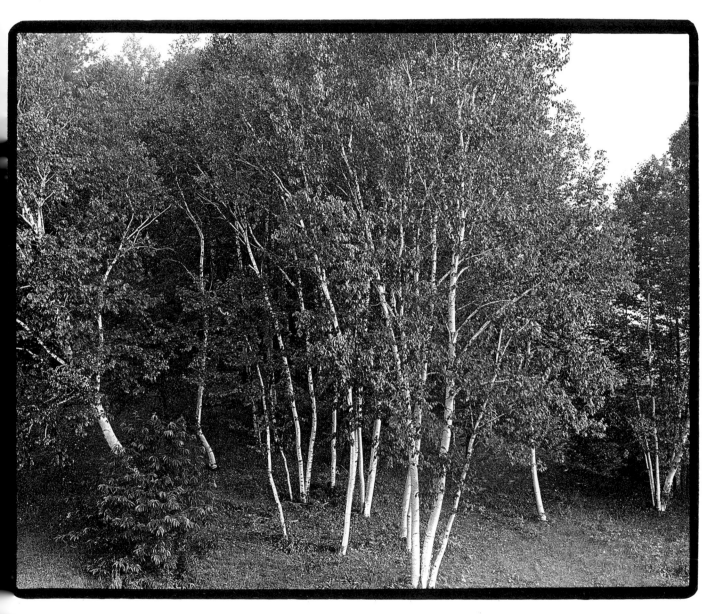

7:57 A.M.

These two photographs were taken only a minute apart. Sometimes waiting a minute or two for the light to change can produce subtle but interesting variations in the image. In this case, the sun appeared briefly and then went behind thin cloud cover. Both photographs have distinctive qualities that are intensified by the conversion to litho film. Closely study the effects of each. The more diffused light, *7:57 A.M.*, allowed the camera to record (and the litho film to hold) greater detail. The more specular light, *7:56 A.M.*, gave the details that do show a more three-dimensional quality.

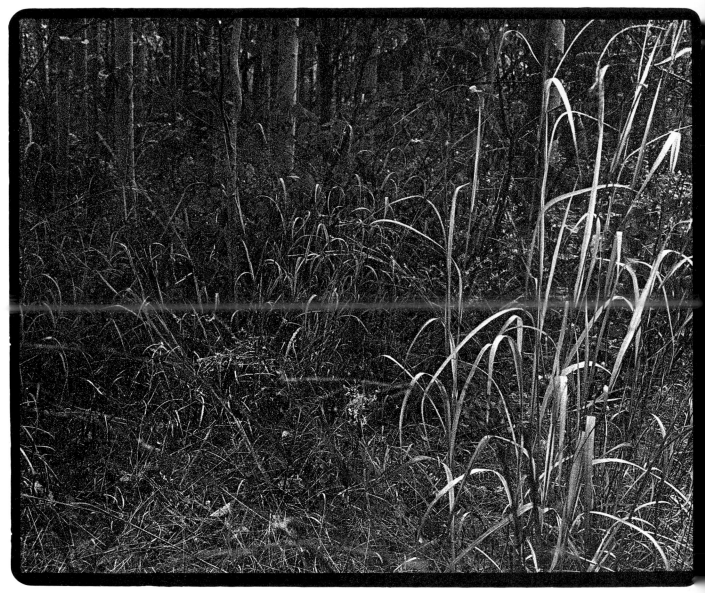

SHUTTER SPEED 1/60—NO BREEZE

Subject motion is an interesting subject for high-contrast
photography. Both shots contain interesting visual informa-
tion. They were recorded under exactly the same diffused
light conditions. The negatives of both images would be vir-
tually unprintable in continuous-tone because of their flat-
ness. The conversion to litho film, however, gives the
images a quality that could not be obtained in any other
way.

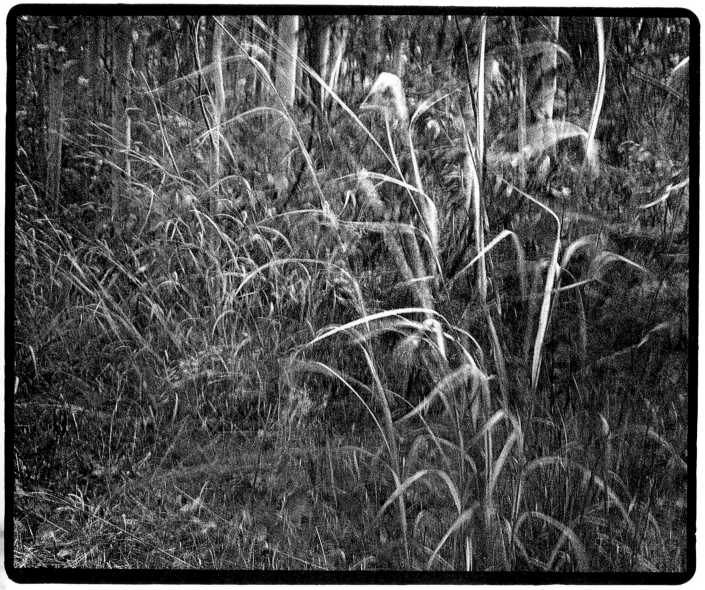

SHUTTER SPEED 1/8—BREEZE BLOWING

Backlight for Silhouettes

A high-contrast photograph of a totally black silhouette against a white background can be created when there is a broad area of bright backlight and a minimum of light falling on the foreground subject. Backlight can give isolated subjects from different negatives sufficient compatibility to be used together in a photomontage.

This light situation often occurs at sunrise or sunset when the sun is low and illuminates only the sky, minimizing the amount of light reflected back onto the subject. It also occurs against a fog or the midday sky when the subject itself is in a shaded area. Occasionally, a light-colored building will be bright enough to produce sufficient backlight.

To create a silhouetted image similar to the examples shown here, the background light must be considerably brighter than any light falling on the subject. The exposure must be calculated to cause the background to block up while exposing a minimum of subject detail on the negative. Meter by taking a reflected reading from the backlight itself and add 1½ to 2 stops to this reading. If you are exposing a whole roll under these conditions, it also helps to push the film.

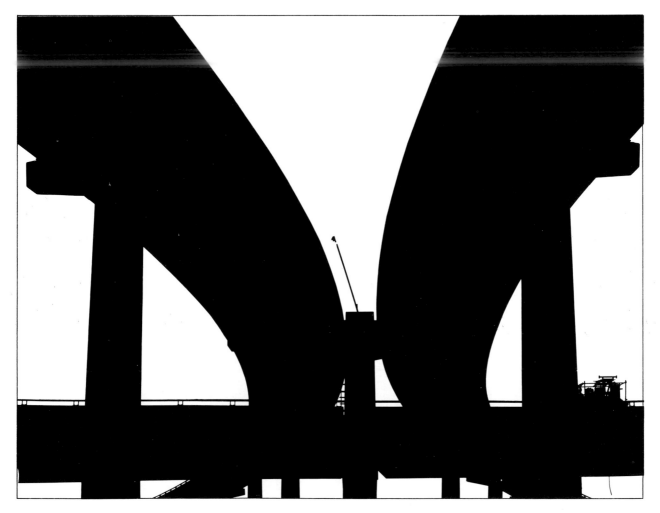

DIANE HOPKINS HUGHES: *Interstate 30, HW # 1 Texas*

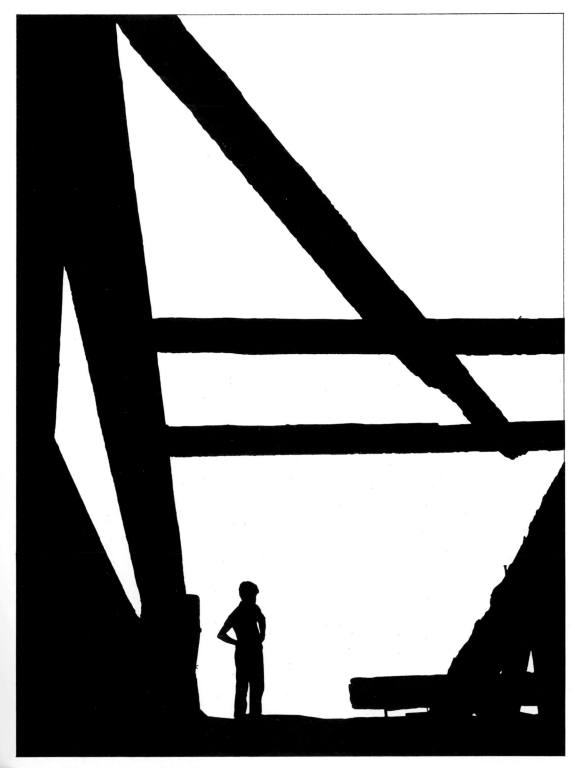

GEORGE TICE: *East River Pier N.Y.*, 1964

Daylight Subjects
Green Foliage

Green foliage can be handled in two basic ways when photographing it for high-contrast conversion. It can be abstracted by treating it as a partial or full silhouette, or it can be exposed and printed to record maximum detail.

Green leaves tend to underexpose (in relation to other colors) on panchromatic black-and-white film. These areas of green foliage are often thin on a normally exposed negative and will be reproduced as black when converted to litho film. If you want to record detail that will hold up during the conversion process, then compensate for the effect of the color green on continuous-tone film when taking the picture. The greens can be made

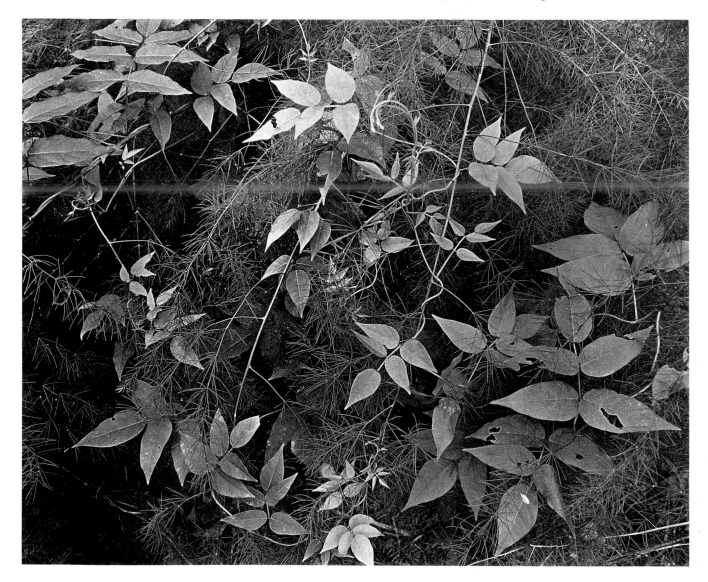

PLANT FORMS, 1977
The green tones in this photograph were lightened considerably by the use of a yellow-green (YG) filter on the camera.

denser on the camera negative to some degree
by the use of filters. A yellow-green filter on the
camera will allow the green foliage to be properly
exposed without overexposing the other areas.
Infrared film can also be useful for providing in-
creased detail in green foliage areas.

GINA ROSENWALD: Untitled, 1979

Snow

Snow can also be treated as high-contrast subject matter. It can function as a pure white background (as shown here), or be used as the primary subject itself.

To use snow as a device to create a pure white backdrop for a silhouette shot, specific light conditions are required. The sky should be fairly bright but overcast, and the subjects should be of medium or dark color value. The film can be pushed, although this isn't always necessary. The objective is to produce a negative that is dense in the snow areas. These areas must be dense enough to prevent light from being transmitted when the negative is printed on litho film.

To capture the textural detail of the snow a dif-

ferent treatment is required. Again, bright but diffused light conditions work most effectively. (The only exception is when the sun is low in the sky and the long shadows help define the textural qualities and shapes of drifts and formations.) To retain the tone in the highlight areas of the snow, the contrast level of the camera negative must be brought into a low-contrast range (see "pulling," page 100). If the tone of the snow is important, you must take care not to overdevelop the negative. The enlargement method (see page 22) is used to convert the image from a camera negative to a high-contrast print. Enlarge the camera negative to its final size on the litho film in the first

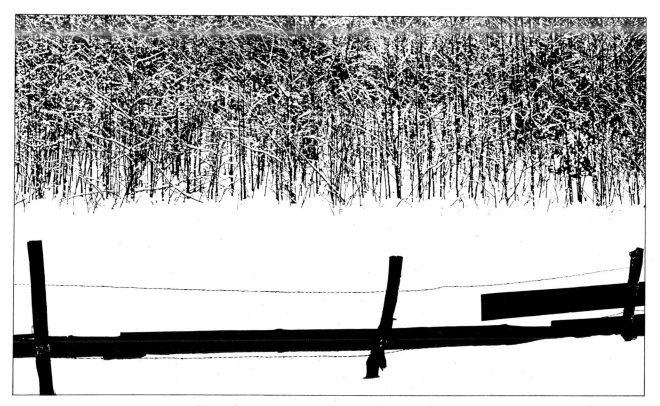

TREES AND FENCE, 1969

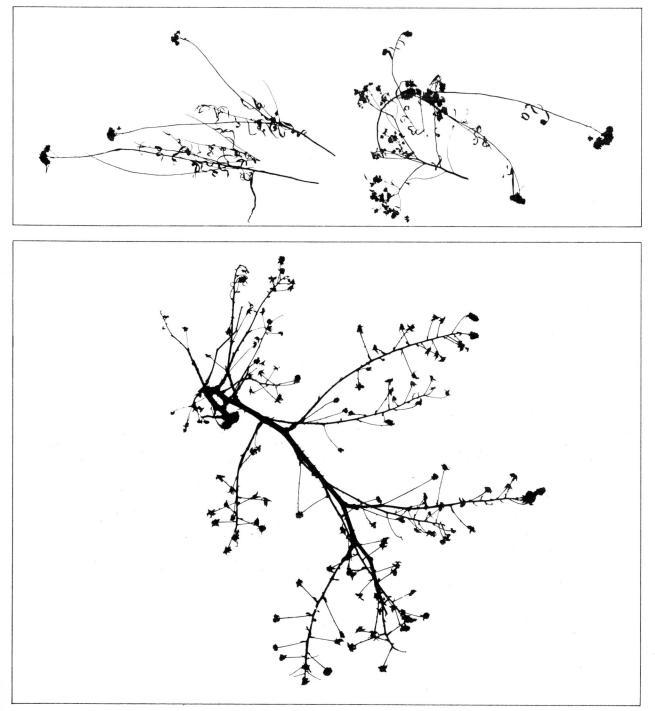

PLANTS IN SNOW, 1969
In the photographs on this and the facing page the snow was used as a blank white backdrop for silhouetted subjects. A reading was taken from the snow itself and the indicated exposure was increased 2 stops. The few remaining traces of tone were dropped from the image when it was converted to litho film.

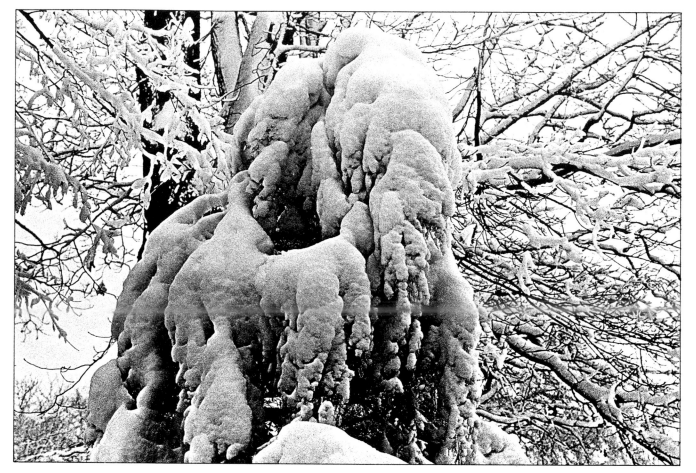

CHARLES SWEDLUND: Untitled, 1979
The original 35mm negative of this image was exposed and developed specifically to accommodate this detailed rendition on litho film. Swedlund started with a low-contrast lighting situation. He fully exposed the negative and then developed the film for low contrast. The camera negative was then enlarged directly to its final size on litho film which had been flashed prior to exposure. It was still-developed in Fine Line developer (see page 86).

step. Remember that there is little subtlety in high-contrast materials. Any information carried on the camera negative *must* be reinterpreted in black, white, or granular patterns when the negative is printed on litho film.

Charles Swedlund exposed the images above on 35mm Tri-X film. He developed them 13 minutes in Agfa Rodinal Developer (1 part stock to 70 parts water at 21.1° C, 70° F). The resulting negative carried full detail in the highlight areas but was low in contrast. The camera negative was enlarged directly to its final size on the litho film. Swedlund used a flashing technique (similar

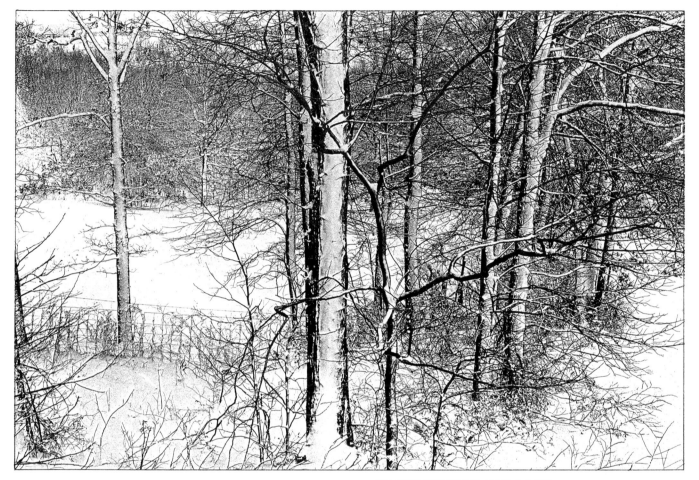

CHARLES SWEDLUND: Untitled, 1979
This image, and the one on the facing page, were produced in the same way. To retain tone in the highlight areas of the snow, the contrast level of the camera negative was held within a range that could be retained on the litho film. The grain patterns are those of the original 35mm Tri-X negative.

to the one described on page 88) to lower the contrast further and extend the tonal range of the film print. The positive was still-developed in Fine Line Developer (see page 86). A contact litho negative was made and contact printed to make these prints.

To produce a similar effect with *normal* negatives (normally exposed and developed), use the frosted glass technique (see page 90) and still develop the film in Fine Line Developer.

Rendering something as subtle as detail in snow can be very frustrating. It takes skill and experience to get each of the variables under full control.

Daylight Subjects, cont.

Fog

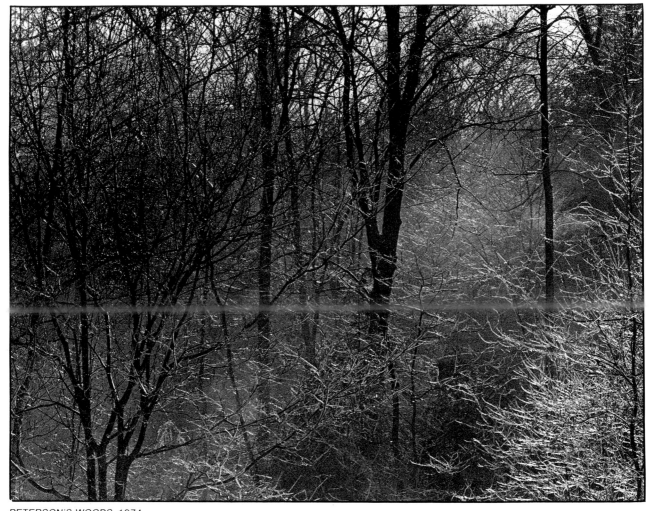

PETERSON'S WOODS, 1974
The penetration of morning sunlight through a clearing fog
highlighted the ice formation on the trees without obscuring
important details in shadow areas.

At certain times of the year a heavy morning fog
will be penetrated by very bright sunlight. This
condition provides an excellent opportunity for
shooting negatives intended for detailed high-
contrast rendition. The bright but shadowless
light is greatly diffused. If you are interested in
recording fine detail, this is the time to do it. The
entire sky canopy works as a giant diffused light,
illuminating the most minute details.

A heavy fog penetrated by sunlight has the ca-
pability to isolate subjects from their natural sur-
roundings *without* turning them into silhouettes.
At times, this is the only way you can effectively
isolate large, detailed subjects against a pure
white field for use in photomontage.

If you are interested in the fading effect
caused by fog, remember to remove the haze fil-
ter if you use one as a lens protector. Adding a
blue filter or slightly underdeveloping the nega-
tive can enhance this fading effect.

THE RED BRIDGE, 1970
The fog in this scene works as a device to separate background and foreground subject matter. The negative was enlarged through frosted glass to even the grain and lower the contrast of the normally exposed negative.

Skies

Clouds and other atmospheric conditions are subjects that can be intensified by conversion to litho film. Skies can be high-contrast subjects themselves, or they can serve as backgrounds for montages.

Consider what normally happens when you shoot a deep blue sky with bright white clouds. Because continuous-tone, black-and-white film responds more intensely to blue than to any other colors, the blue sky becomes almost as dense on the negative as the white clouds. This prevents the cloud formations from being separated adequately on the negative, and they become only faint impressions. However, white clouds and deep blue sky can be separated and intensified by the use of camera filters. A combination of a red and a polarizing filter and push processing (see page 100) produces a continuous-tone negative that prints on litho film as a pure black sky with bright white cloud formations. The red filter withholds excessive exposure from the blue sky without affecting the exposure of the white clouds. The polarizing filter eliminates reflected glare and haze, further separating the clouds from the sky. Pushing the film intensifies the effect by further reducing exposure of the blue sky and blocking up detail in the clouds.

Each of these three devices—red filter, polarizing filter, and the push—requires its own exposure compensation. Ganging the two filters together necessitates an *increase* of exposure. Add 3½–5½ stops to a reflected, hand-held reading to compensate for the combined effect of these filters. The greater the effect of the polarization, the more exposure must be added. Pushing the film, however, will require you to *cut back* the exposure 2 stops. Start by framing your shot (on a tripod if possible). Screw both filters onto the lens: the red first, then the polarizer, then a lens shade. As you look through the viewfinder, slowly rotate the polarizer until the sky darkens to its maximum degree. Remember, this filter has its greatest effect when you shoot at right angles

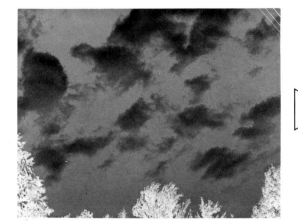

NEGATIVE—PUSHED ONLY

to the sun. If the sky darkens greatly as the filter is turned, add 5 or 5½ stops to the basic reading. If the darkening effect is only slightly noticeable, an increase of only 3½ to 4 stops is necessary. Then *cut back* the exposure 2 stops for the push. A built-in meter, if you use one, automatically compensates for the filters; you will need to cut back only 2 stops for the push. Since there are so many variables and judgments involved in this metering process, insuring the shot by bracketing is highly recommended. Also keep in mind that the combination of these techniques will occasionally have side effects on other subject matter included in the shot.

If you start with a white or light gray sky and want it to be totally white in the final print, remove all filters from your camera and add 1 or 2 stops to the exposure indicated by either reflected, hand-held or built-in meters. The more exposure you add, the more dense the negative will become. Also consider other subject matter appearing in the shot. You don't want to overexpose the main subject in a attempt to create a white sky. To create a gray sky, meter directly and make no compensation at all.

When printing skies on litho film it is helpful to use frosted glass as a screening device. This helps articulate the grain and even out the contrast.

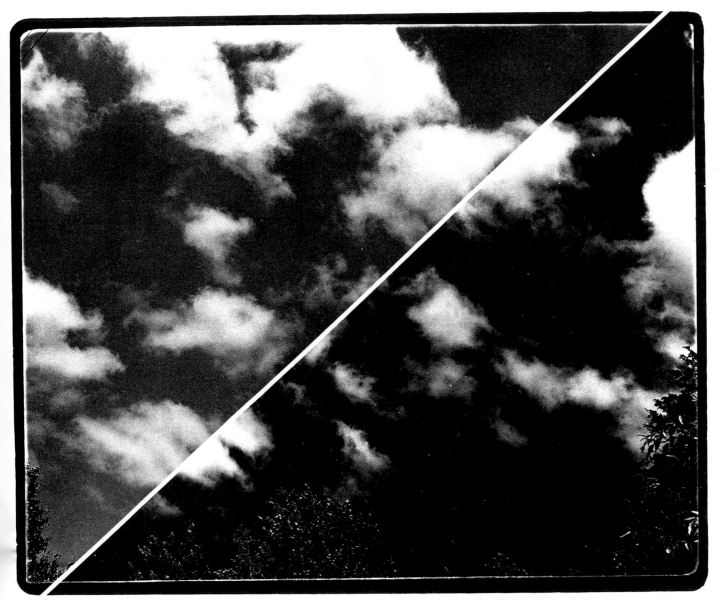

The upper left side of this image was made from the negative on the facing page; the right side was made in the same way using the negative on the bottom of this page. Both negatives were exposed under the same light conditions, on the same roll of film. The sky was deep blue with white clouds. Pushing the film 2 stops, and enlarging on litho film, emphasized the separation between clouds and sky. The right side of the image demonstrates the effect of adding a red and polarizing filter when the camera exposure is made.

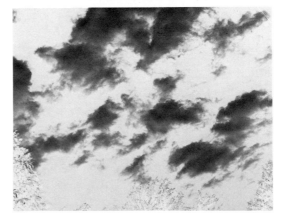

NEGATIVE, RED AND POLARIZING FILTER, PUSHED

Daylight Subjects, cont.

WING WALKER, 1975

BALLOON, 1976

Shooting Under Low-Level Light Conditions

Stage Performances

It is more difficult than you might think to produce negatives at a stage performance that will be suitable for conversion to high-contrast film. Stage light usually originates from banks of focused lights. Unless this light falls against light-colored side flats, there is little or no reflected fill light on the performers. Moreover, each bank of lights creates its own shadows that often overlap in unflattering ways. While not noticeable when a performer is in motion, this effect often poses a severe problem for the still photographer. Shooting under these conditions becomes a matter of making the best of a bad situation, but occasionally great photographs are made under surprisingly adverse conditions.

You can increase your chances of producing negatives that will work as high-contrast images. Most stage lighting is contrasty to begin with, so resist pushing the film if possible. There *is* such a thing as too much contrast, and this is what you would get if you started with a contrasty situation and increased developing time to accommodate an increased film-speed rating. Use your lens at its widest aperture. The softness of the out of focus areas will play down the gross contrast while abstracting background subjects in interesting ways. Try including light sources as part of your shots. The glare and flare from lights and other shiny objects can add unusual shapes and help define depth.

Use a tripod in these situations if feasible. Subject movement can be quite interesting, but camera movement is almost always a disaster. Vary shooting positions as much as conditions will allow. Sometimes it is possible to get above or behind the stage. Be conscious of costume, particularly graphic patterns and shiny materials. Study the ways in which light areas are defined by dark areas and dark areas are defined by light areas. Don't be afraid to incorporate massive areas of black space in your compositions.

Shooting at Night

Only certain types of night photographs will benefit from high-contrast conversion. The main obstacle is usually excessive contrast. In most night situations, the only light bright enough to register on the film in the camera is overly intense. This results in nonexistent shadow areas and blocked-up highlights. This is sometimes desirable, but the light that does fall on the subject must illuminate exactly the right areas to describe the image. You may find that you will get a more interesting (but not identical) result by shooting "day for night." This technique combines the use of red and polarizing filters with the pushing technique (see page 100) while shooting in daylight. It will produce an effect quite similar to moonlight when a darker-than-normal enlargement is made on litho film. This filtered negative will work better than a negative exposed in real moonlight because it will have more shadow and highlight detail.

Surprisingly, night shooting works well when there is fog or mist to diffuse the light, or when there are many sources of light. Quite often, evening sporting events outdoors provide excellent light. Because equal amounts of light hit the subject from opposite directions, there is a useful reduction of shadow-highlight contrast.

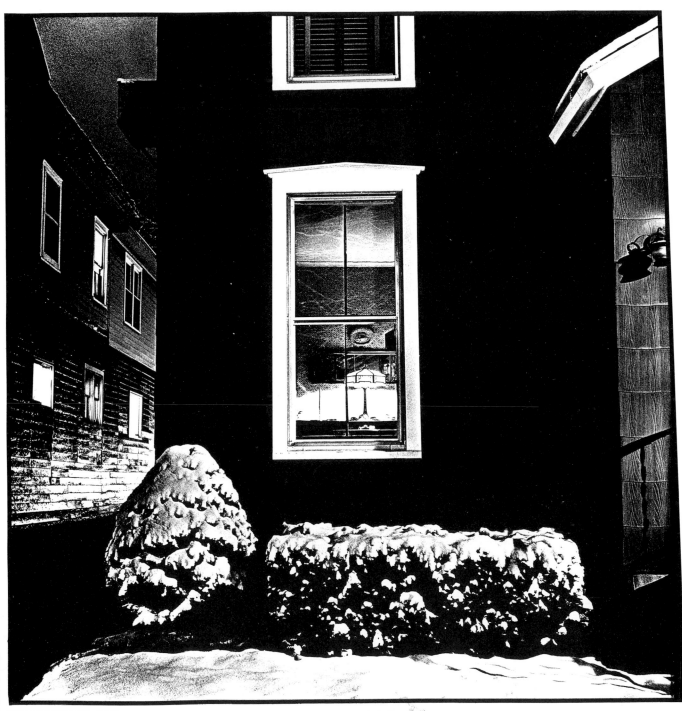

SPRUCE STREET, 1966

Shooting Under Low-Level Light Conditions, cont.

DANIEL MOTZ: *Fireworks 5*, 1979

DANIEL MOTZ: *Fireworks 1*, 1979

These images were recorded by Daniel Motz during a July 4th fireworks display. He used a 200mm lens and held the shutter open 1–2 seconds for each shot. The film was pushed from its normal speed of ASA 400 to E.I. 1600.

DANIEL MOTZ: *Fireworks 6, 1979*

DANIEL MOTZ: *Fireworks 8, 1979*

Capturing a Television Image

Set up the camera on a tripod close enough to the television set so you can use the entire frame of the negative for the screen image. Avoid reflections off the picture tube by darkening the room. Turn the set on and adjust the picture by turning the contrast and brightness controls. If you want a normal image, adjust the picture until there is detail visible in both the highlight and shadow areas of the image. Make an exposure reading from the set, taking the reading from a screen image that is half-dark and half-light. A reflected reading can be taken from camera position. Set the shutter speed first and then determine the required aperture. Selecting the best shutter speed requires testing. A video image is formed by an electron beam scanning across the screen. It takes 1/30 of a second for a complete image to be formed.* A shutter speed faster than 1/30 will fail to capture the complete image and results in a dark band across the image on the negative. Two other factors influence the negative: the speed of the subject movement on the screen, and the shutter mechanism of the camera. Focal plane shutters often create problems when used at speeds above (and occasionally at)

* Typical American video screens.

1/15. When shooting for the first time, try 1/8 or 1/15 for cameras with focal plane shutters, and 1/30 for cameras with iris shutters.

For exposure of a video image intended for high-contrast conversion, it is advisable to set the aperture to underexpose ½–1 stop. This will prevent fine details in the highlight areas from blocking up on the negative.

You should shoot and develop a test roll before doing extensive shooting from a television. Cameras and sets vary widely in their combined response. Bracketing is only feasible on video tape setups where repeated playback is possible.

The video image itself can be modified by adjusting the various controls on the set. Brightness and contrast are the most obvious.

Drastic overexposure (3 to 4 stops), multiple exposures in the camera, and various types of electronic interferences are other variables with which you can experiment. If you have access to a complete video system, there are many additional ways that camera and electronic images can be creatively combined (some of these will be discussed in the section on video montage).

VIDEO COWBOY, 1976 ▶
Video Cowboy, on the facing page, is a sequence of three photographs taken from a television demonstration of a small mechanical tin toy. The image was intentionally distorted by overexposing the 35mm camera negative 2 stops. This was followed by normal development and conversion to litho film by contact. Three images are used to represent the action sequence.

Studio Setups

Certain images and effects can best be created by setting up your own lighting. This is most efficiently accomplished in a photo studio or by improvising with inexpensive flood lamps, a slide projector, and a roll of seamless backdrop paper (available from photo suppliers). Rules and formulas are of limited use when you are working with either available or artificial light. Learning to control light is a matter of developing your powers of observation and studying key cause-and-effect relationships. The best introductory approach to artificial light is through continuous light, light that can be turned on and off, as opposed to strobe or flash. As you move the lights around, you can study their effect through the camera and try to visualize the effect after conversion to high contrast.

Most of the material discussed in this chapter could be applied to any form of black-and-white studio photography. There is, however, a significant difference between the continuous-tone and the high-contrast approach. Shadow areas tend to turn black in a litho image and light tone areas tend to turn white. These effects have to be taken into account when the lighting setup is evaluated.

Most of these setups use a single light source rather than key light, fill lights, effect light, etc. Any additional light comes from reflective panels near the subject. The single-source approach creates a single set of shadows, and this visual simplicity works well with high-contrast materials.

Forks, 1973

IRENE CHU: *Nude,* 1979 ▶
A backlight setup (identical to the one diagrammed on page 138) was used to create a silhouette image. The checked slide shown on the next page was projected on the model at close range. The brightness of the slide, reflecting from the skin, was intense enough to produce total density on the Tri-X negative, creating a simple but elegant image.

Specular Light for Texture or Graphic Effect

Specular light is useful for highlighting textural qualities or when a high degree of image simplification is desired. A focused spotlight or slide projector used at close range is the most efficient instrument for projecting focused light. A bare-bulb flood lamp placed at a great distance from the subject or even direct sunlight coming into a room through a small window will also produce a similar effect.

A small, glancing specular light can be employed to reveal texture. To bring out the weave of a fabric or the grain of a weathered plank, for example, you can direct a focused light across the surface from the extreme sides, top, or bottom of the subject. This creates tiny highlights on the high points, and sharp shadows in the valleys of the surface. These highlights, and dark, hard-edged shadows, can graphically describe a subject in black and white without any use of midtones. Light such as this functions most effectively on objects that are lighter than medium gray and fairly even in tonality.

It is also possible to use specular light with subjects that are black and white to begin with. Remember, however, that litho film is not able to distinguish between real black and dark shadow areas or between real white and bright highlight areas. This visual confusion can create interesting effects when calculated and used creatively.

Using a Slide Projector to Shape Specular Light

A slide projector is an excellent source of specular light in the studio. The light itself can be conveniently shaped or patterned by projecting your own high-contrast slides on the subject. The sharpness of the edge of the light is controlled by focusing the slide projector.

Make the slides in the darkroom from drawings or printed geometric patterns by using your enlarger as a camera (see page 234). After these 35mm litho film prints are processed and retouched, they can be popped into plastic or cardboard slide mounts and used in the projector. At the push of a button you can have a whole series of different light configurations to project on the subject. Be sure that the slides, projector lens, and slide tray are kept meticulously clean, otherwise you will find yourself projecting a field of dust on the subject. Mount the slide projector on a tripod for maximum flexibility.

As the slides are projected, the shaped light will wrap around the subject like a blanket. The photo on the opposite page was made by using light from two slide projectors. The images from the projected slides struck the subject from two angles, producing a wraparound effect.

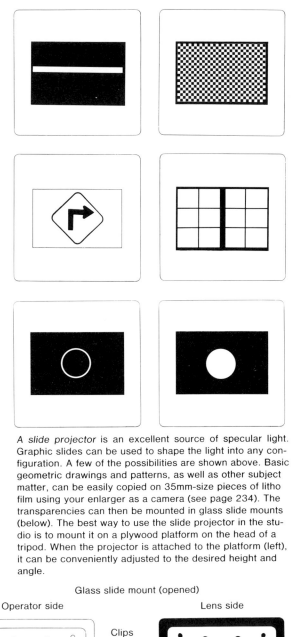

A *slide projector* is an excellent source of specular light. Graphic slides can be used to shape the light into any configuration. A few of the possibilities are shown above. Basic geometric drawings and patterns, as well as other subject matter, can be easily copied on 35mm-size pieces of litho film using your enlarger as a camera (see page 234). The transparencies can then be mounted in glass slide mounts (below). The best way to use the slide projector in the studio is to mount it on a plywood platform on the head of a tripod. When the projector is attached to the platform (left), it can be conveniently adjusted to the desired height and angle.

Glass slide mount (opened)

Operator side Lens side

Clips

Thin glass panel

Metal mat

Plastic mount

The litho film print should be laid onto the dark side of the slide mount (right). It can be held in place by the metal clips. The front and back side of the mount are then snapped together.

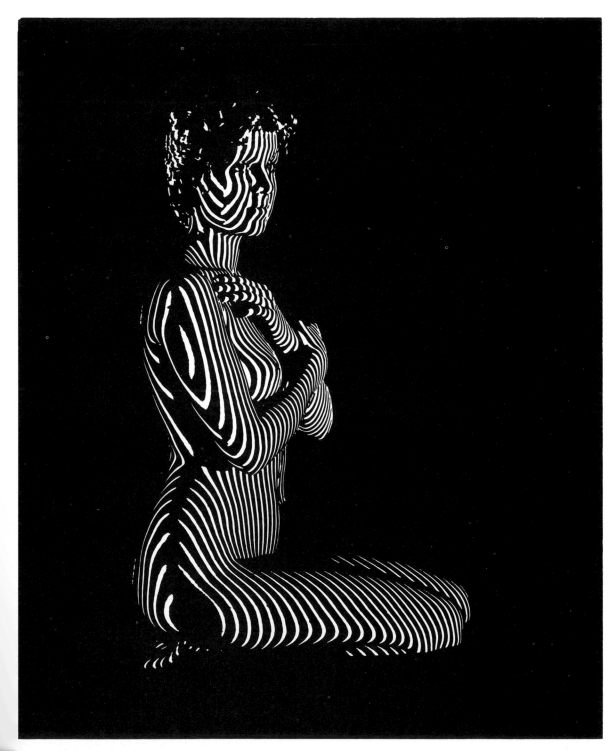

BILL SEELIG: *Striped Nude,* 1975
Two slide projectors, one on either side of the model, were used to produce the light that creates this wraparound effect. The original image on the slide was an even pattern of equally-spaced vertical lines. The contour of the model's body determined the width and curve of the lines in the projected image.

Diffused Light

You can create diffused light in the studio in a number of ways.

Use a very large light source close to the subject.

Bank several smaller lights together into a mass so that they function as a single source.

Use light reflected from a nearby white surface.

Transmit light through a translucent material.

The degree of diffusion is indicated by the shadows. The lighter and softer the edge of the shadows, the more diffuse the light. Commercial photographers sometimes use light that is so soft that no shadow forms at all. The size of the light, in proportion to the subject, greatly influences the degree of diffusion. Larger subjects require larger lights.

The angle at which the light strikes the subject is another important consideration. The same light at the same distance will drastically alter the appearance of the subject as its position is changed. If diffused light strikes the subject head-on from camera position, it is called "frontally diffused"; if it comes from any other direction, it is called "directionally diffused."

FRONTALLY DIFFUSED LIGHT FOR EVENNESS, SOFTNESS, DETAIL

Frontally diffused light is produced by a large light source at, or near, camera position. From this orientation, the shadows created by the light will fall to the sides, out of the view of the camera. This produces a minimum—or absence—of visible shadows.

Frontally diffused light has a reputation for being quite dull. And it will be dull, even in high contrast, unless you apply it to a subject that has interesting relief shape, contrast, or detail. The subject must be interesting enough by itself to look good without help from shadows created by the photographer.

Once a frontally diffused light is set up, you will find it extremely easy to use because you are illuminating an *area* rather than a specific subject. Little adjustment is needed as various objects are placed in this area.

HAT, 1975
Frontally diffused light was applied to this subject to help preserve the intricate detail and texture of the fabric. A large lamp, covered with a diffusion screen, was positioned a few inches left of camera position. The 2¼x2¼ camera negative was fully exposed but underdeveloped by about 20%. It was then enlarged directly to this final size.

DIRECTIONALLY DIFFUSED LIGHT FOR MODELING

When a photographic representation of a three-dimensional object is made, the third dimension is represented by showing the modeling effect created by a directional light. "Modeling" is a drawing term that refers to the distribution of light and shadow falling on the subject. The angle from which light strikes the subject is important in describing the subject's form and volume. When the light source is set at right angles to the camera-subject axis the resulting split between light and dark on the subject is called "maximum modeling." When a diffused light comes directly from the side, above, or beneath the subject, it will evenly light the side nearest the light source while throwing the opposite side into shadow. The darkness of the shadow depends on the amount of light reflected back onto the shadow side. To make the shadow side totally black, be sure there is no reflecting surface on that side of the subject. If you want more light in the shadow area, use a white side drop as a reflector. It must be positioned *very close* to the subject to reflect a sufficient amount of light.

The three-dimensional qualities of the subject are emphasized when diffused light is used for modeling.

Backlight for Silhouettes

TRACTOR SEATS, 1980
A setup similar to, but smaller than, the one described on
the next page was used to photograph these iron tractor
seats. Light was reflected from white backdrop paper
placed behind the seats. Black side panels were used to
prevent any reflected light from striking the subjects.

The purpose of this setup is to produce backlight by illuminating only the white backdrop while keeping as much light as possible from falling on the subject. Unroll one piece of white backdrop paper far enough so that it provides both backdrop and floor coverage. Hang black backdrop paper on both sides of the set. Make sure that the white backdrop is lit evenly, preferably with two or four large lamps. The lamps in the illustration each use a 1000-watt bulb. Place the lamps behind the subject, but far enough off to the sides to be out of camera view. The light should strike the backdrop at 45-degree angles. Put the subject in place and study the setup. The subject should be positioned far enough forward to be safely out of range of any direct light "spilling" from the background lamps. The black sidedrops will hold down the level of reflected light from the sides, producing a cleaner silhouette edge. Room lights should also be turned off to keep the subject in darkness. Take a reflected reading directly from the backdrop. Add about 2 stops to the indicated exposure. This will insure sufficient background density on the negative. If the entire roll is being exposed under these same conditions, pushing the film will assist the silhouette effect (see page 100). This setup is effective for lighting two types of subjects: those with distinctive shapes and those with translucent qualities.

There are additional ways to produce backlight in the studio. Commercial photographers often use "transillumination." A special rig called a "sweeptable"* or infinity table is built or purchased to hold a curved piece of rigid, translucent material. Usually a white plastic, this material is shaped like a relaxed "L" and held in place by a chair-shaped frame. The subject rests directly on the plastic. Light sources are placed behind and/or under the stand. They are aimed

at the subject but are diffused through the plastic. This allows a variety of backlight effects. The light can be shaped or faded from light to dark.

With either of these setups it is important to remember to keep as much light as possible off the camera side of the subject, meter the white backdrop, and add exposure.

* Sweeptables are manufactured by several companies. A model similar to the one illustrated is available from the Bogen Photo Corp., 100 South Van Brunt Street, P.O. Box 448, Englewood, N.J., 07631.

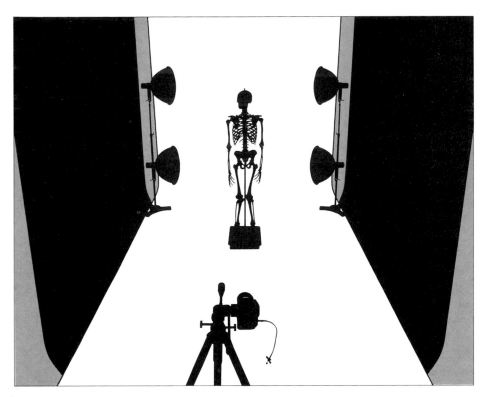

Silhouette setup. A roll of white backdrop paper is hung behind the subject and pulled down across the floor all the way to camera position. Lamps are placed behind the subject and positioned so that they evenly illuminate the white backdrop paper. Black backdrop paper is hung from both sides to absorb any reflected light that might strike the subject. This setup is effective for lighting two types of subjects: those with distinctive shapes, or those with translucent qualities.

A SETUP FOR SMALLER OBJECTS

Consider the size of the subject when planning a backlighting setup. If the subject is a small, opaque object, it is often more efficient simply to make a lithogram in the darkroom (see page 52). This works well but tends to thicken objects slightly. Smaller objects can be photographed in silhouette by placing them on a sweeptable or simple light box. Reflections from shiny subjects can be eliminated by using a black paper tent (see page 144).

Sweeptable or *transillumination stand*

The White Box

The white box setup produces highly diffused, bounced light that evenly surrounds the subject. This setup requires a lot of light and is quite difficult to improvise in a home studio, except in scaled-down size.

The subject and camera are placed inside a setup that resembles a six-sided white box. In the studio, such a box is made by using several large pieces of backdrop paper. One continuous piece of paper should form the rear backdrop and cover the floor. The backdrop and side drop arrangement is the same as in the silhouette setup except that the two side drops are white paper rather than black. Unless your studio has a low, white ceiling, it is necessary to hang an additional piece of white paper over the set. The two front flats are made by taping large pieces of white backdrop paper to thin wood strips and clamping them to light stands. They can be rolled up and stored when the set is disassembled.

The lighting arrangement is also the same as in the silhouette setup. The purpose, however, is slightly different. The object is to bounce light off the backdrop, to the side drops, to the front flats. With this reflection activity, the subject receives extremely soft light from the side and front flats. Although not a particularly efficient use of light, it produces an effect that simply cannot be created by any other setup. The subject is bathed in even, totally diffused light and the backdrop receives two to three times more light than the subject. This is usually just the exact ratio of backlight to "float" or isolate the subject against a blank white field.

The diagram represents a full-scale setup large enough to cover two people, full-length, with even light. It could be reduced in scale to shoot portraits.

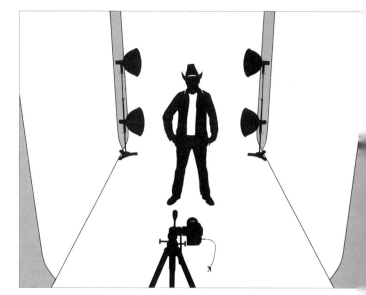

The white box setup. Lamps are placed in the same position as they are for the silhouette setup on the previous page; for this setup white paper side drops are used to bounce the light around the subject intentionally. If the studio does not have a low white ceiling, a fourth piece of white backdrop paper should be hung over the set just out of camera range.

Before the shot is taken, two white front flats are moved into position on either side of the camera, making the six-sided box complete. The reflected light from the backdrop is bounced to the sides and finally to the front flats, illuminating the subject with soft, even, diffused light.

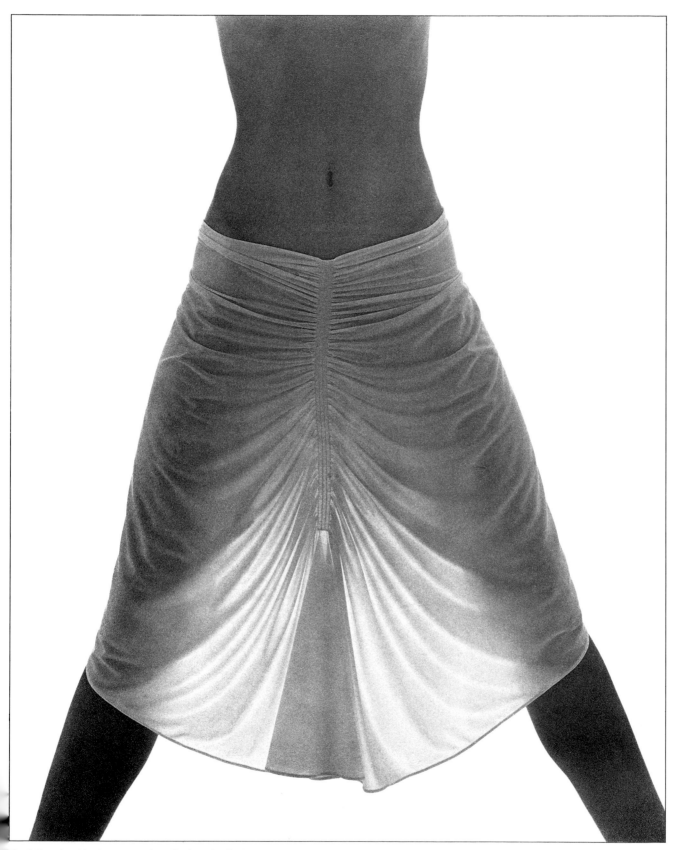

The full-scale white box setup described on the facing page was used to produce this soft backlight effect. There is sufficient light being reflected from the front flats to illuminate subject detail and enough backlight to "float" the subject against a pure white field. This setup is particularly effective with various types of translucent materials.

A Small White Box

A scaled-down version of the white box can be set up for photographing smaller objects. In the example, a light box takes the place of a lighted backdrop. Since the light box creates a self-illuminating background, objects can rest directly on it and the camera can be positioned above. The camera is attached to a tripod, as shown, by extending the tripod legs and reversing the center post. Then the camera is mounted lens down, between the tripod legs.

A small set of reflecting panels can be cut from foam board (available at art supply stores). This is an ideal material to use for panels because it is thick enough to stand upright without sagging, but light enough so it won't damage the subject if it falls over. Foam board is easily cut with a sharp knife or a single-edged razor blade.

Cut the top panel first. The size and shape of the box is determined by the subject matter. In general, the perimeter of the box should be only slightly larger than the perimeter of the subject. If you are shooting a triangular object, make a triangular structure. If the subject is round, substitute a piece of heavy, white paper rolled into a cylinder around the subject. Cut a circular piece of foam board for the top panel of the cylinder.

Cut a hole for the lens in the top panel. Use a tracing of the lens so the fit will be snug enough for the panel to stay in place by itself. With some cameras it is possible to fit the lens shade on the lens after the panel is in position.

The side panels are cut double-width, scored (cut halfway through), and folded back into "L" shapes. This permits them to stand freely without support. The two "L" panels are placed on the light box, completing the six-sided white box. This setup will provide a white background and a diffused light on the subject. You can control reflections and contrast by replacing the top or any of the side panels with a black panel. Black, plush Con-tact paper can be applied to the foam board for this purpose.

A small-scale white box. The camera is mounted above a light box. A reflecting panel made of lightweight foam board is attached to the camera lens. The subject is placed directly onto the surface of the light box.

A second piece of foam board is cut, scored, and folded into an ''L''-shaped panel. This panel is placed onto the light box, forming two side reflectors. Note that the top panel is slightly smaller than the perimeter of the side panels, allowing for limited vertical adjustment of the camera.

A second folded panel is placed into position around the subject, completing the six-sided box. The illustration shows the back of the front panel. The dotted line represents the fold.

Studio Setups, cont.

The Tent

A "tent" is used by commercial photographers to solve many lighting problems. In its simplest form, a tent is made by shaping a small cone out of heavy tracing paper or translucent plastic film.* The cone is enclosed at the top by wrapping it around the camera lens. The bottom is made as wide as necessary to enclose the subject.

The tent traditionally uses transmitted rather than reflected light. This makes it a simple and effective setup for controlling reflections on metallic or polished objects while providing even, diffused light. Instead of reflecting a view of the photographer's studio and lighting equipment, a polished subject reflects only the interior of the tent and the front element of the camera lens.

Background material under the subject can be white, black, or gray because the light is placed outside the cone and transmitted to the subject. Black velvet or a thin black foam sheet sold by photo suppliers** is the best material for a black background. If black paper is used at close range to the lighting equipment, it reflects an unacceptable quantity of light.

Two or more lights can be used to surround the tent. The translucency of the paper helps blend the lights into a continuous source. A more modeled effect can be produced by positioning a

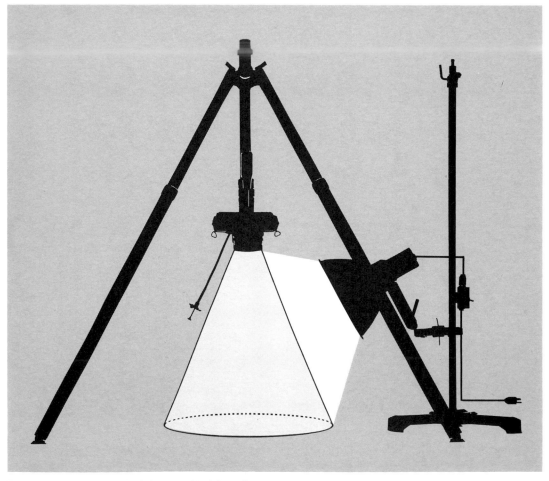

The traditional tent setup. Light is transmitted through a cone or tent made of heavy tracing paper. The subject is placed inside the tent. When a single light is used, the side of the subject nearest the lamp receives the most light while the other side receives evenly bounced light from all other angles. Two or more lamps can also be positioned around the tent to modify the effect.

light on one side. The inside of the tent opposite the lamp will bounce a large quantity of fill light back on the subject. This produces a distinct bright side with a softly "filled" shadow side.

A variation of the traditional tent setup is also illustrated. In this case, the tent is positioned on a light box. The tent can be made from a variety of materials. If the tent is constructed from translucent tracing paper, the light transmitted from the light box is used to create a white background beneath the subject while additional lighting can be set up outside the tent. If opaque white paper is used for the tent it functions in a similar manner as the white box. But when a polished object is photographed the seams from the white box that would normally show in the reflections are eliminated. You can also use a patterned tent to create interesting reflections on polished objects. A tent made from black paper will completely eliminate reflections, producing a silhouette. In the case of transparent objects such as glassware, the black tent provides even backlight without surface reflection.

* Heavy, translucent plastic sheeting is available from Studio Specialties Limited, 409 West Huron Street, Chicago, IL.
** A black, nonreflective foam backdrop material is sold under the brand name "Foam-Ett" by the BD Company, P.O. Box 3057, Erie, PA 16512

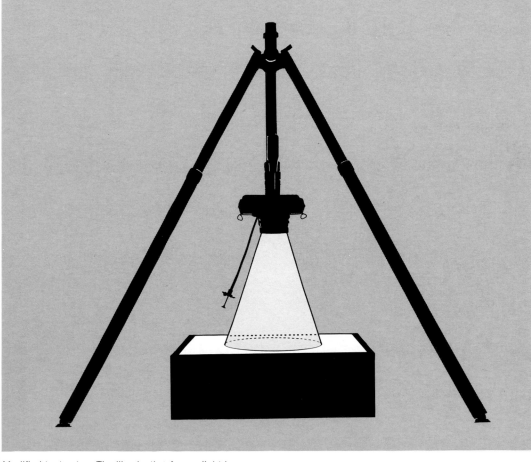

Modified tent setup. The illumination from a light box can be used separately or in combination with lamps placed outside the tent.

Small-Scale Setups for Metallic Objects

All panels white.

A

Front panel black; all others white.

B

Top and back panels black; others white. Slide projector from left side.

E

Top panel black; other panels white, but moved farther away from badge. Slide projector positioned on side nearest top of badge.

F

Left side — Top — Right side

Badge — Back

Front panel not shown

A small-scale white box (shown here) and a tent (opposite) were constructed to control the lighting for this series of badge photographs. The front panel has been removed to show the interior of the box. The light originates from the light box under the subject.

Small-scale white box and tent setups have been modified here to demonstrate the variety of lighting effects you can produce when photographing metallic objects. For this demonstration a micro lens was used on a 35mm camera. The badge was placed on a light box for each exposure. In examples A, B, C and H the light from the box was the only source of illumination. The variation in effects was produced by adjusting the arrangement of the foam-board sides of the box. Black, plush Con-tact paper was adhered to the reverse side of each panel. The black and white sides were used in various combinations to control reflection and overall contrast. In examples D through G, a slide projector was used at close range to produce specular reflection. Examples

Top panel black; all others white. C

White paper tent. Hole cut for slide projector which is positioned on the side nearest top of badge. D

Black paper tent. Hole cut for slide projector positioned at a low level at side nearest top of badge. G

Black paper tent. Illuminated by light table only. All reflections eliminated by use of tent. H

D, G, and H were additionally modified by the use of the tent technique.

Although these setups may appear complicated, it took less than an hour to cut the foam board and tent materials, set up the equipment, and shoot a roll of 20 exposures. All of these examples came from the same roll of film (which was exposed and processed normally). Each negative was enlarged to this size on litho film. The film positives were contact printed to another piece of litho film, and the resulting litho negatives were contact printed to produce the final images. For the purposes of demonstration, no retouching was done at any stage. In each example there are details that could have been improved by minor scraping or stippling on the final litho negative (see page 36).

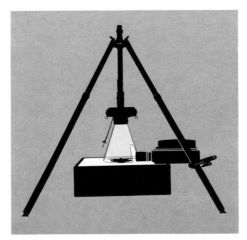

A slide projector was used at close range to produce specular reflection in some of the examples above. A hole was cut in the tent to admit the light from the projector. The background illumination was provided by the light box.

Shooting from an Overhead Position

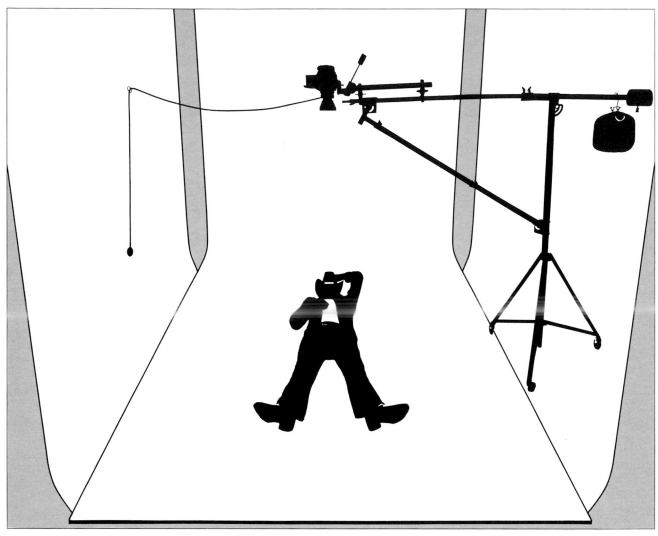

Camera setup. In this diagram a 2¼x2¾ inch format camera equipped with a wide-angle lens is mounted lens down on a boom over the subject area. An air release is attached to the camera so the shutter can be released from the side of the set. In this setup, the subject can be placed on any type or color background material. The backdrop is extended to provide floor coverage. This particular boom is assembled from various pieces of lighting equipment, fastened together by standard photo studio hardware. The center post of a tripod is securely fastened to the end of the boom. The cross brace and extra counter weight (water bag) were required to support the weight of the heavy camera. A less substantial and more flexible boom stand could have been assembled for a 35mm camera. This piece of equipment was used to make several of the photographs in this chapter.

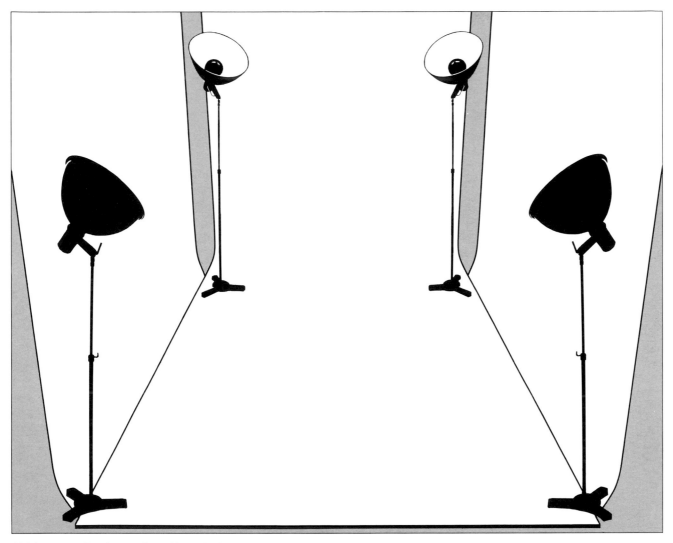

Lighting setup. Four lamps of equal intensity (1000 watts each) are positioned in each corner of the backdrop. They are adjusted so that they strike a fourth piece of white backdrop paper suspended over the set (not shown). The light strikes the paper at a 45-degree angle. This converts the overhead paper into a full-sized reflector covering the subject area with even, diffused light. This is a variation of the white box technique. Many other types of lighting arrangements are possible. Lights can be mounted on booms or introduced at lower levels. The side reflectors can also be changed from white to black to accomplish a variety of lighting effects.

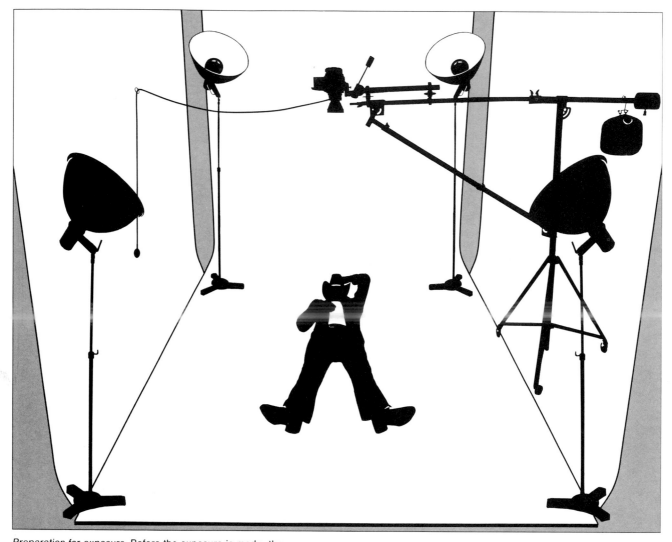

Preparation for exposure. Before the exposure is made, the photographer must climb a step ladder, look through the camera, and check the coverage of the lens and the focus. The feet of the ladder and the subject must share the same area in which the photographer aims the camera. Chalk marks can be placed on the backdrop to indicate the lens coverage. Once focus and coverage are determined, the camera and boom stand are locked. In this example, the camera was set at a low level. The photographer could reach the lens to set the exposure and advance the film after each shot without using the ladder.

Front reflecting panels. Before the exposure is made, two reflecting panels are positioned on the open side of the set. When butted together they form the sixth side of a white box setup. Exposure is determined by taking an incident reading at subject position. The photographer should stay low when taking the reading and making the exposure to avoid blocking the reflected light. When everything is set, the photographer trips the shutter by depressing the bulb of the air release while standing to the side.

Multiple Exposures in the Camera

Two or more exposures can be made on the same negative *while* it is in the camera. A negative produced by this technique can be enlarged on litho film. In fact, most multiple camera exposures will be improved by high-contrast conversion. Since they typically result in low-contrast camera negatives, by converting the image to litho film, you can increase the contrast to a more desirable level.

Making multiple exposures in the camera differs in several ways from methods of darkroom combination printing. For many types of subject matter it is a simpler technique. Because the combination occurs *in the camera*—on the same plane of focus—the problems with multiple image levels associated with sandwich printing are avoided. The examples shown here were not burned-in or dodged, but simply enlarged to their final size on litho film. The final negatives were made and contact printed to produce these images.

No special equipment is needed, but it is necessary to find a way to recock the shutter of your camera without advancing the film to the next frame. Many 35mm cameras are designed *not* to do this. If there is no built-in provision for multiple exposures, it is sometimes possible to fool the film transport system by manually preventing the advance in the following way:

Take up the slack on the film cassette by turning the rewind crank clockwise.

Then while depressing the rewind button, hold the rewind crank to prevent it from turning, and cock the film advance lever.

If this technique is successful, it allows the shutter to be cocked without moving the film. The second shot can then be exposed over the first. An alternate, but less precise, method is to rewind the film after it has been advanced. This can be done with some cameras by depressing the rewind button and *rewinding* the film back a frame to the original position.

It is even possible to run the same roll of film through the camera twice prior to development. If you want the frames to align, the film can be marked for registration when loaded. Place small pencil marks along the film track on the inside of the camera. Corresponding marks should be placed on the film. After the film has been rewound following the first run realign the pencil marks. The film can be placed in the same exact position for the second run through the camera or the marks can be used as a reference to purposely misalign the film for the second run. The frames can be made to overlap at midpoint. The result is a long, continuous negative from which any particular length (single, double, or triple frame size) can be selected for enlargement.

Most photographers who work with multiple exposures plan them in advance by doing thumbnail sketches. Others prefer to leave the final details of the image in the hands of fate. They loosely organize their shooting, expose several rolls of film and then study the results.

Whether you decide to plan the shooting in detail or purposely involve chance in your working technique, it is helpful to keep the following exposure principles in mind:

White—cancels

Gray—creates a misty overlap

Black—functions as a window

Bright overlapping areas will obscure all detail. Dark areas will allow detail from the overlapping exposure to show through, as if it were a window. Overlapping midtones will produce a greater or lesser degree of detail, but it will be only partially visible, as if seen through a mist.

No exposure compensation is necessary when working with numerous solid blacks and a minimum of white. If the shot contains an abundance of light areas on both exposures, the exposure for each shot should be reduced by 1 stop. This keeps the highlight densities from building to unprintable levels.

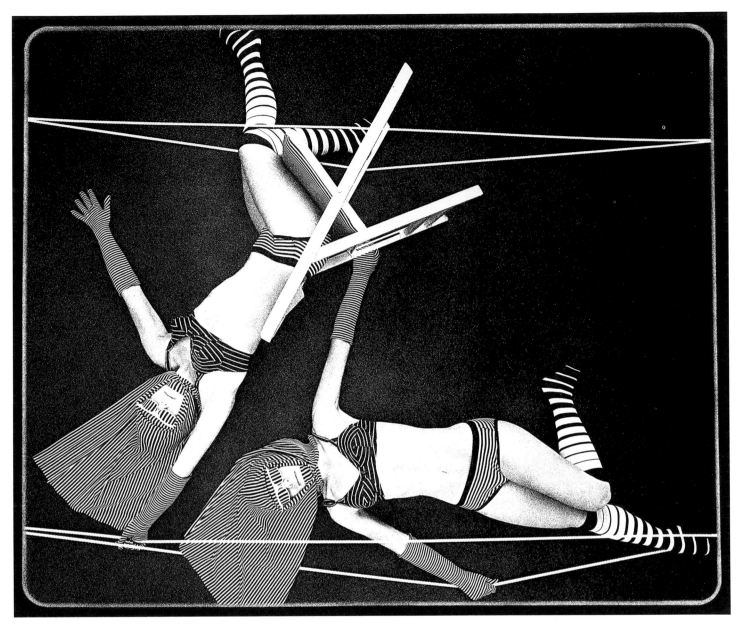

SKYWIRE WITH CHAIR, 22x30 serigraph, 1979

This multiple exposure was made in the camera rather than the darkroom. A single model was recorded in two positions on the same negative. A boom was used to hold the camera over the model as she posed on the floor between two lengths of clothesline. The pose on the left was exposed first. It included the model and the chair (which was pushed up against her body to suggest that she was sitting). A 6m (20-foot) air cable release was used to trip the shutter. Following the first exposure, the shutter was recocked but the film was not advanced. Using the position of the chair as a reference, the model moved to the second pose on the right. The chair was removed and the second exposure was recorded. Because there was a minimum of overlapping, no exposure compensation was required. To produce the grainy effect, the negative was enlarged through frosted glass (see page 90) onto 4x5 size film. It was enlarged to its final 22x30 size only during the last step before it was transferred to silk for final ink printing as a serigraph. Four lamps, one in each corner of the room, were bounced off the white ceiling of the studio. This provided even, frontally diffused illumination.

Multiple Exposures in the Camera, cont.

DREAM SERIES NO. 8, 1975
The basic camera and light setup was the same as the one
described on page 148. This was also a multiple exposure
made in the camera. The model held the same position for
each of the two shots, but the patterned fabric was rear-
ranged after the initial exposure. When two ''regular'' pat-
terns overlap, they create new patterns. The configurations
vary depending on the topography of the model's body.

DREAM STATE NO. 11, 1975
A multiple camera exposure was also made to produce this
image. The first exposure was of a nude model against
black backdrop paper, with one side of her body (our left)
covered with an afghan. The pose was held for the second
exposure, but the afghan was pulled across to the other
side of the frame, entirely covering the model.

Studio Subjects
Still Life

The example shown on the opposite page contains none of the conventional subjects normally associated with still life photography: bowls of fruit, wine bottles, and so on. Too many people think of a still life only as a balanced arrangement of foods and dishes. If you think of still life as an *approach* rather than specific subject matter, you may begin to see a wider potential for creative experimentation. Fascinating high-contrast images can be created from a variety of inanimate objects positioned and lit by the photographer. The light can be moved to the objects, or the objects can be moved to the available light. The arrangement of subject matter can take several alternative forms: traditional objects in untraditional arrangements; untraditional objects in traditional arrangements; untraditional objects in untraditional arrangements.

The photographer has an increased degree of control when shooting inanimate objects. Lightning reflexes are not required. There is no fear of missing a fleeting moment. If working with artificial light, you need not worry about the sun going behind a cloud. If the camera is on a tripod (as it should be), there is no problem with camera movement. This permits the use of slower shutter speeds.

In trade for these advantages, still life demands a great deal more time and patience. There are no ready-made images. It is not a matter of "take it or leave it." The still life photographer has charge of *every* aspect of the image. Demand is placed on the photographer's skill both as a designer and technician.

Try working with objects that possess similar qualities. Consider the shape, texture, reflectivity, contrast, and meaning of objects you select. Mix or match qualities that you find interesting.

If you work with subjects that are strikingly dissimilar, try several types of lighting setups. Keep in mind that light and shadow can be a unifying element.

Black and white objects offer many possibilities. They can be carefully arranged to make the black objects define the white objects and vice versa. An arrangement of all black or all white objects can produce interesting high-contrast images. If you cannot locate a sufficient number of black and white objects, then spray paint may be the answer.

When shooting for planned conversion to high-contrast film, don't forget that everything in the shot will be converted to black, white, or patterns of grain. Train yourself to be especially conscious of the function of shadows in separating light areas from other light areas and dark areas from other dark areas. The final quality of your images will depend on your abilities as a scavenger and collector of unusual objects as well as your originality and skills in lighting and camera operation.

Still Life, Untitled, 1980

Fashion and Clothing

Clothing can be used to add interest to a model; or the model can be used to provide a form for the clothing. It is even possible to use clothing as still life material. In whatever way it is used, for it to function well in high contrast clothing must:

Have interesting dark and light patterns.

Be black or white (or quite dark and light).

Have reflective or textural qualities.

Be translucent, or

Have a shape that can create an interesting silhouette.

If a black-and-white pattern itself is of interest, diffused frontal lighting is usually the best approach. Pushing the film 1 or 2 stops encourages the image to break cleanly into pure black and white when converted to litho film. This type of light will not produce significant shadows, so you must depend completely on the lights and darks of the clothing itself to describe the shape and volume of the model (if this is important).

If you are shooting a mixture of pure black and pure white clothing in the same shot, treat it as a large-scale pattern. When the clothing is all white, you may want to use shadows that can be produced by a more focused, directional light.

If texture is a main concern, the angle of the light will be the key consideration. The less frontal and the more directional the light, the more the texture will be emphasized. A focused light used in this way produces dark, hard-edged shadows and causes the texture to stand out. A directionally diffused light, on the other hand, lightens shadows and softens the appearance of the fabric. The angle of the light and the degree of focus can be used in combination to adjust the representation of contrast and texture.

A lighted white backdrop can be used to silhouette fashion subjects (see page 138); but remember that the shot can only be as interesting as the shape of the clothing and model. Backlight can also be used for working with translucent clothing. When backlight is transmitted through the clothing, the shape of the model's body is clearly visible. The relationship between the clothing, and the body beneath it, can often be successfully intensified by the conversion to high-contrast film.

Two highly diffused studio lamps were used to illuminate ▶ this lace bra and gloves. The lights were positioned at an equal distance from the subject, but the right lamp was moved back almost directly behind the model. A large reflector was set at camera position. The purpose of the light on the right side was to provide a little backlight (behind the right glove) and, at the same time, bounce light from the reflector. The light on the left picks up the highlights from the lace while the light on the right keeps the shadow areas light enough to prevent the loss of any detail. This setup was very carefully arranged to provide maximum modeling without losing detail. The camera negative was exposed normally but underdeveloped 20%. The enlargement method was used to convert the image to litho film. The model was dressed in a black leotard. Traces of remaining detail from the leotard were opaqued out on the final negative.

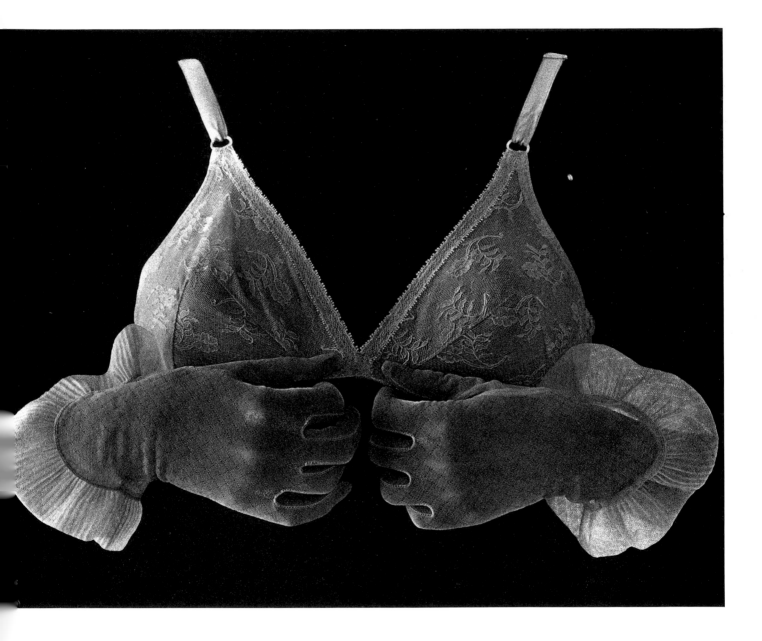

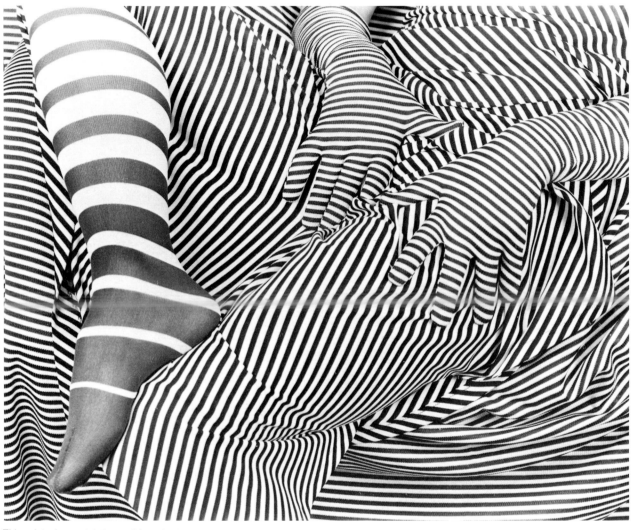

This print of a model dressed in striped clothing was made
on normal contrast enlarging paper from a 2¼x2¾ inch
continuous-tone negative. Two diffused studio lamps were
each placed at 45-degree angles to the subject to provide
even, shadowless illumination.

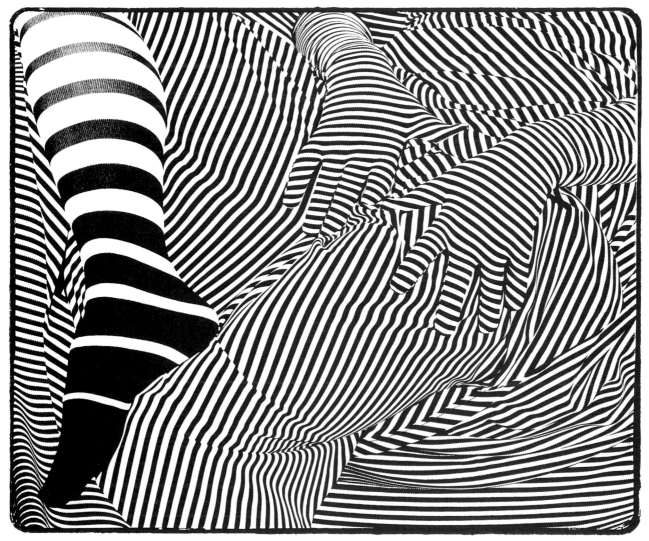

Number 156 from The Stripe Portfolio, 1977
The graphic simplicity of this print, which originates from
the same continuous-tone camera negative, is the result of
darkroom conversion to litho film using the enlarger
method (see page 22). The form and volume of the model
and the clothing are described through the use of graphic
pattern rather than shadow.

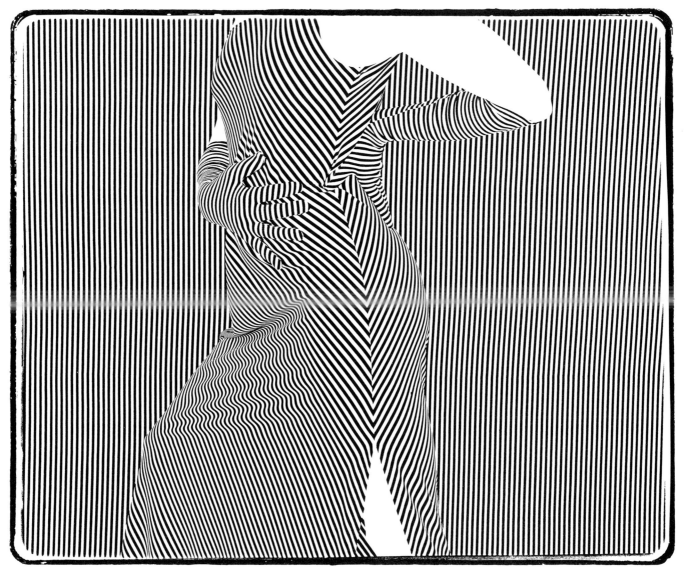

Number 182 from The Stripe Portfolio
A lighting setup identical to the one diagrammed on the op-
posite page was used to make this photograph. 120 film
was pushed 1 stop. The camera negative was enlarged to
this size on litho film. A contact litho negative of this en-
larged positive was used to produce this final print.

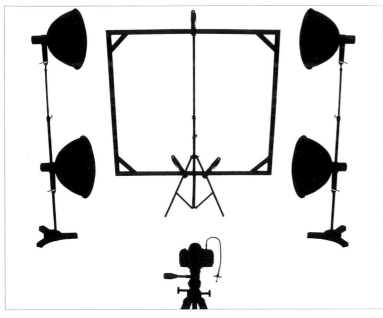

Spring clamps are used to hold a wood frame to a standard
light stand. Four lamps are set at 45-degree angles to the
frame area. The lights are positioned about 5 feet from the
frame.

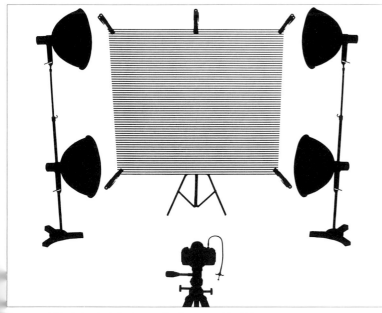

Patterned fabric is stretched over the frame and held in
place by clamps in each corner. To produce the image on
the facing page the subject was placed as close as possi-
ble to the backdrop. The angle of the lights prevented the
formation of dark shadows.

People

Photographs of people fall into two general categories: a person treated as a particular individual (a portrait), or a person treated as a form (a design study). Is it someone's personality or physical appearance that interests you? These considerations are not necessarily exclusive of one another and it may be difficult to separate one from the other completely. It will help, however, to define your objectives as clearly as possible. Do you want to say something about who this person is? Or, is it sufficient to describe how he or she looks? Although high-contrast film has the potential to do either, it is probably more effective as a design medium.

The first thing that usually comes to mind if you are interested in portraiture is a photograph of the subject's face. Quite often a more indirect approach will be more successful. You can capture individual human qualities in many ways other than face shots. In fact, the face need not be used at all. One person may be distinct from another because of shape, posture, unique gestures, or clothing. The model's self-concept can also be explored as expressed through fantasy as well as factual or realistic representation. You are not limited to using people only as "sitters" for portraits.

The physical appearance of the body can also be visually explored as a potential high-contrast design study. If you are working in composite, the model may become only a small part of the larger composition.

FACES

Faces are difficult subjects for the high-contrast approach. The subtleties of facial expression are difficult to retain on litho film. To obtain results similar to the portrait shown here, shoot medium- or large-format film in diffused light, and then process to preserve fine grain detail (see page 84). This combines some of the subtle qualities of continuous-tone with the graphic qualities of high-contrast.

An alternate approach is to purposely employ the inherent abstracting qualities of litho film. Simplified high-contrast portraits are familiar to everyone. They are often used in newspaper advertising, packaging, and signs. Their simplicity permits them to be commercially printed with little difficulty in any size, ranging from mammoth highway billboards to matchbook covers. Portraits of this type are rarely very interesting beyond the novelty of the effect. Most people have two eyes, a nose, and a mouth. High-contrast film, while making these features identifiable, gives very little clue to the differences between one face and another. A simplified high-contrast rendition of a face often drains it of any subtlety that might have made it dynamic as a continuous-tone portrait. Subjects with strong and unique features have the greatest potential for a successful, simplified treatment. If you want to shoot people in this way, look for people who have an interesting shape to their face, eyes, or hair. A face may be made more interesting by applying makeup, glasses, or hats.

The light falling on the subject is an important consideration. Directional light creates shadows that help describe facial features. Frontal light minimizes shadows. Eye and lip makeup for subjects—men, women, and children—is often necessary to retain sufficient detail in the face. When eyes and lips are especially pale, they commonly drop out during the conversion to litho film. Directional, focused light is most commonly used for high-contrast face shots. Watch the shadows move as the light (or the model) changes position. Sometimes throwing parts of the face into total darkness can be a successful simplification device. Any combination of these techniques can be applied in an attempt to emphasize certain characteristics while subduing others.

PORTRAIT OF JIM FRIEDLICH, 1977
This portrait was made on 4x5 Polaroid Type 55 PN to
capture as much detail as possible. The final-sized enlarge-
ment was made directly from the Polaroid negative on litho
film to this final size.

SKIN: LIGHTING FOR SOFTNESS

Softness on litho film can be represented in only one way: as areas of even grain pattern. Producing sufficient evenness is quite difficult and requires experience and patience. The best results are obtained when you:

Use a model with even skin tone.

Use a large, diffused light source.

Make accurate exposures on both continuous-tone negative and litho film.

A large diffused light source, aimed directionally or frontally, creates soft shadows and minimizes skin texture. The white box setup produces the ultimate in soft lighting (see page 140). To create subtle shadow, modify this setup by substituting a black flat for one of the two white front flats. Both flats should then be reset at 45-degree angles to the subject.

If both white front flats are removed and then a black flat is positioned behind the camera, the diffused light bounced from the sides of the set will be prevented from reaching the center of the model. This will cause a fuzzy, soft shadow line that divides the subject in half, creating an eerie but often fascinating effect. A directionally diffused effect can be created by also replacing one of the white side drops with black paper.

The white box works only as long as it has a white background from which the light can bounce. For soft lighting against a black background, bounce light from white side-drops, or use a large diffused light source directly on the model.

The white box characteristically creates a very low-contrast lighting condition appropriate for the fine-grain litho conversion. Other types of studio lighting setups, however, may produce negatives that are too contrasty for this type of conversion to litho film. In these situations pulling

H. RANDOLPH SWEARER: Jamie, 1980

(overexposing and underdeveloping) the film will lower the contrast of the negative to a printable range without sacrificing the quality of the lighting effect. Specific printing techniques (see page 90) are recommended when a soft effect is desired.

SKIN: LIGHTING FOR GRAPHIC EFFECT

Focused light creates hard shadows that emphasize muscle structure, creases, and skin texture. The maximum graphic effect is achieved when the light hits the subject at a right angle to the camera-subject axis, from the side, top, or bottom. When very dark shadows are desirable, keep the model away from any surfaces opposite the light source that might reflect fill light back into the shadow areas. A black flat on the shadow side will absorb stray light. Small-format film also helps to increase the graphic qualities of the shot. Larger-format negatives can be graphically simplified by using the chain reduction process described earlier (see pages 78–79).

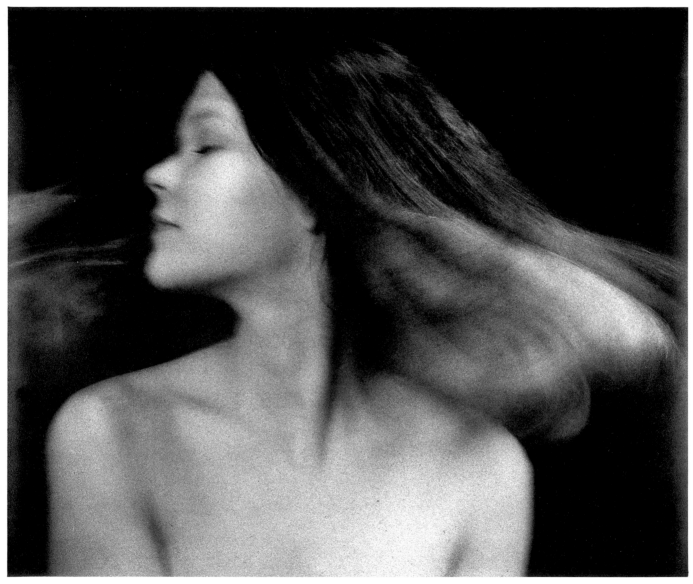

Untitled, 1971

E. From *Stripes Meets Dots Folio*, 22x28 serigraph, 1977

SKIN: AS WHITE SPACE

To make skin totally white on the positive film print, you must start with a light-skinned model. Apply white makeup to areas of detail you wish to eliminate in the final print. Light frontally, to minimize shadows. Push the film 2 stops (see page 100). This causes the highlight detail to block up on the negative. Some details may have to be retouched out when continuous-tone film is printed on litho film, but the underexposure and overdevelopment should cancel most skin tone. It is important to shoot in such a way that you don't have white against white. White skin shapes depend on their reference to black or granular areas for definition.

F. From *Stripes Meets Dots Folio,* 22x28 serigraph, 1977

Combining Shooting and Printing Considerations–Overview

This image, and the one on the facing page, were both made from the same Tri-X 120 negative. This simplified version was made in three reduction steps using the chain reduction technique.

Maximum Simplification for Graphic Effect

☐ Use a small-format camera with fast film. (See page 96.)

☐ Photograph objects that are black and white or dark and light.

☐ Use light that produces the sharp, dark shadows (pages 101, 131) or silhouette (pages 110, 137).

☐ Push the camera film 1 or 2 stops. (See page 100.)

☐ Convert the image to high contrast using the triple contact process. (See page 20.) Consider using the chain reduction process. (See page 78.) Enlarge to make the final print.

☐ Use regular litho developer with continuous agitation. Process in regular litho developer using a continuous agitation technique. (See page 43.)

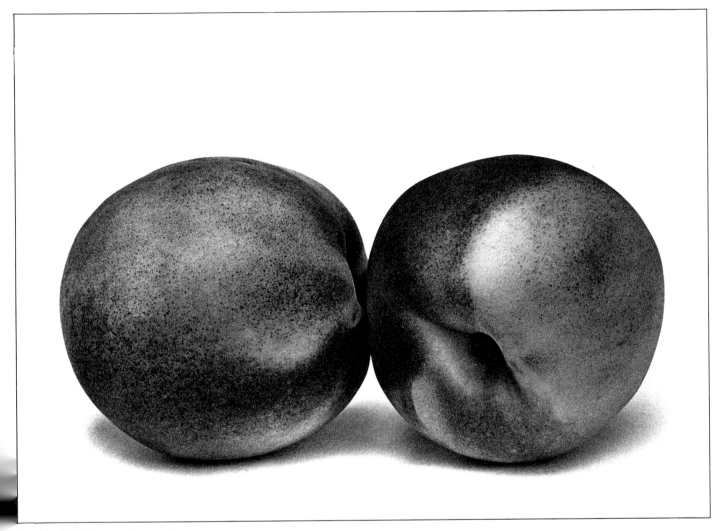

For this detailed image, the negative, originally shot in dif-
fused light, was directly enlarged to this size on litho film.
Both of these images were modified exclusively by litho
printing procedures.

Maximum Detail for Realistic Effect

☐ Use a medium- or large-format camera with
fine-grain film. (See page 96.)

☐ Select objects of medium color value. Filter
if necessary. (See pages 112, 120.)

☐ Use diffused light to create soft, pale shad-
ows. (See pages 105, 134.)

☐ Expose the camera film normally or pull the
film. (See page 100.)

☐ Enlarge the camera negative directly to its
final size on litho film. Consider enlarging
through frosted glass. (See page 90.) Con-
tact print to make the final litho negative.

☐ Still develop in Fine Line Developer. (See
page 86.) Consider flashing the film. (See
page 88.)

PIERRE CORDIER: *Toboggan*, 1966

5

High-Contrast Photomontage

Photomontage is one of the most exciting ways in which many of the high-contrast litho film techniques can be used. A photomontage can be made in enlargement and/or contact steps. This procedure allows for the gradual building of an image in a series of "states." The image-building process can be stopped, or even reversed, at any point to accommodate changes or corrections. Retouching techniques described in Chapter 2 can be used to make minor corrections, or as creative devices to dramatically alter the image. Because litho film transposes everything into either black or white, it increases visual compatibility between different images and among photographs taken at different times and places.

Described in this chapter are many approaches and techniques for constructing new images from previously collected bits of visual material.

Some of these multiple printing techniques are based on principles introduced by O. G. Rejlander and H. P. Robinson in the nineteenth century, and updated in the 1960's by Jerry N. Uelsmann. These techniques differ, however, from both historical and contemporary forms of multiple printing because they are litho film processes.

Stripping is essentially a contact printing process involving the composite arrangement of several pieces of sheet film.

"Paste-up" is an adaptation of a well-known montage method used extensively in the 1920's and 30's and recently in editorial illustration. Pieces of photographs and printed materials are arranged, pasted down, and photographed on high-contrast film.

"Video montage" emphasizes the production and photographing of electronically processed imagery. The individual video images can be recombined in the darkroom using the stripping technique.

These processes and others covered in this chapter are often less difficult to carry out on a step-by-step basis than they are to contemplate. For example, you could easily be put off by noticing that a certain process requires the production of five or six generations of film. In reality, this is not very complicated or time-consuming.

Stripping

"Stripping" is a technique borrowed from the offset printing trade. In its simplest form, stripping results in a high-contrast, final-sized *film* paste-up. Selected pieces are cut apart, separated from original litho enlargements, rearranged, and taped to a sheet of clear acetate. The acetate composite is contact printed to another piece of litho film, producing the final negative. The final print results from contact printing this negative on paper.

The best way to find pieces for the montage is to look through all your contact sheets. A large number can be reviewed in a surprisingly short time. Set aside each sheet containing fragments that strike you as having potential for composite use. In the beginning it is easiest to use individual shots that isolate various types of subject matter against a white background (sky, snow, sand, walls, and so on). Don't overplan the first time. Simply take six to ten negatives into the darkroom and experiment.

1. **Decide on the dimensions** of the finished print. Draw a rectangle this size on a piece of scrap paper to use as a reference while working.

2. **Enlarge each negative** on litho film using the rectangle as a reference. Each potential element should be enlarged to the size it will take in the final print. This is all guesswork at this point because you don't know yet how various pieces will work together. Don't waste film; if you are interested only in a quarter of the negative, use a piece of film just large enough to include that area. If you can't make up your mind about the best size for a certain element, enlarge it to two differ-ent sizes. It is better, in this case, to be somewhat tentative about the final image.

3. **Burn-in and dodge,** as necessary, to increase visual compatibility or to obscure unwanted subject or background detail. Remember, you can always retouch by masking or scraping after the film is dry.

4. **Process and dry** each fragment.

5. **Cut a sheet of clear acetate** slightly larger than the planned size of the final montage. The acetate should be clean and free of scratches.

6. **Trim the enlarged images,** on the pieces of litho film, from their surrounding backgrounds with scissors.

7. **Arrange the images** on the acetate. Take your time and experiment with various arrangements.

8. **Attach each piece** to the acetate, in position, with transparent tape. The emulsion side should face up, away from the acetate. Use *small* pieces of tape. Place them carefully to avoid crossing detailed image areas.

9. **Contact print** the completed montage to a piece of high-contrast film, emulsion to emulsion, to produce the final negative.

10. **Process the negative.** The exposure and development should be sufficient to leave only slight traces from the edges of the tape. Dry the negative in a dust-free area.

11. **Retouch** by opaquing or scraping out unwanted areas (cut lines around fragments, tape marks, dust specks, etc.).

12. **Contact print** the final negative to photo paper to make the final print. The composite on acetate can be made in either the negative or positive state, or both positive and negative elements can be used together.

PLANTS WITH BIRD, 1970

A. The fence was trimmed out from this enlarged film positive.

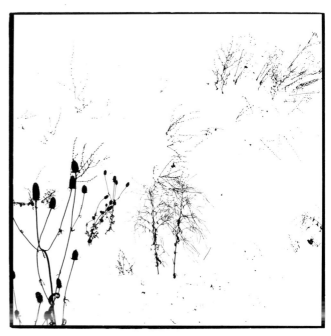

B. The plant was trimmed out from this film positive and combined with the fence in the next step.

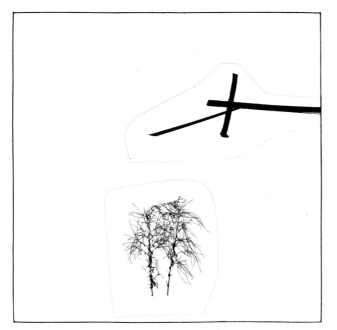

C. The two selected fragments were secured in place with transparent tape on a sheet of clear acetate.

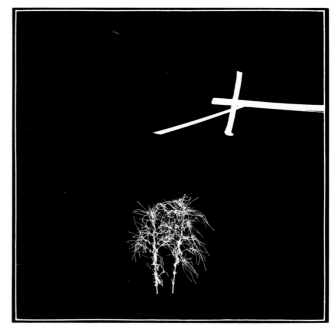

D. The acetate paste-up was printed on litho film, resulting in this high-contrast negative. The faint lines caused by the cut edges and the tape will be painted out with opaque before the final print is made.

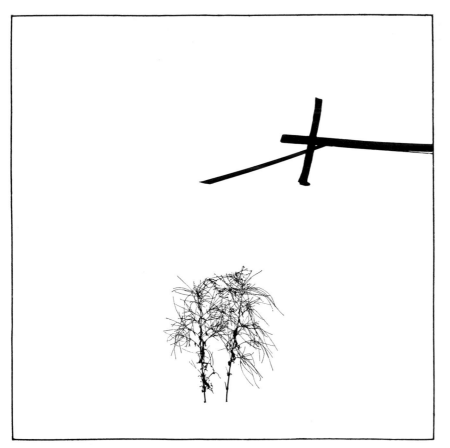

E. The retouched film negative was used to make this final
print.

Stripping, cont.

SUSAN FOX HAYWOOD: *Night Watch*, 1979

The stripping technique was used to combine images from separate 35mm negatives to create these photomontages. Hand-drawing of some details was involved, as well as liberal use of opaque to eliminate background details.

SUSAN FOX HAYWOOD: *Jungle Jet*, 1979

VISIT OF THE SPACE RANGERS, 1978
This composite was stripped together (in its negative state)
from thirty-four separate pieces of litho film. The forest is
composed of separate enlargements of three photographs
of a small metal toy tree. The spaceship is also a metal toy,
but the vapor trail was extracted from a photograph taken
at an air show. The portions of the vapor trail that appear
to be behind the trees were scraped from the film when the
composite was originally stripped together.

THE OLYMPIA DINER, 1978
The same degree of complexity was involved in stripping
together this image. The toy car and the sky were added to
the base image of the diner. The sky was fabricated (see
page 210). The reflection from the hood of the toy car was
lifted from the roof of a real car parked in the left corner of
the original photograph (not in the final image).

Enlarging Techniques

High-contrast film responds reasonably well to most conventional enlarging techniques, including "fading" and "blending" (as well as burning-in and dodging). With standard enlarging skills you can cause an image to fade into darkness or lightness, or blend into a second image. Remember, however, there is a difference between paper and litho film. Litho film cannot reproduce grays, so a fade or blend can only occur in granular areas of an image. The grain will work much the same way as the halftone dots used in offset lithography. When an area fades, the granular pattern becomes gradually more sparse. This creates a smooth transition from dark to light.

Fading

To fade an area into white, block light from the negative by using a large black card above the litho film during the enlargement. Cut the edge of the card to describe the shape of the fade. As the film print is being exposed, hold the black card several inches from the film, just as if you were dodging. The closer you hold the card to the lens, the more gradual the fade will be.

An image can be made to fade into darkness by heavy burning-in. If this proves insufficient, give the area additional exposure using a flashlight. Begin by making the basic exposure. After, be careful not to move the film or bump the enlarger. Insert a red safe filter under the lens and switch the enlarger light on. You will see a faint, "safe" red image projected on the film. If it is not bright enough, open the lens fully. Using the red image as a reference, block the light from hitting the area that is to be left unaffected by dodging using a black card at close range to the film. The white side of the card should face the lens (so you can see the red image). With the other hand,

expose the area that is to go black by using the flashlight. Vibrate the card while exposing the intended area. It works best to hold the flashlight over the card and project the light at a slight angle toward the uncovered area. This prevents an excess of light from seeping under the card. The use of frosted glass over the film (see page 90) will allow for a more gradual fade.

FLYING CHAIR, 1978

Enlarging Techniques, cont.

Blending

When two images from separate negatives are "blended" together in continuous-tone printing, two enlargers are usually required. For litho film, two enlargers are a definite convenience, but not a necessity. Each half of the blend can be done on a separate piece of film. Then they are sandwiched together when dry, to make the final contact negative.

1. **Select the two images** to be combined. Make sure that the blend is designed to occur in a granular area.
2. **Make a sketch** of the final composite on tracing paper by putting each negative in the enlarger separately and loosely tracing the portion of the projected image that will appear in the final print. Make the tracings the same size as the final image will be. Align the two tracings and tape them together.
3. **Attach a clamp-on filter holder** to the enlarger lens.
4. **Align and focus** the first negative on an easel, using the tracing as a guide.
5. **Slip the red safe filter** partially into the holder, blocking only the portion of the negative to be faded out.

6. **Slip a piece of thin-base litho film** into the easel. Be sure the film is large enough to cover the *entire* area of the finished print.
7. **Expose, process, and dry** the first print.
8. **Position the second image** by using the first film print and the tracing as a guide.
9. **Set the filter** again to block the part of the image that you do not want to print.
10. **Expose, process, and dry** the second film.
11. **Sandwich the two film prints.** The success of the blend will be immediately apparent. If you are working with relatively symmetrical subject matter, you can minimize the loss of sharpness by laying the film prints together emulsion to emulsion. If using one image backward is undesirable for aesthetic reasons, they can be sandwiched emulsion to base. Either way, there will be multiple levels of emulsion. The thin-base film will help reduce any problems that might result.
12. **Attach the two film prints** with tape.
13. **Contact print** to a piece of regular high-contrast film to produce the final negative. Process and dry.
14. **Retouch the negative** and make the final print on paper.

A. The bottom of this film positive was intentionally blocked by a red safe filter held under the lens of the enlarger. The filter was held close enough to the lens to create a transitional fade in the grass area in front of the trees.

B. The top of this film print, made from a different camera negative of a different field, was blocked by a red safe filter for the same purpose. Both of these images represent final-sized enlargements made on thin-base litho film.

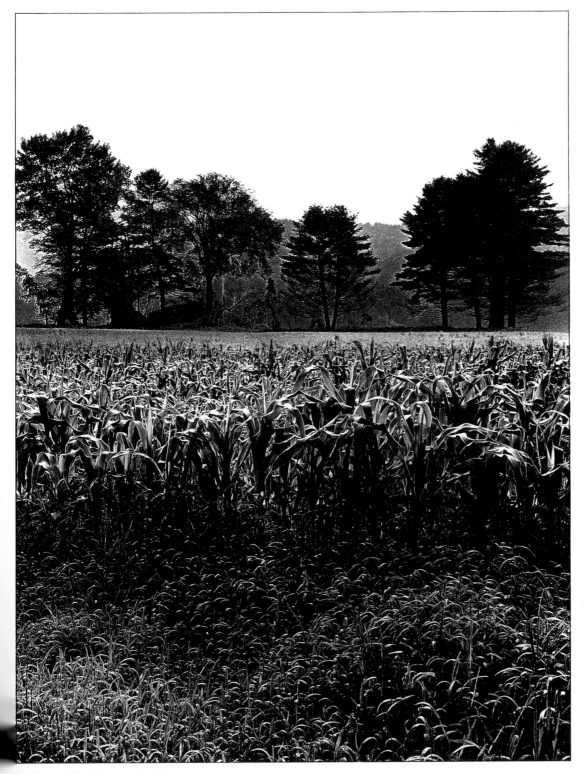

C. The two litho film prints on the facing page were sandwiched together to create a combination image. A contact negative was made of the combination and used to produce this print.

The Process Mask

The "process mask" is used to combine the foreground subject from one negative, with the background from another. It is the most complex process covered in this book. But it is not quite as difficult as it looks. This technique is recommended for montages involving complex backgrounds for which neither stripping nor blending is practical. It creates a specific, clear area in the background film. The foreground subject is contact printed into that space. Skill in handbrush work is necessary to accommodate anything but the simplest shapes.

Enlarge both the foreground and background images to their final size on litho film. Select a foreground object that has been shot against a white background (sky, snow, white paper backdrop, etc.). To avoid having to retouch cut lines, print this object on the litho film in the approximate position that it will occupy on the final print. (There should be a clear field of film surrounding the object equaling the total size of the final print.) When this piece of film is dry, completely opaque out the object on the base side forming a precise silhouette mask. Contact print this masked print with a negative litho film print of the selected background. The resulting film print is a positive background with a clear space left for the foreground image.

After the mask has been contact printed with the background negative, tape the film to a clean surface and, using a damp cloth, carefully wipe off the opaque. Dry the film and then register it to the prepared background film positive. Tape the pieces together with transparent tape and contact print them to litho film to produce the final negative.

There will be a near perfect match if you have skillfully opaqued the foreground object. Small imperfections surrounding the foreground image can be retouched by scraping and stippling. The final negative is then ready for contact printing on photo paper.

Continuous-tone print of a chair covered with a striped sheet made from the original camera negative.

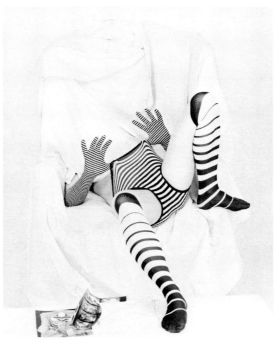

Continuous-tone print of a model posing in striped clothing on the chair. The chair and the model's head were covered with a white sheet to simplify retouching. Both continuous-tone prints on this page are shown as reference only. They were not used in the process.

A. *Litho film positive* enlarged directly onto final-sized litho film from the camera negative.

B. *Litho film negative* made by contact printing the litho positive (A).

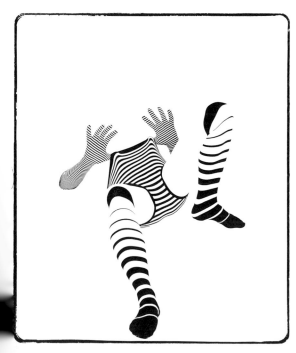

C. *Litho film positive* of the model enlarged directly onto final-sized litho film from the camera negative. All remaining traces of tone were cut out or scraped off the film, so that only the image of the clothing remained.

D. (C) *Litho film positive.* The image area has been carefully painted over with opaque on the base side.

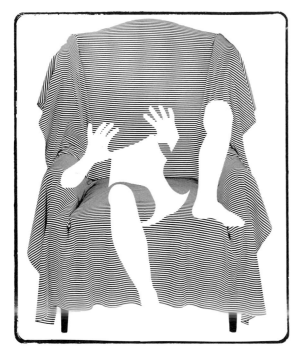

E. *Litho film print* made by contact printing a sandwich of
the chair negative (B) and the opaqued model positive (D).

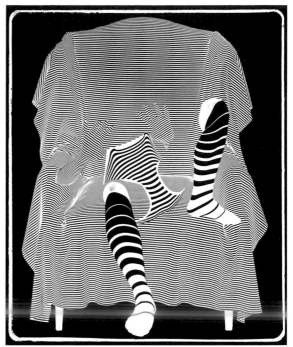

F. *Final litho negative* contact printed from a sandwich of
the chair positive (E) and the positive of the model (D) after
the opaque has been removed.

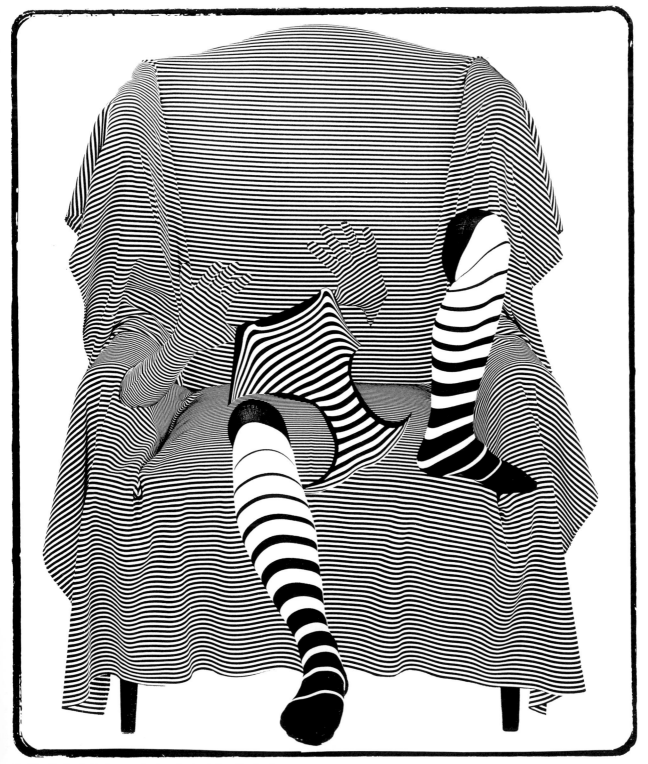

G. *The final print* is the result of contact printing the final litho negative (F) on photographic paper.

Combining a Screen and a Tone Line

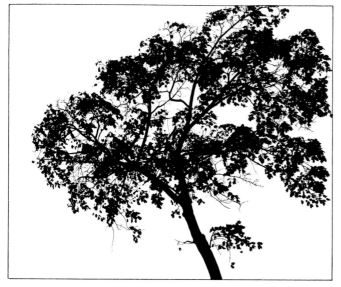

A. *Litho film positive* enlarged from a camera negative.

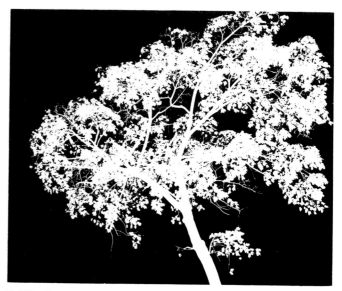

B. *Litho film negative* made by contact from litho film positive (A).

Combining a screen and a tone line. Litho tone-line film images can be readily combined with screens as shown by this combination of a tone-line (see page 60) image of a tree with a homemade random dot screen. This particular technique will work most successfully with silhouetted subjects.

D. *Screen* made by spraying dense black ink on clear acetate.

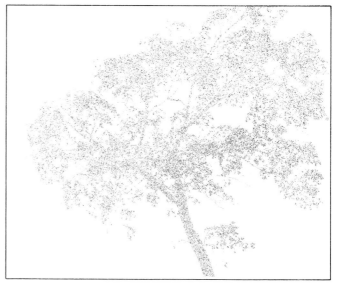

E. *Screened positive* made by contact printing a sandwich of the litho film negative (B) and the screen (D).

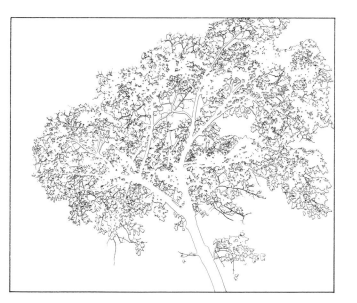

C. *Tone-line positive* made by combining the litho film positive (A) and the litho film negative (B).

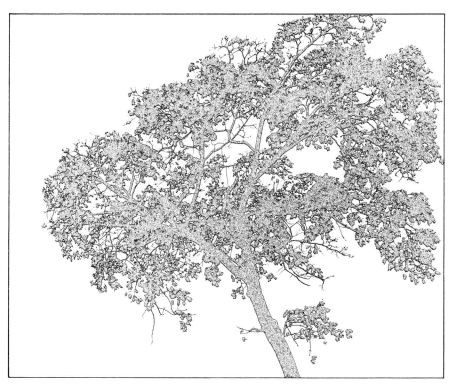

The final print. A contact negative was made from the sandwich of the tone line (C) and the screened positive (E). That negative produced this print.

A Pattern as an Automatic Masking Device

One high-contrast image can be neatly inlaid into another by a masking process that uses corresponding positive and negative film prints of the same pattern. The principles are the same as for the process mask (see page 186). The difference is that the positive film pattern is used to mask one image while the negative pattern masks the other. The two resulting film prints fit together, interweaving parts of both images. The pattern of the mask will determine the breaking lines between the two images. The finished print will look as though small pieces from two separate photos were meticulously cut apart and pasted back together. The success of the resulting image depends on the visual relationship between the two images and their compatibility with the pattern that joins them.

1. **Make final-sized enlargements,** of the two images that will be combined, on regular litho film. Process and dry.
2. **Make contact negatives** of the two enlargements on thin-base litho film.
3. **Retouch** the two contact negatives.
4. **Make a positive pattern mask.** Use a piece of orange plastic mask (or black paper) that is the same size as the contact negatives made in step 3. Cut the desired shape from the orange plastic sheet. This sheet with the piece removed will be used as the positive pattern mask.
5. **Make a negative pattern mask.** Use a sheet of clean acetate that is the same size as the positive pattern mask. Take the piece that was cut from the orange plastic to make the positive pattern mask and attach it with rubber cement to the acetate. It should be positioned so it corresponds to the space left in the positive pattern mask. This sheet of acetate will be used as the negative pattern mask.
6. **Sandwich one of the image negatives with one of the pattern masks** and tape them together. Work on a light table and use the first sandwich as a registration guide to position the other negative with the remaining pattern mask.
7. **Make a contact print** of each of the sandwiches on thin-base litho film, process, and dry. This will produce two positive prints that register when overlapped.
8. **Register the two positive film prints** and tape them together.
9. **Make the final contact negative** by contact printing this last sandwich, emulsion to emulsion, on regular litho film. The final print is made from this negative.

More complex patterns from drawings, wrapping paper, or other materials can also be used to make pattern masks. The pattern is photographed and then enlarged on litho film. This enlarged litho film positive and its corresponding negative, made by contact printing, form the positive and negative pattern masks.

For other pattern ideas see the section on backgrounds (page 201). Some patterns can be copied using the lithogram method (see page 52). Others can be shot by using your enlarger as a process camera (see page 234). High-contrast photographs can also be used as patterns.

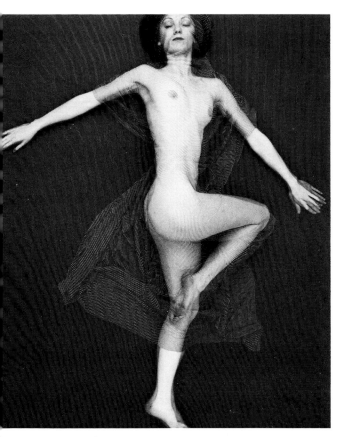

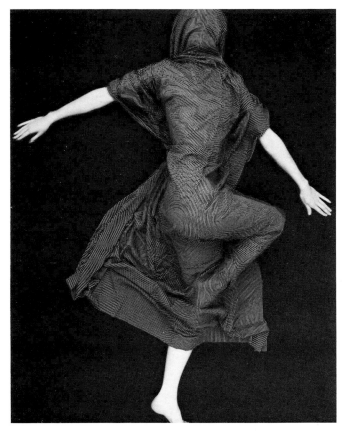

Continuous-tone print from the first of two base negatives selected to be combined on the next page. The negative was double-exposed in the camera. The camera was mounted on a boom as a model posed beneath on a large piece of striped fabric. The fabric was rearranged over the model for the second exposure. The resulting negative was enlarged through frosted glass (see page 90) on to a 4x5 sheet of litho film. The 4x5 positive was then enlarged to the final-sized litho negative.

Continuous-tone print made from the second base negative. The film was advanced after the first double exposure (opposite), but the model retained the pose. The first exposure for this negative was identical to the second exposure of the print opposite. The model then shifted position very slightly and the second exposure was made over the first. The second exposure was intended to cause a slight shift in the alignment of the fabric and a slight blurring of skin areas. The resulting negative from this double-exposure was also enlarged through frosted glass on a 4x5 sheet of litho film. The 4x5 was then enlarged to a final-sized litho negative. Both continuous-tone prints on this page are shown for reference only. The paper prints themselves were not used in the process shown on the next page.

The Process Mask: A Pattern as a Masking Device, cont.

A. *Negative pattern mask* was made by cutting out an "L" shape piece from a larger piece of orange mask (black paper works almost as well). The cut-out space functioned as a window through which to contact print.

B. *Film image produced by mask.* The negative pattern mask (A) was laid over the final-sized litho negative (not shown). The resulting contact print was an image that could be photographically "inlaid" with the image below.

C. *Positive pattern mask.* The "L" shaped piece of orange mask cut from the negative pattern mask above was attached with rubber cement to a sheet of clear acetate.

D. *Film image produced by mask.* The positive mask (C) was laid over the other final-sized litho film negative (not shown), and contact printed. That contact produced this film image.

DREAMSTAGE #202, 1979
The final print made from the negative produced from the
combination of film images B and D. The two base images
for this montage (page 193) were planned to be used in
this combination when they were shot. The actual shape
and size of the mask were determined after the camera
negatives were made and studied.

VARIATIONS ON THE PATTERN MASK

There are an endless number of variations to the pattern mask process. If the basic pattern masks differ in total amount of clear area, one image can be made to dominate the other by contacting its negative to the pattern mask showing the most clear area. Once the pattern masks are made, they can be applied to any two high-contrast film prints that you have. Positives can be combined with negatives. The same base image can be contacted through both pattern masks. It can be used upside-down or backwards for one mask, and in its normal orientation for the other. Lithograms can be combined with lens images, tone lines with lithograms, photographs with drawings, and so on. The more work you have done with the high-contrast process, the more material you will have to experiment with.

The actual configuration of the pattern masks can be as simple as a small square inside a larger square, or as complicated as a marbleized pattern. Three or four masks could be used instead of two. The best results are likely to be produced from a planned effort rather than chance experiment. Shots can be taken that are specifically designed to fit together in a predetermined pattern.

A. *Litho image positive.* A photograph of a chocolate rabbit mold enlarged to final size on litho film.

D. *Litho film negative* made by contact printing the litho image positive (A) to another sheet of litho film.

B. *Litho pattern positive.* Made by painting in random squares on a piece of graph paper. The original grid was then photographed and enlarged to final size on litho film.

C. *Masked image negative.* The result of sandwiching the litho image positive (A) with the litho pattern positive (B) and contact printing.

E. *Litho pattern negative* made by contact printing the litho pattern positive (B) to another sheet of litho film.

F. *Masked image positive.* The result of sandwiching the litho film negative (D) with the litho pattern negative (E) and contact printing.

(continued on next page)

The Process Mask: A Pattern as a Masking Device, cont.

CHOCOLATE RABBITS, 1980
The final image made from the negative produced from the combination of the masked image negative (C) and the masked image positive (F). The checked mask was used to separate the image into interlocking positive and negative components.

SCOTT HYDE: *Modern Business*, from *The Real Great Society Album*
This composite was made from three original negatives.
The two street shots were combined using a masking tech-
nique similar to the one described here. The Modern Busi-
ness logo was used as a device to join the images.

CADETS, 1978
The two base negatives for this print were a silhouette shot
of some paper dolls and a photograph of a cloud formation.
Final-sized litho film prints were made of both negatives.
The sky was enlarged through frosted glass (page 90). The
enlarger lens was moved up and down during the exposure
to produce a zoom effect. Contact negatives were made of
both enlargements. One of the sky film prints was sand-
wiched with the positive paper doll film print and the other
sky film print was sandwiched with the negative paper doll
film print. These two sandwich combinations were contact
printed to litho film to make the film prints that were sand-
wiched together and contact printed to make the negative
for this print. When the last sandwich was taped together,
it was purposely shifted slightly out of register to create se-
parating lines between the foreground and the background.

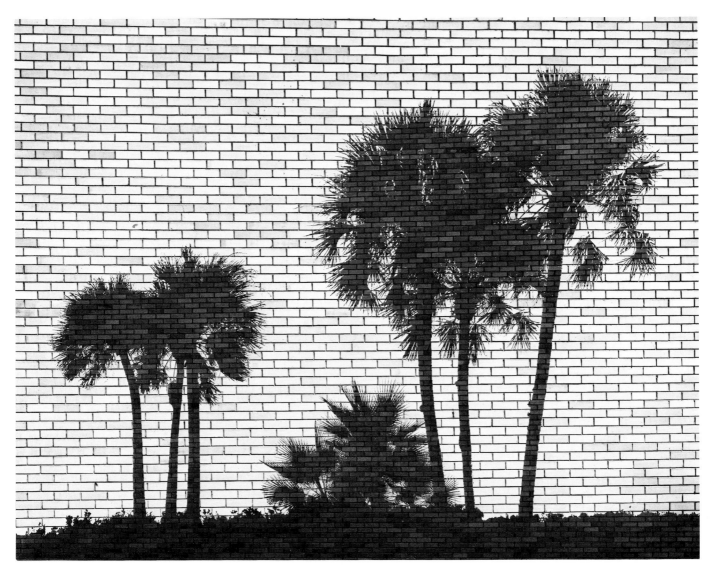

OSCAR BAILEY: *Florida*, 1972
A variation of the pattern mask technique was used to produce this print. Bailey used 14x17 inch corresponding positive and negative litho film prints of tree shapes to make this composite. The positive tree mask was placed in contact with conventional enlarging paper and a continuous-tone negative of a brick wall was printed through it. Then the positive mask was removed and the negative tree mask was placed over the same piece of photo paper. A different brick wall negative was exposed through this mask. The result is a continuous-tone all-brick landscape.

Approaches to Image Building

If you have never done a photomontage, it is best to begin by combining images from negatives that you already have. Selecting the images, and the process that joins them, will give you a degree of creative control.

A photomontage can also be made using images that have been photographed specifically for it. A sketch should be made, in advance of taking any photographs, showing the design, the various elements that will be needed, the camera angles from which these elements should be shot, and how they should be lit. Use the sketch like a script when shooting. In this way, most of the variables can be brought under direct control. Each detail in the production of the photographs is designed to accommodate the final photomontage.

You can also make a photomontage by starting with existing negatives and shooting new photographs to supply any additional elements that are needed. An existing negative of a potentially interesting background for a montage may need foreground elements that will have to be specifically photographed for it or vice versa.

The following are some approaches for gathering montage images.

BEGINNING WITH A BASE NEGATIVE

When you find a base negative that has potential for composite use, try to determine the most appropriate elements to add to it to make an effective montage. Search through your contact sheets. If it becomes apparent that you will have to shoot these additional elements, print the negative you do have and use it as a reference as you shoot. This will help you match camera angles and lighting for compatibility.

ARRANGING ELEMENTS FROM ONE ROLL OF FILM

Shoot one (or more) rolls of film of the same type of subject matter under the same lighting conditions. This will give you a collection of images that can easily be arranged into composite photographs. Because they are shot at the same time, the pieces will look like they belong together. Suitable subjects for composite work can be found at air shows, at the beach, in the desert, in the snow, along the side of the highway, in junk yards, and in many other places.

BUILDING A LONG-TERM COLLECTION

Designate a portion of your general picture-taking as "catalog shooting." Photographs can be shot and collected for future use in composite images. Over the years you can build up a vast collection of raw material for various types of montage work. This approach makes shooting an extremely enjoyable experience. There is no pressure to capture a great photograph in a single frame; instead, you are making a collection of fragments to be rearranged at your leisure.

Most photographers have strong hunting and collecting instincts. Collecting photographs of neon shoe repair signs, or manhole covers, or silhouettes of trees can have a sustaining fascination while providing an ample supply of new material for photomontages. The longer you shoot with the montage idea in mind, the more material you will have to draw from and the more original your images are likely to become.

SCOTT HYDE: Untitled, from *The Real Great Society Album*
Two photographs were superimposed to form this collage. The images were made from separate 35mm negatives exposed specifically to become part of this series. Tri-X film was exposed at an Exposure Index (E.I.) of 125 and developed 40% less than the normal time. A green film inspection safelight was used to flash the camera negatives prior to development. The camera negatives were then enlarged on 4x5 sheets of litho film, which had been flashed prior to the exposure. Hyde used a technique similar to the one described earlier (see page 88). The film prints were still-developed in Fine Line Developer (see page 86). He determined the final arrangement by overlapping several different film prints as he viewed them on a light table. The final step in making the composite negative was to print the selected film prints, in combination, on a single sheet of 4x5 litho film. He usually does this by sandwiching the positives together and contact printing them. When critical detail is involved, Hyde will expose each image separately onto a single sheet of litho film. This print was made directly from the final negative.

SCOTT HYDE: *Caddie*, from *The Real Great Society Album*
The car and the decoration were joined in a film collage using a technique similar to the one described above. These photographs are from *The Real Great Society Album*, Bayonne Publishing Co., Jersey City, N.J.

Backgrounds for Photomontage

Backgrounds: Suggestions

A practical approach when planning composite work is to first separate component materials into background and foreground subject categories. Sometimes you will complete the background first and then strip-in or mask-in the subject or foreground materials. On other occasions, you start with the foreground subjects and find an appropriate background.

Many of the backgrounds suggested on this page can be photographed and converted to litho film using any one of the methods described in this chapter (see pages 227–239). Complex backgrounds can be constructed in the studio or even in the darkroom using contact printing and retouching processes.

enlarger blended images (See page 184)

faded grain (dark to light or vice versa)

naturalistic pattern or texture

geometric pattern*

water

real or fake sky

drawings

photograms

blank forms for sheet music

blank industrial or medical reports

grid paper (printed in black ink)**

targets

wrapping papers

wallpaper samples, dollhouse wallpaper

commercial envelopes (inside privacy patterns)

marbleized endpapers in old books

decorative theme notebook covers

plywood

artist's pattern screens

fabrics

* Several inexpensive, copyright-free, paperback books of patterns are available from Dover Publications Inc., 180 Varick Street, New York, N.Y., 10014.

** You can buy rolls of grid paper, 30 inches wide and 100 feet long, from Creative Publications, P.O. Box 10328, Palo Alto, California, 94303.

FOUR PALMS, 1978
The figure was shot against a white backdrop. A print was
made of the model on litho film and stripped together with
positive and negative tone line prints of a toy palm tree.

Shooting for Compatibility

The best photomontage pieces are usually made
from negatives that were shot specifically or ten-
tatively for that purpose. Successful shooting for
photomontage demands control over the compa-
tability of the various component parts of the
image. There may be many occasions when you
choose to violate this compatability purposely,
but the following factors should be considered
carefully:

Camera angle and lens perspective

Background

Shadow orientation

Contrast

Focus and depth of field

Camera format

Scale

Type of film and processing

These technical considerations, plus design
and all perceptual and conceptual considera-
tions, function together to determine the success
of various combinations of subjects and back-
grounds. Many of these factors can be controlled
when you specifically make images for compos-
ite use.

Artist's pattern screen.

A pattern created by the overlapping of two artist's pattern screens.

Marbleized end paper.

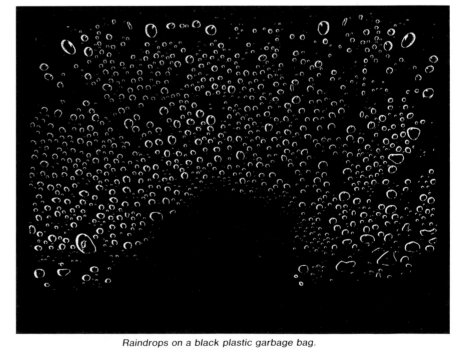

An iron plate.

Raindrops on a black plastic garbage bag.

Skies as Backgrounds

FOUND SKIES

The sky is a good source of background material for photomontage. Skies can be rendered fairly realistically (see pages 120–123), or they can be intensified to the extreme. With the help of polarizing and red filters on the camera, a deep blue sky with light clouds can be turned into a black sky with stark white clouds.

A sky image on a litho film positive can be printed onto photo paper. This will reverse the orientation, producing black clouds against a white sky. If you want a grainy sky, it will help to enlarge the negative onto litho film through a piece of frosted glass (see page 90).

FAKE SKIES

If the appropriate ready-made sky isn't available, one can be modified from an ordinary sky negative. You can enlarge through frosted glass and zoom the enlarger in and out of focus rapidly during the exposure, to create an explosive effect. You can also burn and dodge, blend or fade. Totally new cloud formations can be created by stripping together clouds from different negatives. Make two identical film enlargements (dark clouds against a clear field) on thin-base film, tape them together, emulsion to emulsion, to make a symmetrical "monster" sky. Positives and negatives of different skies can be overlapped. If you are interested in skies as major components in montage work, begin shooting cloud formations everywhere you find them. It might take a year to build up a good collection, but once you have the basic shots, they can be reassembled in endless numbers of new combinations.

MAKING YOUR OWN CLOUDS

Cloud formations can be simulated by squirting concentrated black ink into a tray of water. Take a large, glass baking dish or a clear, glass tray and place it over a light box or arrange it in some other way to get an even light beneath it. Set the camera on a tripod directly above the dish (see page 228). Pour enough water into the tray so that it is about .6cm (¼-inch) deep. Dip the end of a straw or eye-dropper into the ink. (The ink is held in the straw by covering the other end with your finger.) Release the dye into the water in carefully controlled amounts. As the straw is slowly moved, the dye will swirl and make cloudlike formations. The water must be changed after each shot. Meter from camera position, and add 1 or 2 stops. You may want to push the film to increase the contrast (see page 100). Try varying the light under the dish to simulate the horizon. The image can be used as either a positive or negative.

MAKING YOUR OWN STARS

You can make stars to add to a sky by punching holes in a 30x30cm (12x12 inch) piece of black construction paper, putting a light behind it and photographing it out of focus. Be sure to keep any stray light from falling on the front of the paper. Varying distances can be simulated by making three or four exposures on the same negative in the camera. Change the focus for each exposure and add a few new punch holes. If you rotate the paper each time, it will put the stars in different positions. You can also try turning the lens in and out of focus while making a slow exposure. To make stars with long, flare points, use a special filter that has a built-in mesh of tiny nylon filaments that draw the light out into points. This effect can be improvised by shooting through a fine screen of a light-colored stocking stretched tightly over the lens. Stars and cloud formations can be combined into the same image in the darkroom by sandwiching them together in their negative litho states and making a contact print.

Backgrounds for Photomontage: Skies, cont.

SKYDREAM #6, 1979
A large heart was torn from white, seamless backdrop paper.
It was placed on the floor of the studio over a large piece of
black backdrop paper. The model posed between the layers,
pushing her arms and legs through the top sheet of paper. It
was shot with the camera mounted on a boom (see page
148). The sky was added in the darkroom using the process
mask technique (see page 186).

SKYDREAM #9, 1979
A similar technique was used to add make this image. Be-
cause the area where the sky was to be added was black
rather than white, it was necessary to mask in the sky while
the image was in a negative state.

Miniature Hollywood Sets

Several of the photographs in this book (pages 214–215) make use of miniature sets as backgrounds. It is easy to combine life-sized subjects and miniature backgrounds using litho film. In most of the composite processes, both the foreground and background components are originally recorded on the same format negative. This reduces all subjects to approximately the same scale; final adjustments are made when these separate components are enlarged on litho film. After the components are enlarged, they are combined using either the stripping or process mask technique.

Sets are usually constructed to either dollhouse scale or smaller model-railroad scale. The size you select will depend on the coverage of your lens and the anticipated use of scale model props. The larger dollhouse-size set is easier to build and shoot, but there are many intriguing props available for model-train setups.

A 35mm camera is marginally adequate for most miniature set photography. A medium-format camera equipped with a bellows and a slightly wide-angle lens will produce the most realistic effect.

A simple miniature room can be easily constructed. Foam board works well as wall material because there is little warpage and it will stand by itself. Wall sections are cut with a mat knife and hinged together with wide tape. The floor is an oversized piece of foam board. The wall sections stand on top of the floor section. If you avoid attaching the wall to the floor, the angles of the walls can be changed at will to accommodate different effects. A removable ceiling is also useful. Wallpaper, if desired, is pasted to the board. Ready-made window sections, printed on heavyweight acetate, can be purchased in toy stores carrying dollhouse supplies. You can also make your own windows from scraps of litho film. After hanging the wallpaper, cut rough openings for windows; and glue them over the openings, on the camera side of the room. Because you can see through the windows, you can create exterior lighting effects; or have subjects placed outside the room itself.

A large, broadly diffused flood lamp works well to illuminate the room. Place it quite close for most shooting. The most natural effect is achieved when the light is placed just above the lens of the camera. If the ceiling panel is in place, the light will have to come from one or both sides of the camera. Light can also be placed behind the set to illuminate the windows. It can be bounced off a white backdrop, or a slide projector can be used to simulate sunlight drifting into the room. It is even possible to project a slide onto the white backdrop, creating a view through the windows.

The side walls can be pushed out at an angle so that all the walls, the floor, plus a bit of the ceiling can be included in the shot. You can shoot straight into the room or rearrange the walls to give the effect of shooting into a corner.

Dollhouse furniture can be arranged right in the set or full-scale furniture can be photographed separately against a white backdrop and masked in later. If you are combining scale and want a more realistic effect, be sure to match lighting and camera angles.

If a lot of time is spent building a set, it is good general practice to take half a dozen "stock" shots of it from different angles for possible future use. The set can be folded up and stored away, but it will never look as good as it did on the day it was made.

A wide-angle lens was used at close range to give this miniature set a realistic appearance. The lens is shown here set level with the set. If the camera had been raised or lowered and the lens tilted downward or upward, it would have increased the fantasy effect. One of the advantages of using a wide-angle lens at close range is that the photographer can reach into the set and arrange the miniature flats and furnishings while looking through the camera. There are many ways to light a small set, including the use of operative miniature lamps and wall fixtures available for dollhouses. In this example, a large diffused lamp was positioned at close range to provide even light. There was enough light so that an aperture of f/32 could be used for maximum depth of field. This was the basic lighting setup used for the examples on the next two pages.

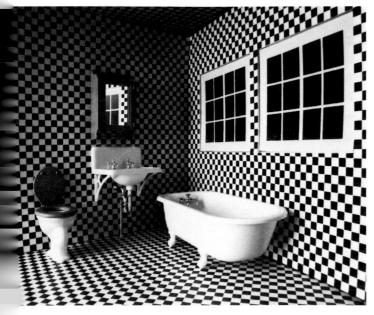

The walls in this miniature set are made from gift wrap paper pasted on 30cmx30cm (12x12 inch) foam-board panels hinged with tape. The windows and fixtures are plastic dollhouse props. Nothing is permanently attached. The walls as well as the furnishings can be instantly rearranged.

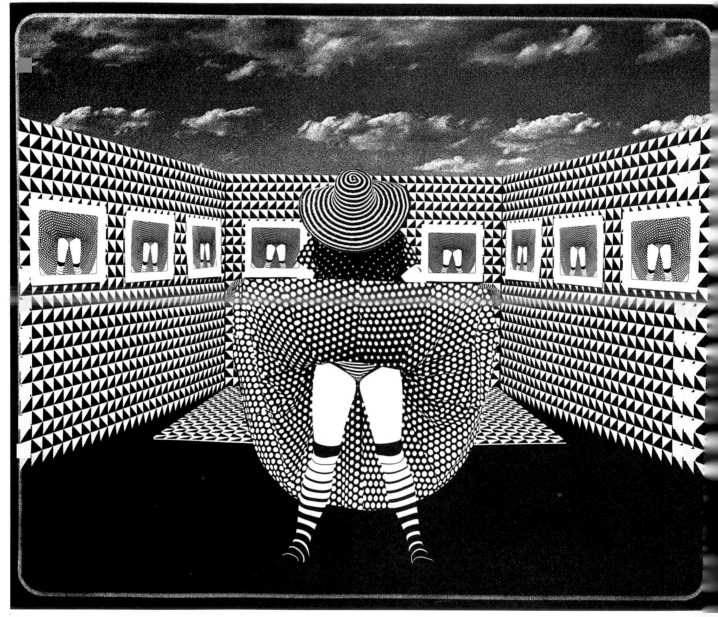

GALLERY, 1979

This image was inspired by an earlier photograph: the print hung on the walls of the set. The foreground figure was shot against a white backdrop. A small set was constructed, 1 inch to 1 foot scale (see page 213), and decorated with postage-stamp-sized prints. The empty set was photographed with a wide-angle lens. The figure and the sky were added later using the process mask technique.

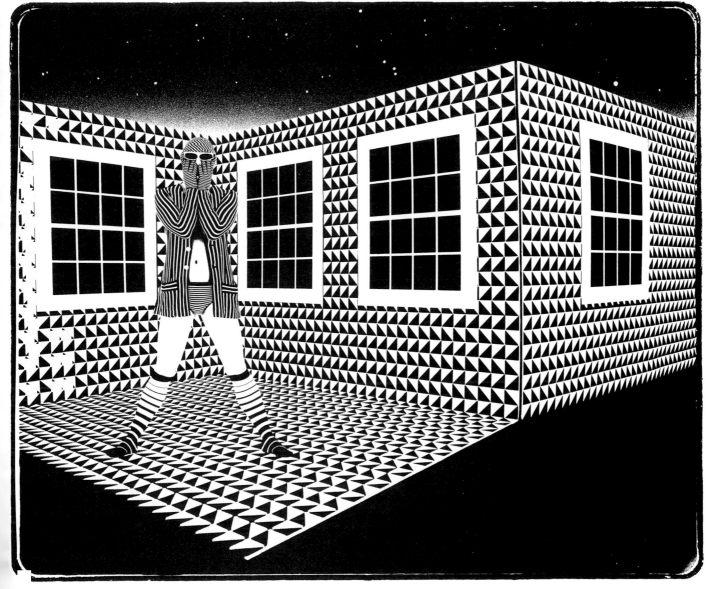

ALL DRESSED UP AND NO PLACE TO GO, 1979
The background on both pages is the same miniature set.
For this shot the angle of the walls was changed and doll-
house windows were added. The figure and the sky were
masked in.

Examples of Photomontage

BETTY HAHN: *Lone Ranger #29*, Serigraph, 18x24, 1977

BETTY HAHN: *Starry Night Variations #2*, 4-color serigraph,
18x24, 1977

Examples of Photomontage, cont.

Charles Swedlund has revived an antique visual curiosity, the Phenakistiscope, to form the basis for this unusual approach to photomontage. The Phenakistiscope, a parlor toy, was invented by J. A. D. Plateau in 1832. Stampfer, working independently, came up with a similar device, called a Stroboscope, at about the same time. Both utilize the principle of persistence of vision, enabling one to see the illusion of motion. The disks shown above were printed on card stock and dye cut. The disk is placed on a spindle with its back side toward the viewer and its image side facing a mirror. The image is viewed in the mirror by looking through the slots in the disk as it spins. The number of slots must equal the number of images on the disk. The slot passing the eye permits a very brief glimpse of the image seen in the mirror. One glimpse is quickly replaced by the next, conveying the impression of motion. The speed of rotation and the distance between the disk and the mirror are factors that affect the quality of the illusion.

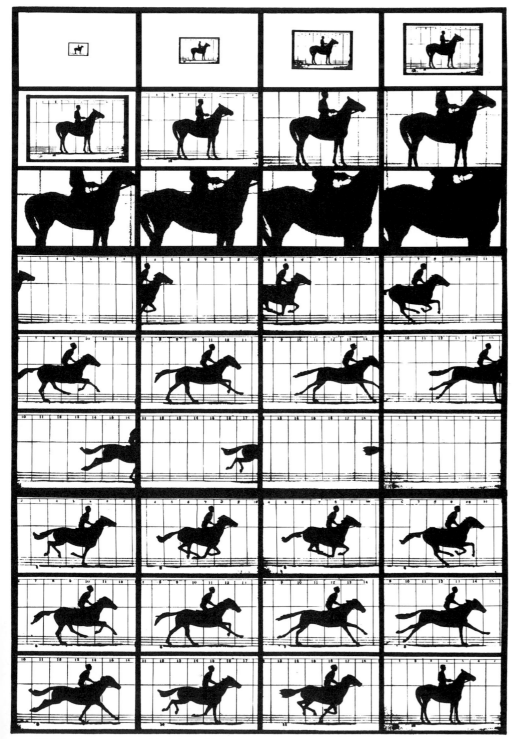

PIERRE CORDIER: *Homage to Muybridge,* 1972

Examples of Photomontage, cont.

NAOMI SAVAGE: *Catacombs,* photoengraving, 1975
A selection of 4x5 portraits on 8x10 contact paper was the starting point for this image (part of a larger series). The original prints (contact sheets) were cut apart with scissors and the subjects separated from their backgrounds. The background pieces became the main components of a collage which was contact printed to a sheet of high-contrast photo paper. A litho film contact was then made of this paper print and was exposed to a thick, photosensitized, metal plate. The plate was then developed in a photo resist developer. The resist pattern that remained after development, protected parts of the image while the other areas, left unprotected, were deeply engraved or etched with acid.

NAOMI SAVAGE: *Roman Profile,* photoengraving, 1967 ▶
This image was originally taken from a continuous-tone negative of a profile portrait. Litho film was used to convert it to a high-contrast image, which was then engraved into a 1.5mm (1/16-inch) metal plate. The plate was painted with black and white paint, an aesthetic as well as a practical decision. Left unprotected, the plate would eventually corrode. The thick outlines resulted from the response of the engraving process to the film image. The effect is enhanced by the paint and by the shadow created by the deep etch. Naomi Savage made the image reproduced here by rephotographing the completed plate.

Examples of Photomontage, cont.

RAY K. METZKER: Untitled composite, 25½x20, 1966,
Collection, Chicago Exchange National Bank

RAY K. METZKER: Untitled composite, 29¼x35, 1967,
Collection, Chicago Exchange National Bank
Ten 35mm camera negatives of models posing in the studio
were involved in the generation of this composite image.
Positive and negative litho film prints were made from the
original negatives. These small pieces of film were then
printed together by contact to form larger units or modules.
Each module graphically integrated bits and pieces of positive
and negative forms. Metzker made a large number of paper
prints of each module and mounted them together, forming
the completed piece.

Paste-up Photomontage

THE MOTORIZED UNDERWATER TROUT CAMERA, 1976

The "paste-up" photomontage has been around since the early days of photography, but the greatest interest in the process was demonstrated in the 1920's and 30's by artists Man Ray, Laszlo Maholy-Nagy, John Heartfield, Hannah Höch, Herbert Bayer, and several others. The technique used by Heartfield was typical. Instead of depending on the multiple printing of separate negatives, Heartfield combined previously printed materials from magazines, newspapers, and other sources with photographs that were shot and printed for him. He cut the paper images apart and recombined them, attaching each piece to the background. The completed montage was then photographed on continuous-tone film. Some retouching was done before the photograph was taken but most was done on the large-format copy negative.

The print at left was made using this classic photomontage technique. The only difference is that it was photographed directly on litho film to retain the original character of the engravings. The individual elements that make up the fish camera were taken from old and new fishing, photography, and automotive catalogs.

Collecting Materials

Printed materials for the paste-up can be gathered from a multitude of sources. Obviously, the more of this kind of work you do, the larger your collection of raw material will become. Previously screened halftone or high-contrast images can be taken from books, newspapers, and catalogs. Use the techniques described in this chapter to make high-contrast copy negatives. After you make a copy negative, make one or more prints of it to the exact size that you will need for a particular composition. This makes it possible to use the image, while preserving the original.

Many artists prefer to work on several compositions simultaneously. After each working session a piece of glass is laid over the work to protect it.

Sources of Printed Materials—Suggestions

old magazines, books, and catalogs*

reprints of old magazines and catalogs

auto parts catalogs

photography catalogs

old seed catalogs

old catalogs of stock cuts**

circus and carnival posters

underground newspapers

old and new postcards

rubber stamps

strings, threads, and ribbons

natural materials

industrial diagrams

dials and gauges

greeting cards

tattoo patterns

model airplane decals

blank labels, tags, and decorative labels

reprints of paper toys and soldiers

comic books

stencils

old mats for newspaper advertising

family snapshots

* There are hundreds of strange catalogs that you can obtain through the mail; many have illustrations suitable for montage work.
** Available from newspaper advertising offices.

Trimming Out and Arranging the Pieces

Use scissors to cut out the individual fragments for the montage. A razor knife may be used to trim out small interior islands. Some montage artists prefer to use the very tips of trimming scissors for intricate cutting. Others work with dressmaking shears and use the inside area of the cutting edges (see illustration). Keep your cutting instruments as sharp as possible. Dull blades tend to cut ragged edges or crease the paper.

When cutting, look for natural areas of division between one subject and another. Certain areas, where there is a lot of fine detail or where one subject fades into another, are impossible to separate neatly. You may be able to cover up or camouflage these areas when the composition is pasted up. As you trim each piece, lay it into a tentative position on the illustration board base.

Actual cutting area

Some composite artists prefer to use the tips of trimming scissors to trim out fine detail; others work with medium-sized shears and cut with the inside area where the blades cross.

Holding the Pieces in Place

Once the pieces of the composition are in their final positions on the board, the work must be secured. Individual pieces can be pasted into position permanently or held temporarily in place by a sheet of glass just long enough to be photographed.

There are several types of adhesives that can be used to attach the pieces to the board. The most common is rubber cement; unfortunately, it stains paper yellow after only a few months. If you want to keep the original paste-up for any length of time, use small amounts of a stable adhesive such as library paste to secure the pieces in place. One of the most convenient adhesives is a hot wax used by layout designers in commercial art. A thin layer of melted wax is applied with an electric roller to the backs of the pieces to be pasted down. The pieces will stick to the board when applied with a little pressure. The advantage of the wax method is that it allows you to peel off and reposition the pieces with little trouble. Unfortunately, the waxer is a little difficult to use on very small pieces because they adhere to the roller and continue on their way into the waxer, never to be seen again.

Pasting work down permits you to retouch right on the original piece with a fine-point technical pen or sable brush and dense black ink. Ink will not stick to most adhesives, so be particularly careful to keep the adhesive on the back side of the individual elements. The technical pen is also a good instrument for adding your own drawing to the montage. Since the composition will be photographed, much of the retouching can also be done directly on the positive or negative litho film states.

Adhesives can be avoided altogether if the individual pieces of the montage are not glued, but are held in place under the camera by a clean sheet of glass. The glass will not cause a reflection if the copy lights are positioned correctly. This technique also allows for rearrangement of the subjects before and after shooting, thus providing an opportunity to record a sequence of individual shots that can be shown as a series. Three-dimensional objects can also be added to the montage if they are relatively flat.

Shooting the Photomontage

There are three basic methods of recording the montage on film. The montage can be photographed on continuous-tone film and then converted to litho film by enlargement. The least involved method is to take the photomontage to a printer who can shoot it directly on litho film with a large process camera. The third method, however, is preferable for many types of work. The montage is shot directly on high-contrast litho film using your enlarger as a camera.

MAKING A COPY SHOT WITH YOUR OWN CAMERA

Mount your camera on a copy stand equipped with a camera column and built-in lights. Measure the light, using an incident meter or a reflected meter with a gray card, and then shoot. Pushing normal-speed, continuous-tone film, 1 to 2 stops, will keep the copy from graying out without losing detail. If the montage is smaller than 25x30cm (10x12 inches) close-up equipment is required. If a macro lens is made for your camera, it will be ideal for this type of work.

Medium- or large-format cameras produce superior negatives, but a 35mm camera is adequate for most purposes. If a copy stand is not available, you can use the camera on a regular tripod and project two floodlights at 45-degree angles to the montage. A montage that has been pasted into position can be attached to the wall and shot vertically. Loose pieces, however, must be held flat under glass. This necessitates suspending the camera above and shooting the montage beneath. Do this by extending the tripod legs, reversing the center post, and mounting the camera, lens down, between the tripod legs.

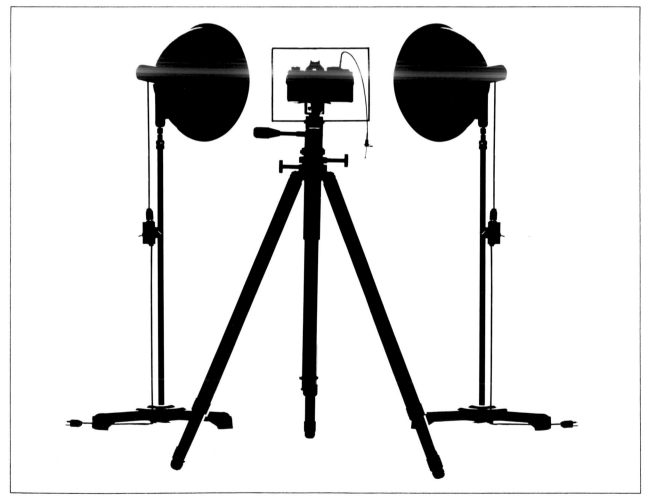

Setup for shooting copy vertically. Two lamps of equal output should be set equidistant from the tripod, directed at 45-degree angles to the copy. They should be adjusted until there is an even amount of light falling on the copy.

Handling the montage is less difficult this way, but it is awkward because the floodlights must also be positioned between the tripod legs.

After processing, the continuous-tone negative is enlarged on litho film, retouched, and contact printed to produce the final negative.

This technique utilizes time and materials inefficiently. Use it only when there is no other practical way, or when there is a high proportion of continuous-tone or three-dimensional material in the montage.

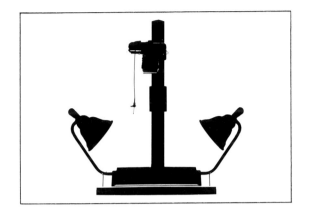

Standard copy stand.

The center post of most tripods can be reversed and the camera mounted lens down, between the legs. With this setup, as with the others, the lights must strike the copy with equal intensity.

Kathleen Kenyon collects old photo albums, old negatives, and catalogs. Collages are pasted up from bits and pieces culled from these collections. To preserve the original material and to control the size of the base images, much of this material is copy shot on either 35mm or 4x5 film. Conventional black-and-white continuous-tone prints are enlarged from the copy negatives. A paste-up is then made from these copy prints. Often, additional bits of original material from catalogs, labels, and the like, are added to the composition. The collage is then photographed (35mm or 4x5) and the resulting negative is enlarged to its final size on litho film. These large film prints are then transferred to screens or lithographic plates for final ink printing. The image is allowed to change and build during the entire process. The litho transparencies are sometimes cut apart, rearranged, and taped back together before the final transfer to screen or plate. Additional elements are added or subtracted during the printing process by masking, overprinting, and color adjustment.

◀ KATHLEEN KENYON: *Heavenly Bodies,* 5-color lithograph, 15x20, 1975
Litho film prints were prepared in a similar way for this image. Two basic film prints were used to make the plates: one piece of standard litho film for the flowers; and one sheet of Autoscreen for the women (see page 67). The use of the Autoscreen simulates continuous-tone. Five colors of ink were applied to two plates using a tiny roller.

KATHLEEN KENYON: *Present,* 11-color serigraph, 25x30, ▶ 1976
The base image of the people in this print was made by enlarging old negatives on conventional photo paper. The enlargement for this print was pasted up with birds and flowers taken from old catalogs and labels. The completed collage was then copy shot on Tri-X film and the resulting negative was enlarged to its final size on litho film. Eleven different tone separations of the negative were then made and contact printed on sheets of stencil film. The eleven stencils were then adhered to screens for silkscreen printing. Each screen was printed in a different color, in register, producing a "full color" effect.

THE POLKA CADETS, 1978
The same model was originally photographed assuming a
variety of different poses against white. An 8-inch paper
doll was made of each pose. The paper dolls were rephoto-
graphed together and the image converted to litho film.

OSCAR BAILEY: *The Boxes,* 1972
A copy of an engraving of a perspective study by Jan Vre-
deman de Vries (1527–1604) was used as a base image
for this paste-up. A large cardboard box was constructed
and different people were photographed carrying it around.
Bailey made several prints, then pasted each onto the base
image. When the paste-up was completed, it was photo-
graphed on litho film.

THE PROFESSIONAL PROCESS CAMERA

The process camera is a large (usually room-
sized) camera used in the offset printing industry.
Larger art schools have process cameras avail-
able for students, but most people will have to
take their montage to a printing company or a
photostat service to have the copy shot taken for
them. This requires that the montage pieces be
securely pasted into position.

Ask the printer or photographer to use a pro-
cess camera to make a "line negative." Because
this negative will be used as a final contact nega-
tive, specify the measurement of the longest di-
mension. Make sure that the final negative will fit
your contact print frame and also fit comfortably
on standard-sized photo paper.

This final negative can be retouched, masked
around the edges, and contact printed directly on
photo paper to produce the final print. This
method is expensive, but will produce the highest
quality results.

CONVERTING YOUR ENLARGER INTO A PROCESS CAMERA

Any enlarger can be temporarily converted into a small, makeshift process camera. A matching pair of desk lamps is the only special equipment needed. The conversion is made by reversing the normal use of the optical system. The material to be photographed is laid on the baseboard of the enlarger, and the film that is to record the image is placed in the carrier above the lens. Any enlarger can be used, but working in a 2¼-inch format with approximately an 80mm lens gives better results than a 35mm format with a 50mm lens. A 4x5 format (135 or 150mm lens) can rival a professional process camera for recording minute detail.

Using your enlarger as a process camera is recommended for several reasons. It is the most straightforward and the least expensive of the three methods. It won't reproduce as much detail as a real process camera, but for most high-contrast work, even the 35mm format will produce adequate results. A premium enlarging lens can even accurately record the grain of continuous-tone prints. If you shoot a previously screened image from a magazine or newspaper, the half-tone screen will be recorded. It is often the best method for converting images into high-contrast when the original negative is not available. The individual elements of your montage are arranged and shot right under the enlarger. There is no need to paste them into position. Each of the elements can go back into your resource file after the shot is made.

Any matching pair of desk lamps equipped with standard 60-watt incandescent bulbs can be used. Use a two-way plug adapter and connect both lamps into the enlarger plug of your timer. Both lights must be switched on and off simultaneously. The enlarger itself can be connected directly to a wall outlet. The cord switch can be used to turn it on for focusing. Position the lights, one on either side of the lens, to beam onto the baseboard at a 45-degree angle (see illustration). Setting them about 500 to 750mm (20–30 inches) above the baseboard will provide enough illumination for most copy setups. Place a small push pin or similar object on the center of the baseboard directly below the lens. Adjust the lights until the shadows on either side of the pin look exactly the same. If the lights are placed at the correct height and angle and the copy is completely flat, reflection glare will not be a problem, even if you choose to cover the montage with glass.

1. **Set the montage** directly on the baseboard of the enlarger. If you are shooting several pieces of the same size, they can be placed in an adjustable easel. The easel can be used to indicate coverage of the lens.

2. **Adjust the lens magnification.** Insert the empty carrier into the enlarger and raise or lower the head of the enlarger while adjusting the focus until a sharp-edged rectangle of light covers the copy with little room to spare. Use masking tape to secure the corners of the copy to the baseboard.

3. **Focus** by placing a continuous-tone negative into the carrier. Project it onto the montage using the enlarger lamp. If you are using a grain magnifier, place it *on the montage*, aligned so that the mirror is in the center of the frame. Critically focus the grain of the projected negative. Double check the coverage. Lock the enlarger and carefully remove the carrier without disturbing the focus. Close the lens down to f/8. (Some lenses produce a sharper image at f/5.6 or f/11.)

4. **Cut the film.** Under the red safelight, trim a piece of unexposed litho film and fit it into the carrier. The width will be determined by the format of the carrier, but the film should extend well beyond length of the opening.

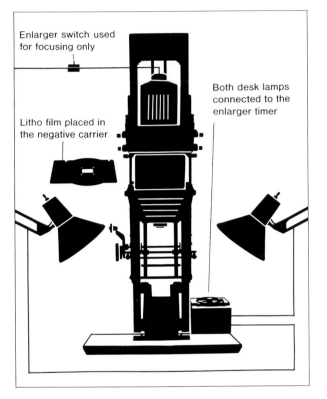

Enlarger switch used for focusing only

Litho film placed in the negative carrier

Both desk lamps connected to the enlarger timer

An enlarger can be converted to a process camera by reversing the normal function of the optical system. The litho film is placed in the carrier (to receive the image). The baseboard is lit as if it were a copy stand with a matching pair of desk lamps plugged into the timer. The copy (montage) is placed on the baseboard. The exposure is made by activating the timer.

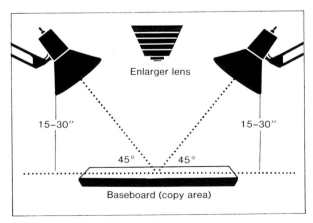

Enlarger lens

15–30″ 15–30″

45° 45°

Baseboard (copy area)

The lamps should be carefully positioned on either side of the lens to beam on to the baseboard of the enlarger at 45-degree angles. They should provide even light.

This will help hold the film flat. The film is placed in the carrier emulsion side down.

5. **Insert the carrier** into the enlarger again, being careful not to jar the focus.

6. **Set the timer.** For most enlargers the exposure will be between 2 and 30 seconds.

7. **Expose** by activating the timer.

8. **Develop the film.** Flip the film over, after removing it from the carrier, so that it develops emulsion side up. Use a standard litho developing solution. Fine Line Developer will produce slightly better results for extremely detailed copy. Agitate during the first 15 seconds, still develop for the remaining 2 minutes and 15 seconds (for either type of developer).

9. **Complete the processing.** Gently agitate the film in the stop bath 10 seconds. Fix for twice the time it takes the film to clear. Over-fixing can bleach the image. Rinse the film briefly in water.

10. **Inspect the negative** using a magnifying glass. View it against a light box to determine if focus and density are satisfactory.

11. **Wash the negative** 10 minutes in running water, followed by hypo neutralizer, a final 5-minute wash, and a solution of wetting agent.

12. **Make the final print on paper by enlarging the negative.** (If you want to do extensive retouching before making a final print, the negative can be enlarged to its final size on litho film, retouched, and contact printed to produce a final contact negative.)

The Enlarger Camera: Other Uses

COPYING FILM PRINTS AND MAKING HIGH-CONTRAST SLIDES

Instead of using desk lamps under the enlarger, you can use a light box as the light source for copying film negatives and positives. The technique is the same for both light sources. Focus by placing the magnifier on top of the transparency (which is resting on the surface of the light box). It requires some testing to determine the actual exposure.

The enlarger camera can be used to make excellent high-contrast slides. They can be shot directly from a print, using the desk lamp setup, and reversed by contact printing. Or, they can be made from your final contact negative, using the light box for illumination. After the slide is processed and dried, it is mounted in a cardboard or plastic slide mount. The Swedish Gepe Mounts provide the best protection for the litho slides. They use thin glass panels on both sides of the film to prevent fingerprints, scratching, and film curvature during projection. The mounts easily snap together and can be taken apart and reused. Most slide projectors will accept these slightly thicker mounts.

Estimating Exposure

For a 35mm negative from 8x10 copy, the exposure time varies between 2 and 30 seconds (depending on your equipment). It will take 15 to 20 minutes of testing to pin down the proper exposure. Use small pieces of film for this testing. If you are shooting 4x5 format, you may want to use half-sized pieces laid diagonally across the carrier. Take notes during the testing procedure. Once a standard is established, good results become easy to repeat. You'll find that 60-watt desk lamps work well for copy up to about 10x12. A larger, more even spread of light is required for shooting larger pieces.

Cord switch for focusing only

Enlarger focus scope
Place on top of copy

Copy area

Light box connected to enlarger timer

The enlarger camera can also be used for copying film prints and other transparent or translucent material. A light box can be plugged into the timer and used instead of desk lamps as a light source. This is an excellent way to produce high-contrast slides from large litho negatives.

This is a print made from a litho negative shot directly in a ▶ 4x5 enlarger camera. Litho film is orthochromatic and does not respond normally to colors. This must be taken into consideration when this film is shot directly in the camera (see page 98). The litho negative will record reds lighter and blues and greens slightly darker than they would appear on panchromatic film. Because this is a print made from such a negative, the reds and oranges have turned dark, and the light blues and greens have lightened slightly. Panchromatic varieties of litho film are available, but they must be handled in total darkness or under a special safelight.

Light blue

Light green

Red

Orange

Red

Light reddish brown

Purple

Green

CRUDE HALFTONE SCREENING

When a negative is shot for offset printing, a special halftone screen is placed over the film in the back of the process camera before exposure. This breaks the image into the tiny high-contrast dots necessary for reproduction of it in ink. The same process, in a crude form, can be used with the enlarger camera. A piece of halftone screen can be sandwiched in a glass carrier with unexposed litho film. A glass carrier is made by taping together two pieces of 5x7 glass (thin-weight glass). The use of the glass prevents the film from sagging during the exposure. When the enlarger condenser is lowered, the weight will hold the screen and the film in tight contact while the exposure is made. Shooting through a screen in 35mm format produces a crude screen pattern when the image is enlarged. If a 4x5 enlargement format is used, the screen will be a bit smaller in proportion to the image. This type of screening can be used for its design effect, or as a preparation for photo silkscreening.

Kodak Autoscreen is a litho film with a preexposed screen built into it (see page 67). It can be used directly in the enlarger camera.

An artist's pattern screen can also be sandwiched in the glass carrier with the unexposed litho film. Although this does not create a true halftone, it will superimpose the pattern on the negative.

SHOOTING FLAT, THREE-DIMENSIONAL MATERIAL

The best lenses in an enlarger camera setup have a maximum depth of field of less than 25mm (1 inch). But within that range they can produce surprisingly sharp and detailed images of three-dimensional objects.

Objects that produce silhouettes (page 58) or interesting transparencies are the easiest subjects to shoot. These objects can be laid directly on the light box. The resulting images will look similar, but not identical, to lithograms.

Many types of flat subjects can be shot under the enlarger camera with the desk lamp setup. The tonality may be unusual because of the misinterpretation of reds and blues and the exaggerated response to highlight detail on litho film. The alligator foot purse shown on the opposite page demonstrates the amount of detail that can be recorded by the enlarger camera. In this example, the object was placed on a piece of graph paper (black rather than blue line) and shot in 4x5 format using a 150mm enlarging lens. The shadows have been eliminated by the angle of the lights. The negative was developed in standard litho developer and enlarged to this size. The contrast, particularly in the highlights, has become exaggerated. The grain is actually the very fine grain of the litho film itself.

This photograph was taken in the darkroom using a 4x5 enlarger as if it were a process camera. The 4x5 negative was developed in Fine Line Developer, then enlarged directly on conventional enlarging paper (#3). Notice the exaggerated response of the litho film to the highlight areas. The grain in this photograph is the grain of the litho film itself.

High-Contrast Video Montage

Access to a complete video system will allow you to make your own video images for use as raw material for photomontage. The electronic scanning patterns incorporated in the image are well suited to high-contrast conversion. A video tape of images can be recorded, played back, stopped on an image, and the images can be photographed from the monitor. After the film is processed, selected negatives can be converted to litho film.

Using a complete video system provides a high degree of control over the image. Because the tape can be replayed, you can take your time examining and selecting images. Video tapes can be stored and replayed at a later date. They provide an excellent way to collect images as raw material for future composites.

The emphasis here is on recording a conventional video image. Many types of electronic equipment are specifically designed to generate moving optical distortions and effects. If you are using video to create still imagery, you will find that most of these electronic effects can be more efficiently created in the darkroom from a conventional video image. Other video effects, however, cannot be imitated by darkroom manipulation. For example, two images can be electronically mixed using two video cameras and/or two video recorders joined by a mixing console. If you have access to a sophisticated system, you will find that electronic blending has obvious creative potential.

The Setup

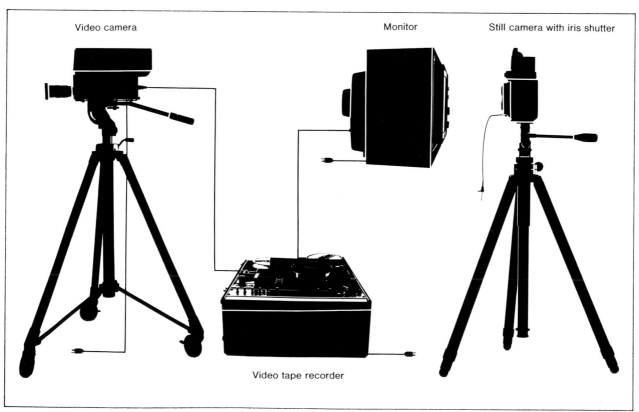

Video camera Monitor Still camera with iris shutter

Video tape recorder

This is a simple, basic setup for recording video images on film. The video camera is connected to the video recorder and the recorder is connected to the monitor. Images can be photographed live from the monitor or they can be photographed as a previously recorded tape is played back. A camera with an iris shutter is recommended for shooting video images.

VIDEO COLLECTION: LEAVES, 1976

Making the Tape

Try making video tapes of different subjects under different lighting conditions. Make video camera adjustments as you watch the monitor. Unless you are working for an unusual effect, find the camera aperture that will give you the sharpest picture under the prevailing light conditions. The best setting will give you a normal-appearing image with the brightness and contrast controls on the monitor set in their middle positions. Taking the trouble to adjust the equipment in this way provides the greatest degree of flexibility during playback. Constantly checking playback while you are recording is also recommended practice. When shooting still subject matter, take at least 10 seconds of tape of each shot. This will allow the equipment to "settle" during both recording and playback phases. It will also lessen the chance of a defect on the tape interfering with the image.

If you are taping moving objects, be conscious of the rate of speed at which they are moving (as well as any camera movement). Video equipment has speed limitations that will become quite apparent. If a sharp image is desired, models can be told to move about at half their normal rate of speed. This allows for a crisp image to be extracted from any part of the moving sequence during playback on the monitor.

"Lag" is generally considered to be a problem or fault by people who make video tapes, but it can be an interesting creative variation. Lag is caused by a quick motion made by either the subject or the camera. It appears as a trailing blur behind the highlights as they move from one part of the screen to another. The effect can be frozen during playback. It is most striking when a small bright area moves rapidly across a black background. Most video cameras are equipped with a zoom lens; through rapid zooming action a different kind of lag can be intentionally recorded on the tape. This produces a halo or aura effect around the subject.

Other interesting effects can be created in a studio situation during the taping phase by changing the lighting. Experiment with backlighting (see page 137) or direct specular lighting (see page 132).

The video camera can also be used to reshoot previously made film prints. The electronic rendition of the image will be quite different from the original. Attach the film prints to a light box and mask around the print so that no stray light can affect the contrast of the video image. It is best to set up the light box vertically because most video cameras are not designed to operate lens down.

If your objectives include getting the highest possible level of video quality, hook up the monitor through the recorder—but do not bother taping. Shoot from the monitor. A directly monitored image tends to be sharper than one that is recorded on tape and played back.

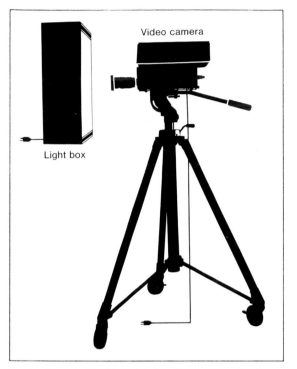

Video camera

Light box

Previously made litho film prints (positives or negatives) can be introduced into the video system by attaching them to a light box and recording each with the video camera. This setup was used to make *Video Collection: Leaves.* Tone-line negatives (page 60) were made from simple lithograms (page 52). These 4x5 images were recorded on tape to introduce the electronic screening effect.

Playback

Set your camera up to shoot directly from the screen (for the best way to do this see page 128). Search through the tape until you have located the images you want to use as part of a montage. This may take a long time; at 30 frames per second, a 20-minute tape can yield 36,000 potential still images. Some video tape recorders have a lever which will "freeze" the image. Though occasionally helpful, quite often a "cleaner" image can be obtained by shooting directly from a moving tape. The freeze device also has the capacity to freeze the tape "between the frames," a potentially interesting, creative variable. With most recorders, stopping the tape in this way causes a slight deterioration of the image near the top or bottom of the screen. This deterioration is responsible for the lightning effect in some of the video images in this chapter (page 245). Many types of electronic faults have potential for creative use.

The Conversion

After potential montage fragments have been shot on continuous-tone film, processed, and dried, they can be enlarged on litho film. The prints can be used as single images, or several can be combined using any of the techniques described in the beginning of this chapter.

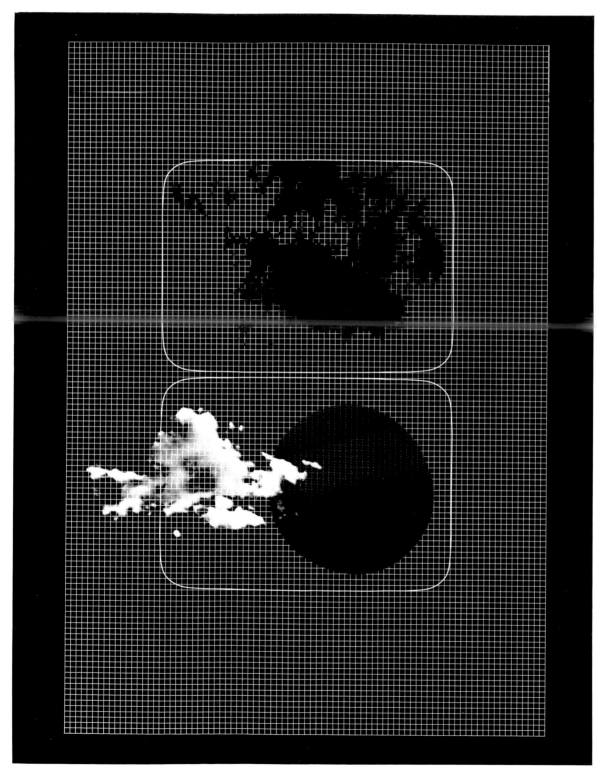

VIDEO SIGHTING, 1977

VIDEO COLLECTION: *INTERFERENCE*, 1976

THE THEORY OF SNOW, 1976

VIDEO CADETS, 1976

Index